PHOTOGRAPHY
AFTER FRANK

PHOTOGRAPHY
AFTER FRANK

Essays by **Philip Gefter**

aperture

CONTENTS

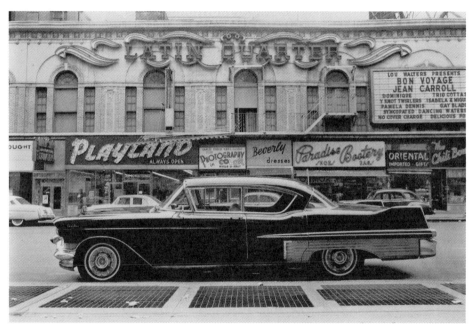

Frank Paulin, *Playland Cadillac, Times Square, New York City,* 1956

This image dates from the same period as the photographs in Robert Frank's *The Americans*, capturing the tenor of the moment when black-and-white street photography began to define the medium. Paulin's perfect symmetry leads the eye directly to the center of the frame, to the word *photography,* announcing the medium that renders in complex optical description a time, a place, and an era.

INTRODUCTION

In the broad sweep of art history, photography is just a blip, coming at the tail end of a long continuum that reflects and parallels the evolution of consciousness. From cave drawings to Greek sculpture to Italian frescoes to French neo-Classical painting, art-making over time is a story about increasingly refined tools, measured accuracy in representing the objective world, and eventually, a gradual progression into perceptual abstraction. Accordingly, the history of art can be viewed as a sequential narrative that charts over thousands of years the simultaneous stages of necessity, invention, and imagination to reveal, ultimately, the manifest intelligence of the species in the complexity of human expression.

Still, during photography's own brief history, humankind has never been brought into sharper focus. Overall, photography has given us a self-adjusting clarity about who we are, what we look like, and how we behave, reflecting our world—individually, culturally, scientifically, and, ultimately, existentially—in ways unimaginable merely two hundred years ago. Whether the camera is a scientific, utilitarian, or artistic tool has ceased to be the relevant debate.

Daguerre, Niepce, and Talbot brought civilization to a new stage of consciousness with the invention of photography around 1839. Life, for the first time, could be captured in its truest visual facsimile. Photography's evolution—along with its progression to cinema, television, video, and, ultimately, cyberspace—has given us the ability to review almost every aspect of our lives instantaneously, if we want, and with exacting detail.

These tools of observation have allowed us a stunning overview of the world in which we live—in fact, nothing less than images of the planet Earth itself, just to put things in perspective, as well as the prenatal development of a human being from conception. But the same technology has brought us to a paradoxical self-consciousness: while the photographic image provides heightened awareness about what is real and factual, the constant representation of who we are in visual terms brings with it a meta-consciousness that refracts authentic, or spontaneous, experience.

One irony of photography's invention is that, while it emerged concurrently with a shift toward Realism in painting, it was artists themselves who grew indignant at the idea that a mechanical method of representation could be elevated to the stature of art-making.

In 1862, Ingres was among the important artists who issued a bitter denunciation of photography, signing an official petition to the Court in Paris against industrial techniques being applied to art. Perhaps the shorthand ease of perceptual accuracy with which the camera captured the world was too threatening; toward the late nineteenth century painting itself veered toward perceptual abstraction. In the twentieth century art became, then, less about rendering the world with true-to-life objectivity than about the emotional, perceptual, and experiential nature of existence (with recent digressions into deconstructive cultural analysis).

While documentation of the objective world was an underlying principle of art-making in photography for a good part of the twentieth century, the formalism that characterized such factual documentation changed in the 1950s with Robert Frank. His book *The Americans*, published in the U.S. in 1959 (and in France the year before), has come to represent a turning point in photography: his pictures show us common people in ordinary situations, but his documentation was as much about his personal experience as it was about his subject matter. As a result, he changed the look of the photograph and the content of photographic imagery.

The artistic climate in which Frank produced the photographs in *The Americans* was defined by Abstract Expressionism. Jackson Pollock and Willem de Kooning rendered spontaneous expression out of the anarchy of form, perhaps setting a precedent for the Beat Generation artists and writers, whose improvisational art-making practices aimed for authenticity and spontaneity in their work as well. Frank's pictures reflect the stream-of-consciousness art-making of the period, and his attempt to capture the experience of an authentic moment in visual terms established a departure from the traditional photographic imagery that preceded him. The immediacy, spontaneity, and compositional anarchy in his picture frame changed expectations about the photograph. It created a new way of seeing for subsequent generations of photographers. In fact, *The Americans* might be looked at today as the apotheosis of the snapshot (the snapshot in and of itself being the backbone of unselfconscious photographic imagery in the twentieth century) and the birth of the "snapshot aesthetic."

In the decade that followed, a pivotal exhibition at the Museum of Modern Art introduced the work of Diane Arbus, Lee Friedlander, and Garry Winogrand, all three of whom worked in a personal documentary manner that, today, looks as if it pays a natural debt to Robert Frank for changing the rules. Friedlander and Winogrand took to the open road as Frank had and documented America—or their own experience of it—as Stephen Shore and William Eggleston would do yet a decade later. Frank's influence extends beyond the road-trip documentation of America, though, to the kind of personal documentation of relationships and families infused with autobiography and intimacy, from the work of Emmet Gowin to Larry Clark to Nan Goldin.

The relationship between artists and photography that followed Frank and his circle of friends (Allen Ginsberg, Jack Kerouac, Franz Kline, and de Kooning)—while not directly as a result—came to reflect an ever more symbiotic exchange: John Baldessari and Ed Ruscha both employed the photographic image in the early 1960s; Andy Warhol began using photographs as a foundation for printmaking; Chuck Close made Photo-Realist headshot paintings. In the 1980s, Cindy Sherman, Richard Prince, Sherrie Levine, Barbara Kruger, and others used photographs as well as a photographic vocabulary to make artwork that commented on the many cultural implications of the photographic image. And photographers like Tina Barney, Philip-Lorca diCorcia, Larry Sultan, Jeff Wall, and later, Gregory Crewdson, began to stage their images and affect the look of an authentic moment.

The simultaneous birth of television and the popularization of the Brownie box—or instamatic—camera in the mid-twentieth century is a signal moment to begin a meditation on how photography evolved to become today a viable, valuable, and substantial sibling among the fine arts. At the same time, photographic imagery has followed a trajectory from captured moments of factual reality and authentic experience to the more calculated artificial tableaux that returns image-making to what pre-twentieth-century painters were doing: setting up narrative scenes on canvas.

The staged photograph draws on the look of cinema and advertising to depict representational narrative scenes, once the hallmark of great painting. In fact, despite the bravura technological production involved in Gregory Crewdson's narrative tableaux, they might be likened to what the neo-Classical painter Jean-Baptiste Greuze, say, was aiming for in the late eighteenth century with his domestic scenes that depicted the decline of the patriarch in family life in France. Painters rendered human experience with a clarity of observation and telling narrative drama that depicted their time and provided insight about who they were, and ultimately, about who we are as a species, too, whether fact had anything to do with it or not.

In the 1990s, digital technology opened up new possibilities for photographers like

Andreas Gursky and Jeff Wall to make mural-sized images that competed with the size— and impact—of paintings, and painters like Eric Fischl started making paintings based on their own manipulated photographs.

The interplay and cross-pollination between artists and photographers over the last half-century have shaped photography and brought us to a point where the distinction between art and photography has finally broken down altogether.

Since the 1950s the history of photography can be tracked any number of ways. In terms of subject matter alone, art-making can be broken down into genres. An evident trajectory of photographers who took on a societal view might begin with Robert Frank in *The Americans* and advance to Garry Winogrand's narrative of America in 1964, to Stephen Shore's documentation of the U.S. on road trips in the early 1970s, to Joel Sternfeld's pictures in *American Prospects* (1987), and in Europe, from Bernd and Hilla Becher's canny chronicle of industrial relics, to Martin Parr's documentation of Thatcher's Britain and Andreas Gursky's sweeping views of society in the global economy. Then there are the subcultures, represented by Bruce Davidson in *Brooklyn Gang* (1959), Larry Clark in *Tulsa* (1971) and *Teenage Lust* (1983), Nan Goldin in *The Ballad of Sexual Dependency* (1986), and, later, by Wolfgang Tillmans's diaristic images of his gay friends and Ryan McGinley's nightlife narrative of club kids. The family has been chronicled by Emmet Gowin, Larry Sultan, Tina Barney, and Sally Mann, and the individual in portraits by Diane Arbus, Richard Avedon, Peter Hujar, Robert Mapplethorpe, Thomas Ruff, Rineke Dijkstra, and Katy Grannan.

The photograph has grown not only in size but in stature. Long considered an art world bastard, it is now a fully acknowledged and respected sibling on museum walls, at auction houses, among collectors, and, even, in the marketplace. Written on the occasion of new books and exhibitions or as meditations on ideas and phenomena, the essays in this book explore the trajectory of photography since the 1950s. It is my hope that they add up to a broader observation about the way photographic art-making has helped us see ourselves in the world more clearly, even as it has separated us from an authentic state of being—in effect, from our innocence.

The Document

In the twentieth century, photography as proof, or documentation, of the objective world came to be regarded as a defining principle of the medium's art-making practice. The visual geometry and descriptive clarity typical of Walker Evans's work, for example, is often equated with such clear-eyed objectivity. But suppose that formalist approach was just a matter of style.

Robert Frank's documentation of America is no less factual than Evans's, but Frank liberated the photographic image from the compositional tidiness and emotional distance of his predecessors. Critics were hostile to *The Americans* when it was published in 1959 precisely because of the informality of the frame, but photographers followed Frank's lead and began to exploit the camera's ability to record and describe (f)actual reality not only as evidence of what exists, but also in expression of their own experience. The expressive nature of the medium itself would soon become as much a visible component of the image as the documented subject.

Several important strains of documentation in photographic art-making dominated the last half of the twentieth century. The first was given a framework by the 1967 exhibition *New Documents*, organized by John Szarkowski at the Museum of Modern Art, which first introduced the work of Diane Arbus, Lee Friedlander, and Garry Winogrand. In the wall text, Mr. Szarkowski suggested that, until then, the aim of documentary photography had been to show what was wrong with the world as a way to generate interest in rectifying it. (He was likely referring to projects such as the documentation of Depression-era America by Farm Security Administration photographers Dorothea Lange, Russell Lee, Arthur Rothstein, Marion Post Wolcott, and Evans.) But this show signaled a change. "In the last decade a new generation of photographers has directed the documentary approach toward more personal ends," Szarkowski wrote. "Their aim is not to reform life, but to know it."

Critics were unsure of how, exactly, to identify the subject of these documentary pictures. Still, the exhibition set in motion a style of image-making that acquired its own term of art, the "snapshot aesthetic," coined from the unself-conscious look of family snapshots and meant to characterize the spontaneity of the documented moment as well as the authenticity of the photographer's experience contained within the frame.

Another seminal exhibition, *New Topographics: Photographs of a Man-Altered Landscape*, organized by William Jenkins in 1975 at George Eastman House in Rochester, New York, included American photographers Robert Adams, Lewis Baltz, Joe Deal, Frank Gohlke, Nicholas Nixon, John Schott, Stephen Shore, and Henry Wessel, as well as Bernd

and Hilla Becher from Germany. Here the documentary subject was clear: the natural landscape altered by modern civilization. The work shared an approach to photographing the landscape, absent an apparent point of view. According to Jenkins, these photographers were "anthropological rather than critical, scientific rather than artistic." In particular, Robert Adams aimed for visual neutrality in his pictures of the American West. At first glance this work seemed mundane, but, today, the images retain both historic significance and poetic resonance.

Concurrent with those documentary approaches, Bernd and Hilla Becher established a legacy of equal weight. Their Neo-Objectivism is at once clinical and conceptual—cataloging individual industrial objects in the landscape as if they were specimens and presenting them in grid form as species. The influence of their controlled documentary methods can be seen in a generation of their students from the Düsseldorf Academy who dominate the medium—or the discourse about photography—in contemporary terms: Andreas Gursky, Candida Höfer, Thomas Ruff, and Thomas Struth. The arms-length distance of objectivity in their work brings the idea of the document in photography full circle.

The essays in this section are by no means conclusive. Rather, they are meditations on individual artists whose methods of documentation vary from one to the next as much as the subject matter that composes their respective bodies of work and the intentions that drive them to make pictures in the first place.

Why MoMA Is Giving Its Largest Solo Photography Exhibition Ever to Lee Friedlander

As a photographer, Lee Friedlander is revered, especially among critics and curators, for his crisp and canny pictures of everyday life. But his photos can also be easy to dismiss: his subjects are so common, so ordinary, that it can be hard to understand what the fuss is about.

At least, it will be until next week, when his five-hundred-image-strong exhibition opens at the Museum of Modern Art—the largest single show the museum has ever mounted of an individual photographer. The museum's point will be unmistakable: as Peter Galassi, its chief curator of photography and the organizer of the show, claims, Mr. Friedlander is one of the great artists of the twentieth century in any medium, positioning him not just within the confines of photography, but in the art world at large.

Mr. Friedlander is a prolific photographer with nearly sixty thousand images in his archive as well as more than two dozen published books and portfolios of his photographs. MoMA purchased one thousand images by Mr. Friedlander five years ago, their largest acquisition of work by a living photographer, adding to the two hundred pictures by him already in their collection.

During a recent conversation in the museum's offices, Mr. Galassi was asked what he would say to those who scratch their heads at the significance of Mr. Friedlander's photographs. He argued that the very familiarity of the work—the storefronts, the nondescript intersections—is what gives it broad appeal. "The things that are in these pictures are not things that are made by or for or experienced by a tiny group of people," he said. "They're made by and for and experienced by essentially the whole nation. Why is this stuff relevant? Because it's so ubiquitous, it's so much a part of who we are."

The ordinary subject matter may be the reason for such varied opinions about Mr. Friedlander's work, but his photographs are by no means ordinary. To look at any one of them is to engage a riddle; even though the cars and buildings in a typical Friedlander street scene are familiar, the seemingly random elements come together in his picture frame as a magical reordering of the commonplace.

In one picture, *New York City*, 1963 (page 78), a man and a woman appear to walk toward each other, layers of glass and spaces between them delineating not only a gender divide but a class divide as well. You're not sure who's entering and who's exiting, what's inside and what's outside; among the reflections in the glass is the photographer's own shadow, echoing the woman's silhouette. The longer you look at it, the deeper the conundrum, made all the more poignant by the lock at the center of the frame, as if waiting for a key to unlock the answer.

In 1967, Mr. Friedlander was one of three photographers—the others were Diane

Arbus and Garry Winogrand—included in *New Documents*, a landmark show at the Modern. Mr. Friedlander, now seventy, outlived both Arbus, who died in 1971, and Winogrand, who died in 1984, continuing to photograph the same subject matter over and over again throughout his career with a curiosity that is less about documenting people, places, and things than it is about picturing his experience of them.

Look at his picture, *Albuquerque, New Mexico*, 1972 (page 78). A dog sits perfectly still at a street corner; the fire hydrant, streetlights, and telephone polls form a geometric jigsaw puzzle around it. Remove a single element and the entire composition falls apart. Mr. Friedlander finds natural patterns in the world in front of all of us, connecting dots we don't normally see until his pictures point them out to us. It's in his observations of the mundane that intelligence itself—perception, logic, and insight—is rendered in visual terms.

In an interview with a fellow photographer, William Gedney, in 1987, Mr. Friedlander said that while "somebody else could walk two feet away to get those poles and trees and stuff out of the way, I almost walk two feet to get into it, because it is part of the game that I play, it isn't even conscious."

If the timing of the Friedlander show seems to correspond with the current Diane Arbus retrospective at the Metropolitan Museum, it's merely a tidy historical coincidence. Mr. Galassi said that this retrospective had been approximately eight years in the making, during which time he spent one day every month or so at Mr. Friedlander's house in New City, New York—initially at the photographer's invitation to select work for the museum, but also with the idea of mounting this show.

Mr. Friedlander had a surprisingly laissez-faire attitude toward the curator from MoMA who was mining his entire body of work. While Mr. Galassi pored over photos, "I was printing, editing, doing something else," Mr. Friedlander said in a recent telephone interview. "I was not involved in the selection. Only with the last fifty pictures or so, which were new. Peter hadn't seen them before." As for the bulk of the show, he said, "I wanted to be surprised."

Mr. Galassi agreed: "With a longer past behind him, older, deeply interested in his current experiments, Lee was ready to have someone else take on the job. I was the serendipitous beneficiary of this."

During MoMA's three-year residence in Queens, Mr. Galassi used several walls in the photography department's office to assemble grids of more than one thousand note-sized copies of Friedlander photographs. He spent hours at a time rearranging images within groups in Rubik's cube fashion.

Curatorially, it made sense to begin with Mr. Friedlander's portraits of jazz musicians—from Count Basie to Ruth Brown to Miles Davis—which are placed together on a wall as you enter the exhibition. As a teenager in Washington State in the 1940s, Mr. Friedlander's interests in jazz and photography developed simultaneously. He started photographing his

jazz heroes in Los Angeles in the early 1950s, and continued when he moved to New York several years later.

The association of jazz to the look of his photographs is not something Mr. Friedlander is willing to concede, but the appearance of improvisation in his pictures can't help but remind a viewer of the musical riffs of bebop or scat. Take his picture *New Mexico*, 2001 (page 79). The telephone pole and the commercial and stop signs form a staccato arrangement of lines, shadow, and shapes, an improvisational visual riff on a generic, all-American street corner.

The rest of the show was harder to organize. Some of Mr. Friedlander's work is arranged by the subjects of his books—self-portraits, American monuments, nudes. What complicated the placement of pictures in the show, however, was the span of time over which Mr. Friedlander has returned to several distinct artistic preoccupations long after he published books on those subjects. For example, his book *Self Portrait* was published in 1970, but he hasn't stopped photographing himself, his reflection in windows, or his presence in shadow. Toward the beginning of the exhibition, there is a grouping of twenty-one self-portraits, with others following throughout the show in loose chronological order.

At one point, when Mr. Galassi's sequencing for the show was still a work in progress, he invited Mr. Friedlander out to Queens to look at the grid walls. "'Looks like an interesting photographer,' was what Mr. Friedlander said when he saw it," recounted Mr. Galassi, who added that the photographer "regards the past as the past and doesn't want to be bogged down in it."

The exhibition may simply be too enormous to absorb in a single visit. But Mr. Galassi defends the size, explaining that Mr. Friedlander's constant revisiting of subjects and techniques has been there from the beginning. Part of what's fascinating, he said, is that Mr. Friedlander has been "able to keep making the same picture without it being the same picture." He added that, because the pictures will be in decisively organized groupings—for example, "Factory Valleys," "Nudes," "The Desert Seen"—"you could think of the show as having seventy or eighty works of art in it."

The last photographer to receive a show of this magnitude at MoMA was Eugène Atget, in the 1980s, and the work was divided into four individual exhibitions several years apart. So why didn't Mr. Galassi consider the same treatment for Mr. Friedlander? "The point of a retrospective is to try to see the thing whole," he said, adding, "You know, if you're measuring in square inches, then this show is a lot smaller than the Pollock show."

Originally published in the *New York Times*, May 29, 2005.

Travels with Walker, Robert, and Andy *On Stephen Shore*

If Walker Evans and Robert Frank established an "on the road" tradition in photography, then Stephen Shore ranks among their natural heirs. Throughout the 1970s, driving tens of thousands of miles back and forth across the United States, Mr. Shore, who is now fifty-six and continues to make photographs, and to teach, took painstakingly detailed pictures that are time-tagged by the cars, the signs, the architecture, the details, and the spoors of American culture. A new, expanded edition of this well-regarded series, Uncommon Places, has just been published by Aperture, and every picture reverberates with the tenor of that era, from the quality of the color down to the structure of the image.

Walker Evans's seminal book, *American Photographs*, both records and defines the 1930s: certainly the cars, the clothes, and the billboards have the look of the period, but that look was also determined by the equipment Mr. Evans used. His vision was bound both by the compositional geometry afforded by his 8-by-10 view camera as well as by the slow black-and-white films available to him then. This is one reason his pictures appear frozen in time.

In the 1950s, the 35 millimeter camera gave Robert Frank greater spontaneity and new freedom in organizing the way the picture is framed by the camera. Pointing his hand-held Leica out the window of a moving car, he skewed the horizon line and thereby changed photography. The sense of immediacy and energy that characterizes his work in *The Americans* came from that new mobility. The grainy look of his pictures is one effect of the photographic film of that period, and corresponds to the broadcast static of the era's black-and-white television, another new technology that had not yet reached its potential for optical clarity.

In the 1970s, Mr. Shore chose to photograph with an 8-by-10 view camera because, as he says, "it describes the world with unparalleled precision; because the necessarily slow, deliberate working method it requires leads to conscious decision making; and because it's the photographic means of communicating what the world looks like in a state of heightened awareness."

Two elements distinguish Mr. Shore's work with a view camera in the 1970s from Mr. Evans's work in the 1930s: one is technical—the use of color as a descriptive element, a radical choice for Mr. Shore in 1973 given an art-world prejudice that considered color to be the hallmark of commercial photography. The Photo-Realist painters may have precipitated this inevitable transition several years before Mr. Shore set out, but only his contemporary William Eggleston was making color work at the same time, and others—Richard Misrach and Joel Sternfeld—soon followed. The other element is perceptual—a kind of stoned contemplation, if you will, that could have emerged only from the 1960s and that

typifies so much of Mr. Shore's work. The state of heightened awareness he refers to in the use of a view camera might be likened to the "expanded consciousness" that defined the age of Aquarius. In the parlance of the day, he achieved the photographic equivalent of "grokking" his subjects.

Growing up on the Upper East Side of Manhattan, Mr. Shore traveled to Europe as a child, but it wasn't until he visited friends in Amarillo, Texas, in his early twenties that he saw anything of the rest of America. "The way people hung out, the way they had fun, the way the city looked, the car culture," he recalls. "All of this was very new to me, and wonderful." In 1972 his experiences in Amarillo prompted him to learn to drive and make his first cross-country trip. In this way, he shares with the Swiss-born Mr. Frank the experience of photographing America as an outsider.

As a child, he was given copies of *American Photographs* and *The Americans*, but a far greater influence on him when he set out on the road was Andy Warhol. As a teenager in Manhattan, Mr. Shore spent a lot of time at Warhol's Factory, photographing and helping out with sound for the Velvet Underground and lighting for several Warhol films. It was from Warhol that he started to think in aesthetic terms. "Andy took a detached delight in culture," Mr. Shore said in a telephone interview. "Not as simple as his being critical of it, but he enjoyed it in a distanced way. I can see some of that in my work, too. He worked in a serial view and I began to think about images in terms of serial projects."

Mr. Shore's 1972 series American Surfaces includes thousands of 3-by-5-inch snapshots of simple things—a radio next to his bed, a toilet, a plate of eggs, an open book, a storefront. This was a visual record of his daily experience and, in effect, a serialized self-portrait that seemed to emulate the Warholian idea about repetition as a visual monotone, bringing the "itness" of something, its actuality, to the surface.

In 1973, on his first trip for Uncommon Places, during which he traveled thousands of miles, Mr. Shore made daily lists of what he ate, how long he drove, what he saw on television or at the movies, how many photographs he took, and the number of photographic postcards from an earlier project that he surreptitiously distributed in drug stores and truck stops. This account derived as much from Conceptual art of the 1960s as it did from Mr. Shore's personal artistic concerns. Those early diaries, both written and photographic, held for him a fascination with the way "certain kinds of facts and materials from the external world can describe a day or an activity."

Between American Surfaces and Uncommon Places, Mr. Shore's intentions shifted from the conceptual to the perceptual. His pictures became more formally precise, as if to make records of objects for forensic scrutiny. But while the work in Uncommon Places is firmly grounded in a serious documentary tradition, the pictures are as much about pure discovery.

"I've often felt like an explorer, and I'm interested in not just bringing my set of values

to the rest of the country, but also in seeing what's there," he says. "When I got into the car to make one of those trips, part of it was the pleasure I would find in driving for days on end, driving down a road."

The pictures taken at motels, in diners, and at shopping centers attest to the traveler on a course of discovery—not of spectacles or charged events but, rather, what turn out to be revelations about the ordinary.

In Mr. Shore's photographs, a descriptive, almost deadpan, quality lets the viewer contemplate the subject without ambiguity. That's the influence of Warhol in this body of work and what gives it the feel of that decade. At the same time, Walker Evans remains the ghost in the frame. Mr. Shore agrees: "If I were to say in the photography world that there was one person who I used as a springboard for ideas and a resource to learn from, it was Walker Evans."

Mr. Shore's work is not quite so sober as Evans's. There is an antic undercurrent to his straight-faced pictures, as if, after staring at the sheer actuality of what was laid out before him, he might have burst out laughing before making the picture. Think of Walker Evans—stoned.

Originally published in the *New York Times*, July 4, 2004.

Southern Exposures:
Past and Present Through the Lens of William Christenberry

"They were like perfect little poems," Walker Evans said about the three-inch-square pictures of the American South that William Christenberry took with his amateur Brownie camera.

The Brownie was never intended for exacting documentation or creative expression; it was the camera used for snapshots of family gatherings and vacations in the 1940s and '50s. What a crafty little camera, then, for Mr. Christenberry's persistent chronicle of the regional architecture and artifacts in his native Hale County, Alabama. His little snapshots managed to capture the local dialect of his hometown in visual terms.

Mr. Christenberry was born in 1936 in Tuscaloosa, Alabama, not twenty miles away from the migrant farmers Evans photographed that same year and later published in *Let Us Now Praise Famous Men* with text by James Agee.

The sharecroppers in Evans's photographs lived in a house across the cotton fields from the farm owned by Mr. Christenberry's grandparents. By the time Mr. Christenberry discovered the book, in 1960, he was a young artist. When he moved to New York the next year, it took him months to work up the courage to call Evans, then the picture editor at *Fortune*.

"Young man, there is something about the way you use this little camera that makes it a perfect extension of your eye," is how Mr. Christenberry recalls Evans's reaction to the Brownie prints. Speaking in a courtly Southern drawl in a phone interview from his studio in Washington, he said that Evans encouraged him to return to the South to continue his work.

The South became Mr. Christenberry's subject, not only in the photographs for which he is now best known, but also in sculpture, painting, and assemblages exploring his relationship to his Southern past. A major yearlong exhibition of Mr. Christenberry's work in these mediums has just opened at the newly refurbished Smithsonian American Art Museum in Washington, and a comprehensive catalog, *William Christenberry*, has been published with Aperture. Simultaneously, an exhibition of Mr. Christenberry's photographs is opening at the Aperture Gallery in Chelsea.

By 1962 Mr. Christenberry had moved to Memphis. He met a young local photographer named William Eggleston and invited him to his studio, where a series of his color Brownie snapshots had been tacked to the wall. In the early 1960s color film was considered too commercial and artificial to be used for art photography. Still, Mr. Eggleston's one-man exhibition of color photographs at the Museum of Modern Art in 1976 was a milestone—despite its disapproving critics—and he became known as a pioneer among the first generation of color photographers. "It's interesting to think that if Evans hadn't encouraged Christenberry to go back to the South, Eggleston might still be a black-and-

white photographer," writes Walter Hopps, the founding director of the Menil Collection in Houston, in a posthumous essay in the catalog to the Smithsonian show.

Initially Mr. Christenberry picked up the Brownie camera to make color prints as references for his paintings. "I was about as interested in photography as I was in physics," he said. "If you thought of the Brownie picture as a dream or an apparition, the prints were nothing more than a distant feeling of what the color made them seem."

Mr. Christenberry, who has lived in Washington since 1968, makes annual pilgrimages to Hale County to document the personal landmarks of his youth. After the first big exhibition of his Brownie pictures, at the Corcoran Gallery of Art in Washington in 1973, he became acquainted with other photographers of his generation. Encouraged by Lee Friedlander to experiment with a large-format view camera he took thirty sheets of 8-by-10-inch negative film down to Hale County in 1977.

"I didn't know what I was doing," he said. "I had to get a commercial photographer from Tuscaloosa to load the camera for me. I double-exposed the first sheet."

Since then he has been working not only with the Brownie camera but also with 35 millimeter and 8-by-10 cameras. The different types of equipment, formats, and films affect the look of a picture as much as the position of the photographer and the lighting conditions.

Compare *Church, Sprott, Alabama*, 1971, taken with a Brownie camera, and *Church, Sprott, Alabama*, 1981, taken with an 8-by-10 view camera. The Brownie image looks like a plastic toy model of a church. The exaggerated color gives the structure an unreal patina, and the lack of fine detail flattens the surfaces. By contrast, the level of fine detail in the 8-by-10 contact print, as well as the lens clarity, present a more recognizable record of the church as it really looked when Mr. Christenberry took the picture.

"The church just pulls me in," said Mr. Christenberry, who had been photographing Sprott Church every year. "It's truly, as the hymn says, the church in the wildwood."

Yet his photographs are only one component. In 1991 he returned to Sprott Church, disturbed to see that its spires were gone. Mr. Christenberry relied on his decades of pictures to make several sculptural pieces. *Sprott Church (Memory)*, 2005, made of illustration board, encaustic, and soil, is not only a homage to the church but also a souvenir from the region where he spent his youth.

"As I get older," he said, "memory becomes a major part of my being."

There are other sites he has chronicled from the same spot over many years, using different cameras, like the country store in Hale County that eventually became a social club. The photographic grids of these prints show the deterioration, transformation, or even demise of individual structures over the course of time. The effect of the grid format is cinematic, like a long time-lapse movie slowed to individual frames at particular years.

Mr. Christenberry's grids present the relics of a time and a place in a format similar to the work of the German photographers Bernd and Hilla Becher, whose photographic

grids catalog the vestiges of a disappearing industrial landscape with a clinical eye. But Mr. Christenberry's documentation is more personal, interpretive even. "The vast majority of what I do is a celebration of where I came from," he explained.

Nicholas Nixon, another photographer Mr. Christenberry came to know in the 1970s, has been making annual portraits of his wife with her sisters since 1975. Collectively Mr. Nixon's photographs chronicle the passage of time and its effect on his family, just as Mr. Christenberry's grids record how the passage of time changes vernacular architecture. They both return to the same subject, although with different intentions.

Despite Mr. Christenberry's affection for Hale County, which to some extent drives his own expressive chronicle, not all aspects of the bygone South were halcyon. "How can I, as a Southerner, have turned a blind eye on racism?" Mr. Christenberry asked.

In the mid-1960s he was able to take pictures of Ku Klux Klan events with a hidden camera. These images are part of an installation piece he has added to over the years, called *The Klan Room*. It's a Pandora's box of a room, filled with his paintings of Klansmen, photographs, sculptural objects, and relics: a stark acknowledgment of the dark side of the South's cultural history.

Mr. Christenberry didn't grow up around the graceful antebellum mansions and elegant public buildings that reflect the gentility of the South, and they are not represented in his work. He chooses buildings, signs, and relics based on their relationship to his own experiences.

"Son," he recalls his mother once saying to him, "everybody in Washington, D.C., is going to think Alabama is one rusted-out, worn-down, bullet-riddled place based on your work."

TB Hicks Store, Newbern, Alabama, 1976, depicts a place that triggers memories. A vestigial structure that sagged to the left and the right when Mr. Christenberry shot it, the photograph provides an example of the vernacular architecture of his youth and a record of a building that no longer exists.

"It was a one-chair barbershop," he said, with fondness, recalling that its chrome-trimmed, leather swivel chair reminded him of barber chairs he sat in as a child. "It was a great building as it began to shift, and, later, until it collapsed."

Evans's influence on Mr. Christenberry is evident in this picture. The straightforward approach, the simple composition, the ordinary roadside subject matter—all seem to quote directly from the style and the theme of *Let Us Now Praise Famous Men*.

"Walker was a very meaningful person in my life, but don't forget Agee," Mr. Christenberry said. "What Agee was doing in the written word was what I wanted to do visually."

Originally published in the *New York Times*, July 2, 2006.

John Szarkowski, Curator of Photography, Dies at Eighty-one

John Szarkowski, a curator who almost single-handedly elevated photography's status in the last half-century to that of a fine art, making his case in seminal writings and landmark exhibitions at the Museum of Modern Art in New York, died on Saturday in Pittsfield, Massachusetts. He was eighty-one.

The cause of death was complications of a stroke, said Peter MacGill of Pace/MacGill Gallery and a spokesman for the family.

In the early 1960s, when Mr. Szarkowski (pronounced Shar-COW-ski) began his curatorial career, photography was commonly perceived as a utilitarian medium, a means to document the world. Perhaps more than anyone, Mr. Szarkowski changed that perception. For him, the photograph was a form of expression as potent and meaningful as any work of art, and as director of photography at the Modern for almost three decades, beginning in 1962, he was perhaps its most impassioned advocate. Two of his books, *The Photographer's Eye* (1964) and *Looking at Photographs: 100 Pictures from the Collection of the Museum of Modern Art* (1973), remain syllabus staples in art history programs.

Mr. Szarkowski was first to confer importance on the work of Diane Arbus, Lee Friedlander, and Garry Winogrand in his influential exhibition *New Documents* at the Museum of Modern Art in 1967. That show, considered radical at the time, identified a new direction in photography: pictures that seemed to have a casual, snapshot-like look and subject matter so apparently ordinary that it was hard to categorize.

In the wall text for the show, Mr. Szarkowski suggested that until then the aim of documentary photography had been to show what was wrong with the world, as a way to generate interest in rectifying it. But this show signaled a change.

"In the last decade a new generation of photographers has directed the documentary approach toward more personal ends," he wrote. "Their aim has not been to reform life, but to know it."

Critics were skeptical. "The observations of the photographers are noted as oddities in personality, situation, incident, movement, and the vagaries of chance," Jacob Deschin wrote in a review of the show in the *New York Times*. Today, the work of Ms. Arbus, Mr. Friedlander, and Mr. Winogrand is considered among the most decisive for the generations of photographers that followed them.

As a curator, Mr. Szarkowski loomed large, with a stentorian voice, a raconteurial style, and a distinct Midwestern accent that wrestled his words to the ground for emphasis at every turn. Still, he was self-effacing about his role in mounting the *New Documents* show, "I think anybody who had been moderately competent, reasonably alert to the vitality of what was actually going on in the medium would have done the same thing I did," he said

several years ago. "I mean, the idea that Winogrand or Friedlander or Diane were somehow inventions of mine, I would regard, you know, as denigrating to them."

Another exhibition Mr. Szarkowski organized at the Modern, in 1976, introduced the work of William Eggleston, whose saturated color photographs of cars, signs, and individuals ran counter to the black-and-white orthodoxy of fine-art photography at the time. The show, *William Eggleston's Guide*, was widely considered the worst of the year in photography.

"Mr. Szarkowski throws all caution to the winds and speaks of Mr. Eggleston's pictures as 'perfect,'" Hilton Kramer wrote in the *Times*. "Perfect? Perfectly banal, perhaps. Perfectly boring, certainly." Mr. Eggleston would come to be considered a pioneer of color photography.

By championing the work of these artists early on, Mr. Szarkowski was helping to change the course of photography. Perhaps his most eloquent explanation of what photographers do appears in his introduction to the four-volume set *The Work of Atget*, published in conjunction with a series of exhibitions at MoMA from 1981 to 1985.

"One might compare the art of photography to the act of pointing," Mr. Szarkowski wrote. "It must be true that some of us point to more interesting facts, events, circumstances, and configurations than others."

He added, "The talented practitioner of the new discipline would perform with a special grace, sense of timing, narrative sweep, and wit, thus endowing the act not merely with intelligence, but with that quality of formal rigor that identifies a work of art, so that we would be uncertain, when remembering the adventure of the tour, how much our pleasure and sense of enlargement had come from the things pointed to and how much from a pattern created by the pointer."

Thaddeus John Szarkowski was born on December 18, 1925, in Ashland, Wisconsin, where his father later became assistant postmaster. Picking up a camera at age eleven, he made photography one of his principal pursuits, along with trout fishing and the clarinet, throughout high school.

He attended the University of Wisconsin, interrupted his studies to serve in the Army during World War II, then returned to earn a bachelor's degree in 1947, with a major in art history. In college, he played second-chair clarinet for the Madison Symphony Orchestra, but maintained that he held the post only because of the wartime absence of better musicians.

As a young artist in the early 1950s, Mr. Szarkowski began to photograph the buildings of the renowned Chicago architect Louis Sullivan. In an interview in 2005 in the *New York Times*, he said that when he was starting out, "most young artists, most photographers surely, if they were serious, still believed it was better to work in the context of some kind of potentially social good."

The consequence of this belief is evident in the earnestness of his early pictures, which come out of an American classical tradition. His early influences were Walker Evans and Edward Weston. "Walker for the intelligence and Weston for the pleasure," he said. In 1948, Evans and Weston were not yet as widely known as Mr. Szarkowski would eventually make them through exhibitions at MoMA.

By the time Mr. Szarkowski arrived at the museum from Wisconsin in 1962 at the age of thirty-seven, he was already an accomplished photographer. He had published two books of his own photographs, *The Idea of Louis Sullivan* (1956) and *The Face of Minnesota* (1958). Remarkably for a volume of photography, the Minnesota book landed on the *New York Times* best-seller list for several weeks, perhaps because Dave Garroway had discussed its publication on the *Today* program.

When Mr. Szarkowski was offered the position of director of the photography department at the Modern, he had just received a Guggenheim Fellowship to work on a new project. In a letter to Edward Steichen, then curator of the department, he accepted the job, registering with his signature dry wit a reluctance to leave his lakeside home in Wisconsin: "Last week I finally got back home for a few days, where I could think about the future and look at Lake Superior at the same time. No matter how hard I looked, the Lake gave no indication of concern at the possibility of my departing from its shores, and I finally decided that if it can get along without me, I can get along without it."

A year after arriving in New York, he married Jill Anson, an architect, who died on December 31, 2006. Mr. Szarkowski is survived by two daughters, Natasha Szarkowski Brown and Nina Anson Szarkowski Jones, both of New York, and two grandchildren. A son, Alexander, died in 1972 at age two.

Among the many other exhibitions he organized as a curator at the Modern was *Mirrors and Windows*, in 1978, in which he broke down photographic practice into two categories: documentary images and those that reflect a more interpretive experience of the world. And, in 1990, his final exhibition was an idiosyncratic overview called *Photography Until Now*, in which he traced the technological evolution of the medium and its impact on the look of photographs.

In 2005, Mr. Szarkowski was given a retrospective exhibition of his own photographs, which opened at the San Francisco Museum of Modern Art, touring museums around the country and ending at the Museum of Modern Art in 2006. His photographs of buildings, street scenes, backyards, and nature possess the straightforward descriptive clarity he so often championed in the work of others, and, in their simplicity, a purity that borders on the poetic.

One picture in the traveling retrospective, *The Farmers and Merchants Union Bank, Columbus, Wisconsin, 1919, 1954* (page 73), shows an authentic moment in small-town America, and epitomizes Mr. Szarkowski's eye: first, the arches of the Louis Sullivan bank

building are central to the composition, but two larger arches are formed by the branches of the trees at the top of the picture frame. The arches are again echoed in the windows of the car. The stationary bicyclist seems propelled forward by the car's shape, as well as by the locomotion effect of the bank's arches in consecutive order. Meanwhile, the wheels of the bicycle balance out the two men sitting on the bench.

From his own early photographs, which might serve as a template for his later curatorial choices, it is easy to see why Mr. Szarkowski had such visual affinity for the work of Friedlander and Winogrand.

One of his most romantic works, *Mathew Brady in the Back Yard*, 1952 (page 73), is an image of his dog taken during a visit to his parents' house when he was twenty-seven. One of the few personal pictures in the exhibition, it possesses the spirit of Alfred Stieglitz before him and anticipates the apparent spontaneity of the snapshot aesthetic, a movement that emerged in the 1960s. Here, the invisible hand of the photographer is also at play: parallel lines are everywhere, from the wood slats in the building to the vertical pole and the back of the rocking chair; a filigree of power lines props up the top right corner of the picture frame.

Mr. Szarkowski was in pursuit of what he calls a discovery of the authentic, one of the most elusive characteristics to identify or contain in formal terms. In this picture, the actuality of the experience saves it from a descent into cliché, and structure emerges out of a simple, emotionally resonant backyard scene.

When asked by a reporter how it felt to exhibit his own photographs finally, knowing they would be measured against his curatorial legacy, he became circumspect. As an artist, "you look at other people's work and figure out how it can be useful to you," he said.

"I'm content that a lot of these pictures are going to be interesting for other photographers of talent and ambition," he said. "And that's all you want."

A briefer version of this obituary was originally published in the *New York Times*, July 9, 2007.

The Imagist's Eye *On Henry Wessel*

"Most musicians I know don't just play music on Saturday night," Henry Wessel explained. "They play music every day. They are always fiddling around, letting the notes lead them from one place to another. Taking still photographs is like that. It is a generative process. It pulls you along."

Mr. Wessel has been pulled along for nearly forty years. From the moment he landed in Los Angeles in 1969, he wanted to photograph everything in sight. "I walked out of the airport into one of those clear, sharp-edged January days," he said. "The light had such physical presence; it looked as though you could lean against it."

The first of 140 pictures in Mr. Wessel's new boxed set, comprising the slender volumes *California and the West*, *Odd Photos*, *Las Vegas*, *Real Estate Photographs*, and *Night Walk* (Steidl), suggests how the photographer allows himself to be led by his eyes. You see a road in an empty desert landscape; a small dot is in the center of the frame; looking closer, your eyes force the letters into focus, coaxed perhaps by the recognizable shape of a stop sign. Just as an eye chart forces your vision to narrow, many of his pictures compel you to take a closer look.

His obdurately spare and often wry black-and-white pictures of vernacular scenes in the American West were first given a one-man show at the Museum of Modern Art in 1973. A year later his work was included in *The Snapshot*, an influential book published by Aperture that identified an emerging genre in photography of the period. The "snapshot aesthetic" combined the immediacy of family snapshots, the authenticity of documentary images, and the increasingly informal style of news pictures, as photographers tried to capture the spontaneity of a moment with heightened descriptive clarity.

"Innocence is the quintessence of the snapshot," Lisette Model wrote in the book's introduction. "I wish to distinguish between innocence and ignorance. Innocence is one of the highest forms of being and ignorance one of the lowest."

Mr. Wessel, who was born in Teaneck, New Jersey, sixty-four years ago, aims for that innocence in his work: he wants to narrow the distinction between the subjects he chooses and how they look photographed. (As Garry Winogrand always said, the only reason he himself took pictures was to see what things looked like photographed.)

From the beginning Mr. Wessel has used only one camera, a Leica with a 28-millimeter lens, and one type of film, Tri-X, which allows a full range of tones. He still processes his own film and makes his own black-and-white prints. Limiting his tools to a single camera with the same lens over the years has so deepened Mr. Wessel's sense of how light translates to film, and then to paper, that it's almost instinctive.

His most important choices are where he stands and when he shoots. But what goes into those decisions is elusive.

"Part of it has to do with the discipline of being actively receptive," he said over lunch recently in Manhattan. "At the core of this receptivity is a process that might be called soft eyes. It is a physical sensation. You are not looking for something. You are open, receptive. At some point you are in front of something that you cannot ignore."

In *Santa Barbara, California*, 1977 (page 81), a man stands on a patch of lawn staring at a flock of birds. The birds swirl in flight at eye level. Mr. Wessel took the picture at a bus stop, and said that the axial light of the early-morning sun was what at first attracted him.

"As I approached this scene, the birds were feeding in the grass," he said. "Startled for some reason, they took flight. I instinctually shot, exposing three frames before they were gone. When I look at it now, I marvel at how much of the world is hidden in the flux of time." The picture has the effect of a visual Zen koan, as if the man's gaze were what suspends the birds in flight.

Mr. Wessel suggested that photographs have a close affinity to Imagist poems, a comparison that reflects his own artistic influences. The Imagists wrote laconic verse with hard-edged description, creating precise visual mental images. Mr. Wessel's photographs too have an optical precision and silvery veneer that aim for that mental-image clarity.

Tucson, Arizona, 1974 (page 81), his picture of a small bungalow behind towering reeds, was taken while he was stuck in late-morning traffic on a trip from Waco, Texas, to Los Angeles. He was driving a 1959 Chevy Parkwood station wagon and saw a house as he glanced over his shoulder: "When I think back to this event, it serves as a reminder that it can happen anywhere at any time, like William Carlos Williams sitting on a bus, then writing about the back of the woman's head who was sitting in front of him."

In another picture, *Southern California*, 1985, a shirtless, well-built beach boy leans against a table, wearing sunglasses in the sunlight. You can see what Mr. Wessel means by the physicality of the California light; it's so sharp that the young man looks like a cutout against the concrete wall. The name on the building behind him, Ocean Sands, leads you to think that he is on the beach, even though there is no water in sight.

"Whenever I am in San Diego, I walk the beachfront neighborhoods, mindless, yet attentive, letting things catch my eye," Mr. Wessel said, adding that the best time of day is during the brilliant afternoon sun before the twilight fog rolls in. "I have no recollection of having taken this picture, but according to the contact sheet I took this photograph and two variants."

One of Mr. Wessel's rules is to put his contact sheets away for a year before deciding which images to print. "If you let some time go by before considering work that you have done, you move toward a more objective position in judging it," he said. "The pleasure of the subjective, physical experience in the world is a more distant memory and less influential."

While not widely known to the public, Mr. Wessel has taught at the San Francisco Art

Institute since the early 1970s and has influenced generations of photographers.

"Even in Wessel's early work in the desert and California, the high Western light that fills his pictures seems almost hallucinatory," Tod Papageorge, director of the graduate program in photography at Yale, wrote in an email message. "I think this had a strong influence on photographers who followed him in the later seventies, but none of them attempted to deal with the range of subjects, or made pictures that possess the extreme, and oddly personal level of visual precision that marks all his work."

In an era of digitally scanned, wall-size color images, Mr. Wessel's modest black-and-white prints take on the quality of handmade objects. "People don't pay much attention these days to the descriptive, expressive, and suggestive facts found in a good still photograph," he said ruefully, before offering a clue to his motivation. "The process of photographing is a pleasure: eyes open, receptive, sensing, and at some point, connecting. It's thrilling to be outside your mind, your eyes far ahead of your thoughts."

Originally published in the *New York Times*, May 21, 2006.

Beauty Is Not a Four-letter Word *On Richard Misrach*

Don't let the beauty of Richard Misrach's photographs fool you. His handsomely composed desert landscapes strike a deliberately refined classical note, but what lies beneath the surface is more to the point.

For thirty years, Mr. Misrach's frequent forays into the American West have been motivated by seemingly contradictory impulses: one is love for the desert, and a desire to render that landscape with documentary precision; the other is disgust, about the use of the land by government and industry. "For me the desert is remarkably powerful and beautiful," he told an interviewer for *Art Papers* magazine several years ago. "I hope that gives it a reason to be saved."

A new book, *Richard Misrach: Chronologies* (Fraenkel Gallery/D.A.P.), assembles 125 of his photographs in the order in which he took them, from his first pictures of cactus in 1975 to his recent aerial views of people lying on the sand at the ocean. There is no text beyond the name and date of each photograph. The book, he said, was conceived in the tradition of "the artist's book," that is, a conceptual work that stands on its own. In this case, *Chronologies* was intended as a record of his working process, as opposed to a retrospective of his work. "I wanted it to be as spare as possible and let the pictures do the work," he said in a recent telephone conversation from his home in Berkeley, California. Next month, pictures from *Chronologies* will be exhibited concurrently at Pace/MacGill Gallery in Chelsea and Fraenkel Gallery in San Francisco.

Mr. Misrach organizes his work as cantos—each of which is like a song in a song cycle or a chapter in an epic poem. He works on several projects simultaneously, assigning each picture to a canto. His first book, *Desert Cantos*, published in 1987, divided the work into four groups: the Terrain, the Event, the Flood, and the Fires. Since then he has added two dozen more.

It's easy to trace the evolution of Mr. Misrach's work from his college years at the University of California, Berkeley, in the late 1960s, where the antiwar movement instilled in him a sense of political engagement. In the early 1970s, a shift to more spiritual pursuits— he has cited yoga, meditation, the whole earth movement, William Blake, Gurdjieff, and Carlos Castaneda—sent him in a different direction, toward the desert.

The first picture in *Chronologies*, a black-and-white photograph of an illuminated cactus, has the effect of a primitive explosion—as harmless as a high school science fair experiment—in which the entrails of a bomb streak into the twilight desert sky. The image could be a template for Mr. Misrach's later photographs of bomb-testing sites, military installations that he discovered were closed to the public and highly polluted. He remembers thinking that he couldn't photograph the beauty of the American wilderness without

addressing this environmental intrusion. "It would have been the equivalent of sticking my head in the sand," he said.

Now, as then, his trips into the desert last two or three weeks at a time. He loads his Volkswagen van with a cooler full of trail mix, apples, carrots, and gallons of water, as well as a suitcase full of mostly nonfiction books. He loves the heat and the quiet, he said, and just wanders, chasing the light, often following the weather as a guide.

But the mechanics of photographing—setting up his 8-by-10 camera, dealing with film holders, calculating exposures, waiting for the right light—can get in the way of a pure meditative state. Still, his almost metaphysical reverence for the land is as evident in the photographs as is his technical skill. "When the light is great, I go crazy inside," he said. "If I go out there with a specific idea in mind, it never works out. So I would just stumble on things. That's how I discovered Bravo 20."

Bravo 20, an area of the Carson Sink desert in Nevada, was used by the United States military at the end of World War II for high-explosive bomb testing, which continued for many years. There are still bomb craters and thousands of unexploded bombs buried in the sand. In 1985, local civilians opposed the military's expansion of the site and, in the process, learned that its permission to test had expired nearly forty years before. Citing an 1872 mining law, they were able to temporarily halt the bomb testing.

Because it had been public land, there were mining shares, and Mr. Misrach bought claims to them for a nominal sum, and invoked his right to survey and mine his property. As a result, he was able to photograph at Bravo 20 for more than a year before the military reclaimed the land. These pictures constitute Canto X.

What began for Mr. Misrach as documentary exercises in the desert evolved into works infinitely more complex. "Misrach has progressed from a deeply rooted social conscience to an artist who exploits scale and the emotional power of color to create works that are more about aesthetic concerns," said Weston Naef, curator of photographs at the Getty Museum, in Los Angeles, during a recent trip to New York. "The book moves between beauty and its opposite, allowing the beautiful and the meaningful to be seamlessly juxtaposed."

Given the crisp detail and the majestic vistas in Mr. Misrach's photographs, it comes as no surprise that he cites the Sierra Club books of the 1960s as an early photographic influence, specifically the dramatic Western landscapes of Ansel Adams and Eliot Porter.

Those kinds of images were once dismissed as calendar art, but a new kind of landscape photography emerged in the 1970s. In 1975, a landmark show at the George Eastman House in Rochester titled *New Topographics* identified a movement to document social and industrial encroachment on the American landscape—what is now called suburban sprawl. A statement by one photographer in that show, Robert Adams, who has chronicled the changing American West in black-and-white photographs, serves as an

apt summary of the movement's creed: "I set one ground rule: to include in the photographs evidence of man. It was a precaution in favor of truth that was easy to follow, since our violence against the earth has extended to anonymous arroyos and undifferentiated strands of scrub brush."

Mr. Misrach said that his concerns and those of Mr. Adams certainly overlap, but that their approaches differ. "I deal with issues of color and scale; his is a more restrained palette," Mr. Misrach said. "Silver is crucial to Robert Adams's work; color is crucial to mine."

The serene colors and opalescent light in Mr. Misrach's *Diving Board, Salton Sea*, 1983 (from Canto III), at first suggest a desert oasis. But the diving board is actually part of a relic of an environmental disaster, and its appeal something of a desert mirage. The Salton Sea is an artificial lake fed by waters diverted from the Colorado River; the maintenance companies lost control of the water levels in the late 1970s and caused a decade of flooding. The motel swimming pool in the picture was among the property destroyed.

In *Desert Fire, No. 249, 1985* (Canto IV), the flames come from an agricultural controlled-fire meant to clear alfalfa fields. "I saw smoke in the horizon and I followed it," Mr. Misrach said. The horizon is marked with an almost calligraphic line of flames, and the color of the smoke-filled sky matches that of the ground—a scorched-earth Color Field painting on the one hand, a record of air pollution on the other.

"Misrach's work is very beautiful," Sandra S. Phillips, curator of photography at the San Francisco Museum of Modern Art, said in a conversation earlier this month. In terms of landscape photography, Ms. Phillips said, "people in New York City don't understand that most of this country is country—and you can't fully understand the breadth of his accomplishment if you don't take into account that it's about the politics of land use."

Not all of Mr. Misrach's work, however, is so sobering. The Event, from his *Desert Cantos*, documents contemporary rituals that attract people into the desert: there are people congregated with campers and lawn chairs to watch the space shuttle landings, and photographs of speed testing at the Bonneville Salt Flats.

On a more playful note, *Desert Croquet #3 (Balls, Plane, Car), Black Rock Desert, Nevada*, 1987 (Canto VIII) (page 87), was made during a two-day art installation in which artists from a collective in San Francisco played a giant game of croquet, using balls that were six feet in diameter. Mr. Misrach captured the otherworldly light during a desert windstorm. Still, in the context of his work, the giant croquet balls take on a more sinister aspect—perhaps that of explosive devices—and their scale against the car and the plane sitting nearby looks postapocalyptic.

One criticism often leveled against Mr. Misrach's work is that it aestheticizes disaster. To such criticisms, he has responded that if he were to make ugly photographs of bomb testing sites, no one would consider the land worth preserving. By delivering the bad news

with visual finesse, he suggests, there is potential for greater scrutiny. "Shakespeare uses profoundly rich and gorgeous language to convey the most terrible and tragic elements of the human condition," Mr. Misrach said. "It's the way the story is told that makes us reexamine life afresh."

Originally published in the *New York Times*, February 19, 2006.

The Tableau Inside Your Town Hall *On Paul Shambroom*

Town council meetings are not necessarily the stuff of art, but in the work of the photographer Paul Shambroom, they are certainly the subject of systematic scrutiny. From 1999 to 2003, Mr. Shambroom, who lives in Minneapolis, traveled the country photographing democracy in action on the local level, bringing his 4-by-5 field camera to more than 150 town council meetings in thirty states. Forty of the pictures have just been published in a book, *Meetings* (Chris Boot Ltd.), along with notes of the councils' proceedings. A selection of the images is on view at Julie Saul Gallery in Manhattan.

The documentary tradition of photographic cataloging goes back to the beginning of the medium in 1839, when William Henry Fox Talbot made records of leaves, buildings, and works of art in Britain to demonstrate the capabilities of his calotype process. Later, in France, Eugène Atget made a poetic visual record of the architecture and gardens of the ancien régime. In the United States, Eadweard Muybridge used time-lapse photography to capture and chronicle people and animals in motion. In Germany, August Sander photographed individuals as archetypes of German society.

In the last fifty years, photographers have explored this form of artistic inquiry with the rigor and discipline of forensic scientists. The most influential photographers working in this genre are Bernd and Hilla Becher, who catalog water towers and factory buildings, creating a permanent record of industrial age relics before they disappear from the modern landscape. Richard Barnes documents zoological specimens in the storage rooms of natural history museums around the world. Hiroshi Sugimoto photographed darkened movie theater interiors by exposing his film for the duration of the movie being shown.

In each case, the photographer uses a consistent format with exacting fidelity to present the subject (or object) unadorned. But at what point does this documentary form enter the precincts of art?

In Mr. Shambroom's case, the choice of subject matter and the precision with which he renders it suggest a devotion to a larger idea.

"My interest is about power," he said in a recent telephone conversation. "Where it comes from and how it is used. The whole process of decision-making and leadership is what I was exploring here, at the smallest of the small levels."

His subjects ranged from the town council in Dassel, Minnesota (page 115), with a population of 1,134, to Community Board 7 in Manhattan, representing a population of 207,699. Some meetings were held in city halls, where council members shared a long bench with the mayor, maps of their municipalities on the wall behind them; others were in schoolrooms, at tables with folding chairs. In some photographs, framed paintings of

the city fathers hang in the background; in some you see the plywood-paneled walls of a recreational facility.

Tracking down the meetings took some detective work. Mr. Shambroom began by obtaining directories of town councils from state municipal leagues and importing the data into mapping software that gave him geographic clusters of meetings and their schedules. Reactions to his request for permission to photograph the meetings varied; some council members did not understand why he was interested; some required a vote to allow him to proceed; still others were flattered, and welcoming.

Mr. Shambroom chose a panoramic format for the pictures, setting his camera on a tripod at a fixed distance from the council members and photographing the meeting table or podium at an angle parallel to the camera lens. It is the repetition of form that yields the catalog effect.

Adding to the formality is the meeting place's proscenium, whether a dais or a table, and a sense that the proceedings are bound by rules, minutes, and the business at hand. We enter the pictures in medias res, yet the stillness of the frozen moments adds another layer of distance, allowing us to observe the council members as if specimens in a uniform social ritual.

Although Mr. Shambroom adheres to a documentary approach, he deviates from its standard conventions by digitally altering his pictures. He plays with the light, creating an evenness that evokes the studied artifice of neo-Classical painting. That, combined with the size of the photographs—each is 66 inches by 33 inches—gives the images a diorama-like quality.

In Maurice, Louisiana, Mr. Shambroom spent more than an hour making forty to fifty exposures of the village council, an unusually long time for him (page 115). "I was looking for a peak moment, when there was a stark pause," he said. "At first this was for technical reasons, but then I started to like what I was seeing in the pictures, that hypno-tized quality."

The rapt expressions on the faces in the pictures unite these people. Serious business is taking place, and listening is a sober activity. The ritual of the meeting brings that gravity to the surface: you see it on every face. "You're inside yourself as a private person," Mr. Shambroom said, "but you're playing a public role."

Power is not a new subject for Mr. Shambroom. In 1992, he set out to photograph America's nuclear arsenal, and over the next nine years made thirty-five visits to two dozen weapons and command sites. "My goal is neither to directly criticize nor glorify," he wrote of that project. "My objective is to reveal the tangible reality of the huge nuclear arsenal, something that exists for most of us as only as a powerful concept in our collective uncon-scious." (A book of those photographs, *Face to Face with the Bomb: Nuclear Reality After the Cold War*, was published last year by Johns Hopkins University Press.)

Mr. Shambroom's approach suggests an anthropologist's method and rigor. He has created a visual catalog of the artifacts of power, but his pictures also function as narrative: part theater, part film still, consistently hyperreal. As for the issues being discussed in each meeting, you are left to fill in the blanks.

Originally published in the *New York Times*, October 31, 2004.

Bernd Becher, Seventy-five, Photographer of German Industrial Landscape, Dies

Bernd Becher, known with his wife, Hilla, for photographing relics of industry in the changing urban landscapes of the late-twentieth-century in Europe and the United States, died on Friday in Rostock, Germany. He was seventy-five.

He died after heart surgery, said the photographer Thomas Struth, a former student.

In 2004, the Bechers received a Hasselblad Award, one of the highest international honors in photography. The award citation called the couple "among the most influential artists of our time," noting that "their systematic photography of functionalist architecture, often organizing their pictures in grids, brought them recognition as conceptual artists as well as photographers."

The Hasselblad Foundation also said that as the founders of what became known as the Becher School, they influenced "generations of documentary photographers and artists."

The weight of the Bechers' achievement is grounded in a tradition of photographic documentation that is scientific in method and ostensibly mundane in its choice of subject. The blast furnaces, gas tanks, water towers, and coal tipples in their pictures serve singular industrial purposes, and they photographed each one with exacting fidelity to every detail, making images as true in description of the object as the medium of photography is capable of providing.

The couple's stature in the art world grew with the years for reasons both perceptual and conceptual. For one thing, the structures in their work are too large for any individual to scrutinize whole, so the exacting frontal presentation in each image enables a more complete observation than is possible by standing in front of the real thing. More interesting, though, is that the truer the Bechers' photographic representation is to the object itself, the less mundane and more optical the image. Such precision of detail approaches a verisimilitude that borders on the sublime.

The Bechers' documentation extended to systematically cataloguing each type of structure through series, or what they labeled "typologies." Each typology is composed of objects of a single industrial purpose presented in a grid of multiple photographs. It is not unusual for a typology to include images made over the course of thirty years, in various countries in Europe as well as throughout the United States.

The blast furnaces of one such grid were made between 1968 and 1995 in Alabama, Maryland, Ohio, Pennsylvania, as well as in Belgium, France, and Germany. The blast furnace is a breed of industrial object with a primitive tubular apparatus on the outside that might be likened to mechanical intestines. While each furnace is distinct, all of them have the collective imprint of their utilitarian function. The Bechers' scientific approach to their

photographic documentation enters a much larger conceptual arena when their study of the specific is placed in context of the generic, and you can view each specimen as it defines the entire species.

The eye dances whenever it sees a grid of multiples. (Warhol is not Warhol for no reason.) In a Becher typology, it seems as if the same object is repeated over and over and therein lies the visual anomaly. The objects are all of a breed (a dying breed, at that), but each one is unique. This is the case with another grid of water towers, with thirty images made between 1963 and 1993 in England, France, Germany, and the United States. The individual water towers reflect architectural moments like Brutalism, Futurism, or Modernism that define the eras in which they were built, as well as the neo-Gothic and Tudor styles favored by particular regions of origin. The variations within this single species of object create visual harmonies that underscore the perceptual strength of the Bechers' grids.

The industrial landscapes the Bechers photographed place the respective typologies of individual structures in context of their utility and application. In real life it is hard to find the visual logic in such large and imposing spaces, but the height and distance from which the Bechers made this separate body of work provides a sense of order and clarity to the otherwise forbidding industrial countryside. What unites the images is not only the consistency in how each one was photographed, but the look of industry with which time stamps them. Because industry continues to evolve with new technologies, the Bechers' work is that much more significant as a meticulous record of an industrial era as it enters the realm of artifact.

Bernhard Becher was born on August 20, 1931, in the coal-mining town of Siegen, Germany. He studied painting and lithography at the State Art Academy in Stuttgart from 1953 to 1956 with the painter Karl Rossing. He began photographing industrial sites close to his hometown, which he noticed were disappearing fast.

He and Hilla Wobeser met in Düsseldorf, where, in 1957, they started working together on the record of the industrial landscape that became their lifework. They married in 1961 as art students at the Düsseldorf Academy. One of their first projects, which they pursued for nearly two decades, was published as *Framework Houses* in 1977 (Schirmer/Mosel), a visual catalog of types of structures, an approach that characterized much of their work.

In 1976, Mr. Becher started teaching photography at the Düsseldorf Academy, where he remained on the faculty for twenty years. Before him, photography had been excluded from what was largely a school for painters.

Mr. Becher's seminal influence can be measured in the success of his students Andreas Gursky, Candida Höfer, Thomas Ruff, and Thomas Struth, among others whose work extends the tradition of a clinical documentation of the actual world with a conceptual eye to photography as an art-making discipline. One could argue that the Bechers' influence in the practice of objective photographic documentation in Germany parallels that of the late

John Szarkowski, the consequential curator of photography at the Museum of Modern Art from 1962 until 1990, who shaped a legacy of documentary photography more subjective in nature.

Szarkowski championed the work of Lee Friedlander, Garry Winogrand, Diane Arbus, and William Eggleston, all of whom documented the world with evidence of their own experience of their subject in the frame. Szarkowski's own photographic work might well serve as the template for his hegemony, just as Bernd and Hilla Becher's work served as the basis for theirs.

In addition to his wife, Mr. Becher is survived by their son, Max, also a photographer.

A briefer version of this obituary was originally published in the *New York Times*, June 26, 2007.

Keeping It Real: Photo-Realism

In 2006 a traveling retrospective of Robert Bechtle's paintings, drawings, and watercolors completed its cross-country tour at the Corcoran Gallery of Art, in Washington, D.C. The show, which originated at the San Francisco Museum of Modern Art in 2005, included at least two dozen of the Photo-Realist works that established this Bay Area artist's reputation in the late 1960s and early 1970s: suburban scenes of cars parked in front of stucco houses and people standing in snapshotlike poses, all bathed in sun-bleached California light. Today his strikingly true-to-life scenes are remarkable not only for their well-crafted detail but for the palpable feel of that period in America and the sense of nostalgia they elicit. "Probably more than any other exhibition at the Corcoran during my tenure, the Bechtle show was loved virtually uniformly," says Jonathan Binstock, formerly a curator at the museum and now an art adviser at Citigroup, in New York. "Artists, collectors, and the general public all seemed moved and impressed."

Janet Bishop, a curator at SFMOMA who organized the Bechtle show, observes that the retrospective has had a ripple effect on the artist's reputation. "When I was initially visiting museums with Bechtles in their collections, the works had not been seen for a long time," Bishop says. "Now he is slowly having a presence in those museums' galleries." She also notes that one of the works in the show, *Watsonville Chairs*, 1976, was the cover image of Christie's *First Open* catalog from last February; it was the top lot in the sale, bringing $396,000, close to the artist's record of $408,000, paid for *'62 Chevy*, 1970, in November 2006, also at Christie's.

It's not just Bechtle but also other Photo-Realist artists who are being reevaluated, says Bishop, and not only in the salesroom. "This is a moment when Photo-Realism is ripe for reconsideration," she says. "Fellow curators are certainly interested." The idea of Photo-Realism as a movement fizzled, Bishop says, because the technically accomplished works gained such broad popular appeal "that the art world became suspicious. Now they are circling back with the realization that these are extraordinary paintings."

Over the course of photography's 168-year lifespan, painting and photography have been locked in a kind of gravitational dissonance. It is worth noting that the birth of photography coincided with the rise of Realism in painting. As photography depicted the world with optical clarity and visual accuracy, painting veered from Realism to Impressionism. As the Post-Impressionists ventured back toward the representational, a group of photographers known as Photo-Secessionists experimented with a painterly, out-of-focus style. In the early twentieth century, as photography's documentary potential was rising to the fore, painting took a turn toward heightened abstraction—Cubism, Surrealism, Dada. And, as Abstract Expressionism dominated the mid-twentieth century, the pendulum

swung again as a new kind of photographic image emerged with street photography of the 1950s. In the 1960s, artists such as John Baldessari, Robert Rauschenberg, Gerhard Richter, Ed Ruscha, and, of course, Andy Warhol were exploring the photographic image in other, more conceptual terms, taking pictures of their own, as well as using found images, and incorporating them into their work.

In the early 1970s, artists such as Bechtle, Chuck Close, Robert Cottingham, Richard Estes, Audrey Flack, Ralph Goings, and Philip Pearlstein strove to render scenes from daily life with the optical precision of photography. Their bravura paintings were termed "photorealistic" because of their technically daunting resemblance to photographic images, sometimes heightened by the use of an airbrush to create a seamless surface. Richard Estes is known for visually complex urban scenes that shimmer with meticulously detailed reflections, whether on storefront windows or in the shiny surfaces of cars or telephone booths of the period. Robert Cottingham focuses on signage from retail stores and theaters, which he often depicts in extreme close-up and on a large scale. Ralph Goings's suburban streetscapes feature parked cars and pickup trucks and are presented as matter-of-factly as his meticulously painted arrangements of diner condiments—bottles of ketchup and hot sauce, jars of relish—on gleaming Formica tabletops. Philip Pearlstein and Chuck Close concentrated on the human figure and portraiture, respectively, treating the flesh and features of their subjects in frank, unidealized ways. Audrey Flack is known mostly for still lifes in which paint tubes, brushes, and other symbols of art-making are arranged alongside traditional vanitas objects such as fruit, flowers, skulls, and candles.

In its lens-sharp clarity, viewfinderlike cropping, and happened-upon moments, Photo-Realism reflected the new pervasiveness of photography in contemporary life. By the 1960s, the latter medium had altered the way people saw—and framed—the world. More and more, commercial photographs appeared in color; the Polaroid, meanwhile, brought color home to the personal snapshot. Even serious photographers were taking life's most ordinary, incidental moments, both domestic and public, as their subject matter. By the late 1960s, the term "snapshot aesthetic" came to denote the commonplace quality that characterized these images, but the roots of the style can be traced to the previous decade and the work of Robert Frank. Frank's photographs in the book *The Americans* were initially dismissed because of their raw, informal look. At first glance they seemed amateurish, but they possessed the same spontaneity and modesty as the work of the Beat poets and writers with whom he associated. Frank's documentary approach paved the way for photographers like Diane Arbus, Lee Friedlander, and Garry Winogrand, whose pictures reflected their personal experience of the world.

Here's what Lisette Model wrote in *The Snapshot*, a book published by Aperture in 1974: "A snapshot is not a performance. It has no pretense or ambition. It is something that happens to the taker rather than his performing it. Innocence is the quintessence of the

snapshot. I wish to distinguish between innocence and ignorance. Innocence is one of the highest forms of being and ignorance is one of the lowest."

The similarities between the work of the Photo-Realists and that of these photographers may not be deliberate, but in retrospect the two groups seem ineluctably connected. Ralph Goings's *McDonald's Pickup*, 1970, depicts a suburban street with a pickup truck parked in front of the fast-food restaurant and a palm tree nearby. The precisely rendered scene gives the painting a photographic quality, as does its construction: the middle-ground point of view, objects placed at an angle to the picture plane, the inclusion of peripheral details. The work brings to mind Friedlander's *Texas*, 1965 (page 78), which also features a pickup truck. (The photographer's overt concern with the properties of his medium is evident in the presence of his shadow in the picture, reminding us that he was there to capture it, as well as the knot of juxtaposed elements that keeps our eyes moving through the frame.) It is worth noting that Stephen Shore and William Eggleston, pioneers of color photography in the early 1970s, borrowed, consciously or not, from the Photo-Realists. Their photographic interpretation of the American vernacular—gas stations, diners, parking lots—is foretold in Photo-Realist paintings that preceded their pictures.

Considered in this art-historical context, Photo-Realism seems inevitable, yet it has been generally dismissed as a conceit. For more than thirty years, critics and scholars have, for the most part, written it off as an example of style trumping substance—of trompe l'oeil bravado. Many twentieth-century painters, too, regarded the camera as a mere tool, without the potential for creative expression. The photographic image, they thought, lacked the ideological grandeur—never mind the artistic validity—of painting. The photograph's optical fidelity to reality may have possessed its own magic, but the use of the camera to create a shorthand of objective representation was just too easy.

What's more, to paint from a photograph was one thing, but to establish a photographic vocabulary within the realm of painting was quite another. The Photo-Realists did just that and were accordingly deemed to have crossed a line. For their audacity alone, no doubt, they were scorned. Perhaps as a result, the Photo-Realist artists, most of whom are still actively making and showing their work, have distanced themselves from the style—and its negative associations—despite having essentially defined it. Some of them have evolved a looser, more textured and brushy technique while continuing to portray similar subject matter. Interestingly, by the late 1970s, Chuck Close had begun to explore a more experimental approach in his large-scale portraits and has enjoyed a broader success than the others.

Today, however, many experts give Photo-Realism more credit. "Not only do these artists have great technical skill, but they are the great depicters of pure Americana," says Barrett White, a former contemporary specialist at Christie's who is now the director of the New York branch of Haunch of Venison gallery. "This is not a gimmicky art but in fact a

very important movement. It is the conclusion of Pop art in the same way that Color-Field painting is the conclusion of Abstract Expressionism."

New York dealer Jeffrey Deitch recalls that when he first arrived in New York, in the early 1970s, the art world establishment had turned its back on Photo-Realism, but "artists found it fascinating." And continued to do so. He remembers hearing artists during the 2004 exhibition *The Photorealist Project*, at New York's National Academy of Design, "talking about the work. Even radical, nonfigurative artists were sharing their enthusiasm for it." Deitch notes the current trend to representational painting but believes that Photo-Realism still needs a critical sifting to single out the top works. "Then there should be a great American exhibition that shows the great [Photo-Realist] works. It's going to happen."

Photo-Realism was grounded in a host of conceptual ideas. As Richard Estes famously said, "I don't believe the photograph is the last word in realism." These painters weren't copying photographs or just documenting their surroundings—not even a photograph shows you the world with the complexity of an Estes painting. Rather they were concerned with larger questions about the nature of perception.

New York dealer Louis Meisel, who first represented many of the Photo-Realists in the early 1970s at his SoHo gallery, is credited with coining the controversial label. Meisel has an inventory of fifty or so "early major works" by Estes, Goings, Bechtle, and others. "I loan them for museum shows from time to time," he says. "For over twenty years, I was trying to convince people to buy Bechtle. The works were going for $25,000 to under $100,000. After the SFMOMA show, the prices skyrocketed. There hasn't been a blistering Estes on the market for ten years, but today one could easily command $500,000 to $1 million."

"The market finally matters for Photo-Realism," says Barrett White. In 2003, Christie's sold Goings's *Blue Chip Truck*, 1969, for $320,000, and in 2006 his *Still Life with Hot Sauce*, 1980, sold for more than $400,000. "Those kinds of results have encouraged people to start letting their own paintings go. Today, if you had a great Photo-Realist work come up for auction, like a perfect Bechtle, it could command $1 million. It's a matter of the right material being available," White explains. "You will see another step up in the market when that happens."

Several works do appear each season, mostly in day sales, and prices have climbed to the six-figure range. At Christie's last November, Robert Cottingham's *Billy's*, 1980, brought $253,000 (estimate $80,000–$100,000), a record for the artist. The same month at Sotheby's New York, Goings's *Relish*, 1994, sold for $481,000 (estimate $300,000–$400,000), and Estes's *Ticket Window*, 1969—which just two years earlier had fetched £96,000 ($173,000) at Sotheby's London—realized $265,000 (estimate $200,000–$300,000). In the same sale, Cottingham's *Ode*, 1971, was snapped up for $241,000—a significant jump from the $69,600 garnered by the work just two years earlier at Christie's.

In the last five years or so, as photographs have gained unprecedented value in the marketplace, the gravitational dissonance between painting and photography continues: witness the size of the photographic print, which has grown in proportion to the market. Technological capability has allowed it, but, also, the sheer monumentality of such optically precise wall-sized imagery positions photography on more competitive footing with painting. Still, as collectors familiarize themselves with the expressive properties of photography and gain greater knowledge of the history of the medium, it makes sense that Photo-Realism, a school of painting that explores the very anatomy of the photographic image, would garner renewed attention.

At the same time, the photographic work of Philip-Lorca diCorcia, Gregory Crewdson, and Jeff Wall, among others, has veered away from the medium's roots in authentic representation to the more conceptually constructed image, or the staged tableau—once the province of painting. Given this turn of events in photography, Photo-Realist painting, with the look of the photographic image and its essential comment on a photographic view of the world, becomes that much more significant.

"Collectors ask me if there is an inventory of work from the period," says Robert Fishko, director of the Forum Gallery in New York, which represents Cottingham. Fishko adds that such inquiries have increased in the past two or three years, explaining, "An interest in photography, which is much greater today, has had a lot to do with it." In fact, most recently, it is the black-and-white documentary pictures from the 1960s and 1970s—a source for Photo-Realist painters—that have gained considerable attention from collectors and curators alike.

In *The Photographer's Eye*, the late John Szarkowski, longtime head of the photography department at the Museum of Modern Art, writes: "More convincingly than any other kind of picture, a photograph evokes the tangible presence of reality. . . . The photographer's vision convinces us to the degree that the photographer hides his hand." In their own way, the Photo-Realist painters aspired to hide their hands and let the plain facts be their subject. To have represented a 35 millimeter universe in painting was a serious artistic achievement. What is photographic about their work may seem deceptively simple. But in fact, they identified a significant cultural force—the mitigated image. "I photograph to see what things look like photographed," Garry Winogrand once said. We might say that the Photo-Realists painted to see what life looks like photographed—an undertaking perfectly relevant to our much-documented contemporary world.

A briefer version of this article was originally published in *Art+Auction*, January 2008.

Portraits of American Paradises, Mostly Lost *On Joel Sternfeld*

The "perfect society" may be a figment of the idealist's imagination, but from the early years of the republic, many Americans have tried to give those ideals a tangible form, organizing their lives and those of their neighbors in a variety of social experiments.

Between 1810 and 1850, at least six hundred utopian communities were established across the continent, approximating both religious and secular visions of the perfect life. In the 1960s, social upheaval led to a new wave of alternative communities, or communes, some of which still survive today. And, more recently, in the 1990s, new ideas about urban planning have led to more practical experimentation with a utopian vision of suburban design.

For the last twelve years, Joel Sternfeld has been photographing the sites of utopian communities across the country—the land on which they once resided, buildings that still remain, or monuments erected to symbolize their ideals. This body of work, *Sweet Earth: Experimental Utopias in America*, on view at the Luhring Augustine Gallery in Chelsea, is an extension of his continuing chronicle of the American landscape, most notably his seminal series, American Prospects, with crisp, color-saturated photographs taken in the 1970s and early '80s in which structures of modern life fit awkwardly into the natural landscape.

The chapel without walls in New Harmony, Indiana, was designed in 1960 by Philip Johnson as an inverted rosebud to echo the founding ethos of the community, home to one of America's first secular utopian experiments. It was started in 1824 by Robert Owen, a British industrialist who believed that education, equality, and communal life were vital to the formation of moral character. "Happiness," he held, "will be the only religion of man." Johnson intended the chapel to cast the shadow of a rose, the symbol of the New Harmony Community of Equals.

Seaside, Florida, was the brainchild of Robert Davis, a builder who wanted to develop the land he inherited along Florida's Gulf Coast in line with his childhood memories of beach-town life. The community, which was first opened in the 1980s, was designed as a small town with everything within walking distance, and vernacular architecture that recalls an ideal past that may never have existed.

The school bus is among the dwellings at The Farm, a commune established in the 1970s that at its peak had a population of fifteen hundred members. The motivating source was Stephen Gaskin, a professor at San Francisco State University whose lectures about cultural upheaval developed such a cult following that hundreds of students followed him on a speaking tour around the country. Eventually, many people in that caravan of buses and vans acquired land in rural Tennessee and set up The Farm.

In 1982, while Mr. Sternfeld was still working on American Prospects, he visited a

socialist thinker, Scott Nearing, then ninety-nine, in Maine. Looking through Mr. Stern-feld's images for that series, Mr. Nearing advised that they were too critical of America. "Picture an ideal world and photograph that," he told the photographer. Mr. Sternfeld evidently took his advice, capturing in this body of work if not an ideal world, at least the idea of it.

Originally published in the *New York Times*, September 18, 2005.

Keeping His Eye on the Horizon (Line) *On Sze Tsung Leong*

The meticulous, soft-colored photographs of Sze Tsung Leong capture contrasting landscapes: the verdant green of Germany; the mirage of shimmering towers in Dubai; the urban geometry of Amman, Jordan; the red-tiled roofs of Italy. But always the eye is drawn to the distinct line where sky meets earth.

In Mr. Leong's panoramic photographs of major cities and rural landscapes around the world, the horizon line consistently falls in the same place. So when his images are hung side by side—as sixty-two of them are now at the Yossi Milo Gallery in Chelsea—they create an extended landscape of ancient cities and modern metropolises, desert vistas, and lush terrain.

"The horizon is such a basic way of comprehending the space around us, comprehending our basic relationship to the globe," Mr. Leong said one recent morning over tea in Manhattan.

If the horizon seems to offer possibilities, he said, it also establishes a boundary. "In terms of looking, the horizon is the farthest we can see," he explained, yet in terms of knowledge, it reflects "the limit of experience."

For the last seven years Mr. Leong, a thirty-eight-year-old Chinese-American with a British accent and a Mexican birth certificate, has expanded his experience by traveling to unfamiliar cities, where his first priority is to find a sweeping view from an elevated position.

"When I'm really familiar with a place, it is more difficult to visualize it," he said, citing New York, his home, as an example. "But being confronted with a new situation, I find that I'm more aware of things visually." He traveled to Amman because he hoped the uniform construction of its buildings might cast an even pattern and tone across the surrounding hills, which would offer him distant vantage points. And the Roman ruins there attracted him as a reminder of the reach of the Roman Empire across national borders.

He often travels alone to new cities. Asked about his sense of isolation during his five days in Amman, he referred to his childhood in Mexico City, where he lived until his family moved to Los Angeles when he was eleven. "There's always a sense that was natural to me from the beginning of being an outsider," he said. "I don't think about feeling foreign, because that is the natural state."

He studied at the Art Center College of Design in Pasadena, California, and then earned degrees in architecture at the University of California, Berkeley, and at Harvard. Perspective drawing fascinated him. "I was interested in figuring out the mechanics of how you represent space on a two-dimensional surface," he said. "And of course the horizon line plays a very important part in perspective drawing."

He points out the similarities between perspective drawing—in which divergent lines extend to vanishing points—and the flattened projection of an urban landscape against the ground glass of his 8-by-10 view camera. The grid in the viewfinder lets him compose images with matching parallel lines.

His panoramas integrate broad swaths of natural terrain, urban architecture, and symbols of culture, and Mr. Leong said architectural history courses at Berkeley had a great influence on how he sees the built environment. "Their approach was to consider buildings and cities and their social and political contexts," he said. "Buildings are the result of social forces and political power."

Before traveling to Egypt, Mr. Leong picked up Max Rodenbeck's *Cairo: The City Victorious*. "I read about this ancient trash heap that had been in use for several centuries, which had gotten taller and taller," he recalled. "From the top you get this view of the old part of Cairo."

He shot his panoramic image of Cairo from this ancient trash heap, now a park on a hill. He returned three times before the lighting conditions provided the tonal quality he sought. The best conditions for his preferred evenness of light occur either at noon, when the fewest shadows are cast, or when it is overcast. "When things fall into deep shadow, it is more difficult to capture a detail," he said.

Mr. Leong photographed Dubai because "it is a new city created out of oil wealth," and he shot his skyline panorama several miles away, from the surrounding desert. "I was afraid the film might get damaged," he said, since the outdoor temperature was 110 to 120 degrees in the noonday sun. "The camera was hot to the touch."

By contrast he went to Venice in January, when the winter sky was most likely to be overcast and the light would yield the finest detail. His picture *Canale della Giudecca*, 2007, was taken at dusk from the mainland. The densely packed, sharply articulated buildings hover in a narrow line between water and sky.

"For this image the exposure time was about a minute," he said. "So anything that's moving becomes a blur or disappears. The water that is moving becomes a blank sheet. People sometimes ask if this picture is Photoshopped because of the blankness."

Mr. Leong still uses negative film and makes all of his prints in the darkroom. He believes that light projected through a negative onto paper provides more continuous tone than is possible with the digital process. "If you blow up a digital scan, you'll see it is made up of different squares, each one a different color, which corresponds in the computer's mind to a numerical value," he said. "In analog it will be a continuous curve."

Mr. Leong acknowledges the influence of nineteenth-century photographers like Felice Beato and John Thomson, who photographed in China and India using a view camera. But he also cited the contemporary photographer Thomas Struth, whose technical precision Mr. Leong admires, as well as his images documenting cities. "You're not only looking

at what is depicted on the picture plane, but a kind of emotional context he is trying to describe," he said. Citing Mr. Struth's photograph of the Pantheon in Rome, he added: "There's a heaviness, the weight of history and the weight of the light. A certain sense of sadness about it."

It's a sentiment that may come to mind when viewing an earlier series by Mr. Leong, History Images, which documents the vast rows of modern towers in China that are rapidly engulfing the country's cultural past. The photographs were shown in 2006 at the High Museum in Atlanta, and Julian Cox, its curator of photography, called the work prescient in capturing what Mr. Leong has labeled the "erasure of history."

Last year the Yale University Art Gallery acquired fifteen of Mr. Leong's panoramic images, and he worked with Joshua Chuang, assistant curator of photographs, on their installation at Betts House, the university's center for international studies. Placed side by side, Mr. Chuang said, the images juxtapose modern industrial landscapes with those that are slower to change, like mountain ranges and bodies of water. "We're left to contemplate, along with the photographer, how much longer these landscapes will look this way, and why," he wrote in an email message.

Another example of Mr. Leong's interest in contrasting natural terrain with the constructed environment is *Victorville, California*, 2006, which depicts suburban sprawl between Los Angeles and Las Vegas.

"I wanted to include an image of the new cities in the U.S., cities that lie outside of the recognizable cities," he said, adding that he was seeking an image to "communicate this sort of flatness and impending urbanization," one providing a "counterpoint to the other images I had of natural landscapes and dense cities."

The cul-de-sac in *Victorville* at first glance could be a pond. Only some of the newly built houses are occupied, and the picture was shot before any landscape planting had begun. As in so many of Mr. Leong's photographs, the natural terrain is visible and vast, even as the architectural imprint of humanity begins to encroach.

Originally published in the *New York Times*, April 6, 2008.

The Staged Document

Our eyes tend to respond to the photographic image as if it were a factual document. Our minds, of course, are more circumspect. Certainly, photographs are used to provide medical proof or legal evidence. And evidence is the hallmark of photojournalism. For a good part of the twentieth century, such unwavering fidelity to fact was unquestioned. In the 1950s and '60s, a new breed of photographic image-makers emerged who drew on photojournalistic tenets of factual documentation, but instead of recording newsworthy events, photographers like Robert Frank, Lee Friedlander, and Garry Winogrand pursued a more existential approach to documenting the objective world. Their intention was to capture the authenticity of their own experience in the spontaneity of the real-life moment.

By the early 1970s, black-and-white documentary photography had set the tone for the medium in museums, on gallery walls, and in art schools. At the same time, Duane Michals employed the photographic image to create intimate narrative sequences of a phenomenological nature. In one sequence, *The Spirit Leaves the Body*, 1968, a shadow rises out of a reclining naked figure, sits at the edge of the bed, stands, and walks away. Michals's use of black-and-white film and natural light gave his staged scenes the look of factual reality, and his method of storytelling would anticipate the constructed narrative photographic image that ushered in the twenty-first century.

The divorce of art world photography from the terra firma of factual reality began to occur in the mid-1970s. Among the young artists of that period to challenge the cultural applications (and implications) of photographic documentation were Mike Mandel and Larry Sultan. Their seminal book *Evidence* (1976) is a collection of black-and-white pictures culled from the archives of government agencies, public utilities, university laboratories, and private corporations. While the photographs were made or acquired as proof of actual fires, crime scenes, land sites, and experiments, the artists removed them from their contexts and sequenced them without captions, imbuing the pictures with surrealist properties subject to endless narrative interpretation. Still, they closely resemble the look of black-and-white documentary images of the period that came to define "art photography." *Evidence* was among the early work to contest the growing acceptance of photography as art, photographer as "artist-author," photographic documentation as fact, the truth-telling capability of the medium as unwavering, and so forth.

Throughout the 1980s, the photograph underwent a rigorous, necessary, and unforgiving examination by postmodern artists and critics. They challenged its fidelity to fact, its role in constructing social realities, its validity as a form of art—to the point where straight documentary photography seemed conventional, even retrograde.

Artists like Cindy Sherman and Laurie Simmons utilized the look of promotional and advertising imagery to construct scenes that explore issues of gender and identity; Sherrie Levine re-photographed images by Walker Evans and Edward Weston and sold them in galleries as her own to challenge the nature of authorship and exclusivity in a medium in which a single image can be endlessly replicated; Barbara Kruger explored the relationship of image and text so integral to the advertising format; Richard Prince appropriated advertising imagery like the Marlboro Man, most famously, to underscore the ways in which meaning is derived from visual symbols, whether the iconicized subject is based in reality or not. Carrie Mae Weems, an African-American artist, combined text with photographic images that she either made or appropriated to explore themes of race and identity.

By the middle of the eighties, color had entered the vocabulary, and on a technical level, it was not as easy to make exposures that captured the snapshotlike spontaneity that so defined the black-and-white pictures of the previous generation. (In regard to working in color, Nan Goldin's straightforward documentation of her own downtown Manhattan demimonde was the exception to the rule.)

Of course the field of advertising has long exploited the factual look of photography with invented narrative scenes in which gorgeous couples in stylish clothing, say, smile at each other in fine enjoyment of a cigarette or a drink or a brand-new convertible or an ocean cruise. Concurrent with the 1980s postmodern critique of the photographic image, artists such as Tina Barney began to stage the documentation of their own real-life situations, borrowing, perhaps, from the ubiquity of the advertising tableaux. Barney's domestic scenes are based in fact only by association of artist to subject, but are by no means the spontaneous moments they are staged to emulate. In the early 1990s, Philip-Lorca diCorcia made a documentary series called Hustlers, also straddling the line between pure documentation and deliberative narrative artifice. For the series he paid male prostitutes along Santa Monica Boulevard in Los Angeles to pose in or around the motels where they worked; the title of each picture includes the amount of money the hustler was paid.

Digital technology has made it that much easier to sever the photographic image from its relationship to factual reality. Jeff Wall took the staged document one step further by constructing large-scale scenes that reference nineteenth-century paintings, and that also draw on the narrative properties of cinema. Gregory Crewdson stages narrative scenes of domestic life for his wall-sized images, employing dozens of people who function much like a full production film crew: sets are built, actors are hired, many exposures are made; then he sandwiches the negatives together to create density and depth in the final digital image. While Robert Polidori's photographs are grounded in pure documentation, his manipulation of color adds a layer of artifice.

The look of factual reality is one of the inescapable properties of photography, but its relationship to fact is the subject of examination in the following essays.

Photographic Icons: Fact, Fiction, or Metaphor?

Truth-telling is the promise of a photograph—as if fact itself resides in the optical precision with which the medium reflects our native perception. A photograph comes as close as we get to witnessing an authentic moment with our own eyes while not actually being there. Think of all the famous pictures that serve as both documentation and verification of historic events: Mathew Brady's photographs of the Civil War; Lewis Hine's chronicle of industrial growth in America; the birth of the civil rights movement documented in a picture of Rosa Parks on a segregated city bus in Montgomery, Alabama. Aren't they proof of the facts in real time, moments in history brought to the present?

Of course, just because a photograph reflects the world with perceptual accuracy doesn't mean it is proof of what spontaneously transpired. A photographic image might look like actual reality, but gradations of truth are measured in the circumstances that led up to the moment the picture was taken.

The viewer's expectation about a picture's veracity is largely determined by the context in which the image appears. A picture published in a newspaper is believed to be fact; an advertising image is understood to be fiction. If a newspaper image turns out to have been set up, then questions are raised about trust and authenticity. Still, somewhere between fact and fiction—or perhaps hovering slightly above either one—is the province of metaphor, where the truth is approximated in renderings of a more poetic or symbolic nature.

The impulse to define, perfect, or heighten reality is manifest in a roster of iconic photographs that have come to reside in the world as "truth." While Mathew Brady is known for his Civil War pictures, he rarely set foot on a battlefield. He couldn't bear the sight of dead bodies. In fact, most pictures of the battlefield attributed to Brady's studio were taken by his employees Alexander Gardner and Timothy O'Sullivan—both of whom were known to have moved bodies around for the purposes of composition and posterity.

In *Home of a Rebel Sharpshooter, Gettysburg*, 1863, a picture by Gardner, the body of a dead soldier lies in perfect repose. His head is tilted in the direction of the camera, his hand on his belly, his rifle propped up vertically against the rocks. There would be no question that this is a scene the photographer happened upon, if it weren't for another picture by Gardner of the same soldier, this time his face turned away from the camera and his rifle lying on the ground.

In the Library of Congress catalog, the photograph *Dead Soldiers at Antietam*, 1862, is listed twice, under the names of both Brady and Gardner. In the image, approximately two dozen dead soldiers lie in a very neat row across the field. Could they possibly have fallen in such tidy succession? Knowing what we do about Gardner's picture of the rebel soldier, the possibility lingers that he moved some of these bodies to create a better composition.

Or it could be that other soldiers had lined the bodies up before digging a mass grave for burial. But whatever the circumstances that led to this picture, it is verifiable that the battle of Antietam took place on this field. We know that numbers of soldiers were killed. Evidence of the battle remains—the soldiers that died on that date, the battlefield on which they fought, the clothes they wore, and so on. Just how much of the subject matter does the photographer have to change before fact becomes fiction, or a photograph becomes metaphor?

"Mathew Brady used art to forge a relationship between photography and history, but when the memory of Brady the artist vanished, we came to accept his images as fact," Mary Panzer wrote in her 1997 book *Mathew Brady and the Image of History*. "Acknowledged or not, Brady's careful manipulation of his subjects continues to influence our perception, and still shapes the way in which we see his era, and the story of the nation."

Lewis Hine's 1920 photograph of a powerhouse mechanic symbolizes the work ethic that built America. The simplicity of the photograph long ago turned it into a powerful icon, all the more poignant because of its "authenticity." But in fact, Hine—who was interested in the human labor aspect of an increasingly mechanized world, and once claimed that "there is an urgent need for intelligent interpretation of the world's workers"—posed this man in order to make the portrait. Does that information make the picture any less valid?

We see in the first shot that the worker's zipper is down. Isn't it a sad fact that the flaws in daily life should prevent reality from being the best version of how things really are? In our attempt to perfect reality, we aim for higher standards. A man with his zipper down is undignified, and so the famous icon, posed as he is, presents an idealized version of the American worker—dignity customized, but forever intact. Still, the mechanic did work in that powerhouse and his gesture is true enough to his labor. The reality of what the image depicts is indisputable, and whether Hine maintained a fidelity to what transpired in real time may or may not be relevant to its symbolic import.

Le Baiser de l'Hôtel de Ville, 1950 (Kiss at the Hôtel de Ville) by Robert Doisneau, despite its overexposure on posters and postcards, has long served as an example of how photography can capture the spontaneity of life. What a breezy testament to the pleasure of romance! How lovely the couple is, how elegant their gesture and their clothing, how delightful this perspective from a café in Paris! It makes you believe in romantic love: you want to be there, as if you, too, would surely witness love blossoming all around you—or even find it yourself—while sitting at a café in the City of Light.

But despite the story this picture seems to tell—one of a photographer who just happened to look up from his Pernod as the enchanted lovers walked by—there was no serendipity whatsoever in the moment. Doisneau had seen the man and woman days earlier, near the school at which they were studying acting. He was on assignment for *Life* magazine, for a story on romance in Paris, and hired the couple as models for the shot. This informa-

tion was not brought to light until the early 1990s, when lawsuits demanding compensation were filed by several people who claimed to be the models in the famous picture. Does the lack of authenticity diminish the photograph? It did for me, turning its promise of romance into a beautifully crafted lie.

Ruth Orkin was in Florence in the early 1950s when she met Jinx Allen, whom she asked to be the subject of a picture Orkin wanted to submit to the *Herald Tribune*. *American Girl in Italy* was conceived inadvertently when Orkin noticed the Italian men on their Vespas ogling Ms. Allen as she walked down the street. Orkin asked her to walk down the street again, to be sure she had the shot. Does a second take alter the reality of the phenomenon? How do you parse the difference between Doisneau's staged picture and Orkin's re-creation?

Iwo Jima, Old Glory Goes Up on Mt. Suribachi was taken in 1945 by Joe Rosenthal, an Associated Press photographer. As documentation of a World War II victory, the picture immediately assumed symbolic significance—indeed, it won Rosenthal a Pulitzer Prize, and is one of the most enduring images of the twentieth century. For some time, it was considered a posed picture, but this was due to a misunderstanding. The famous image was the first of three pictures Rosenthal took of the flag being raised. For the last shot, he asked the soldiers to pose in front of the raised flag, thinking that the newspapers back home would expect a picture in which the soldiers' faces were visible. Later, asked if his picture of Iwo Jima was posed, he said yes—referring in his mind to that third frame, not the one that had been published. Still, that moment captured in the well-known picture occurred just as we see it today surely confirms the truth-telling capability of photography.

The birth of the civil rights movement is often dated back to a moment in 1955 when Rosa Parks, a black woman, refused to give up her seat on a crowded city bus to a white man in Montgomery, Alabama. (While she was not the first black bus rider to refuse to give up her seat, her case became the one on which the legal challenge was based.) Many people assume that the famous picture of Parks sitting on a city bus is an actual record of that historic moment. But the picture was taken on December 21, 1956, a year after she refused to give up her seat, and a month after the U.S. Supreme Court ruled Montgomery's segregated bus system illegal. Before she died, Parks told Douglas Brinkley, her biographer, that she posed for the picture. A reporter and two photographers from *Look* magazine had seated her on the bus in front of a white man. Similar photo opportunities were arranged on the same day for other members of the civil rights community, including Martin Luther King. Here is a staged document that has become a historic reference point, and a revealing parable about the relationship of history to myth.

As a witness to events, the photojournalist sets out to chronicle what happens in the world as it actually occurs. A cardinal rule of the profession is that the presence of the camera must not alter the situation being photographed. Four years ago, Edward Keating,

among the best staff photographers at the *New York Times*, was fired because of questions raised about one picture he took that ended up in the newspaper (page 112). This correction was published in the *Times* five days later:

> *A picture in the early editions on September 20, 2002, showed a 6-year-old boy aiming a toy pistol alongside a sign reading "Arabian Foods" outside a store in Lackawanna, N.Y., near Buffalo. The store was near the scene of two arrests in a raid described by the authorities as a pre-emptive strike against a cell of Al Qaeda, and the picture appeared with an article recounting the life stories of the detainees. The picture was not relevant to the article and should not have appeared.*

The correction went on to say that photographers on the scene from other news organizations had reported that Keating asked the young boy to aim the toy pistol. Upon further inquiry and a full inspection of the images from the entire photo assignment, the "editors concluded, and Mr. Keating acknowledged, that the boy's gesture had not been spontaneous." Altering the reality of the situation is a violation of journalistic policy, and it turned Keating's image from fact to illustration—a potent editorial statement about the Arabic community at a highly sensitive moment.

Paradoxically, looking through the photography archives of the *New York Times*, one is struck by the numbers of prints in which one or more people have been airbrushed out of the picture. The technique has been used at times to highlight an individual relevant to a particular news story, or simply to sharpen a line for better reproduction on newsprint. Other pictures have red-pencil crop marks, with which the art director or picture editor isolated only that part of the image relevant to the news story. To be fair, these changes were made not for the sake of censorship, but rather as part of an editing process simply to filter out unwanted information—perhaps no more egregious than cutting down a subject's spoken quotation to its salient points. The invention of photography, around 1839, provided a revolutionary method of replicating reality in accurate visual terms. What a great tool for artists and painters to construct images with greater perceptual facility. The history of art is a continuum of constructed images that depict reality as it was truly, or else as it was imagined in ideal terms. Photography did not change that continuum; it only made the difference between perception and reality more difficult to determine.

Originally published in *Aperture* magazine, Winter 2006.

The Picnic That Never Was *On Beate Gütschow*

Photographs may correspond to the way things actually look in the world, but optical precision is not the same thing as reality. In the art world, the truth-telling capabilities of photography are tethered less to fact than to ideas about perception, emotion, and cultural evolution. If documentary work shows us that life may be stranger than fiction, recent conceptual photography counters that fabrication may be truer than life.

Beate Gütschow, a thirty-four-year-old artist in Berlin whose first New York show is on view at Danziger Projects in Chelsea, has made a series of landscape pictures in which grass, trees, sky, and figures all look authentic enough. And individually, the elements are genuine; she photographed them as she found them in forests and public parks in Germany. But the landscapes in her pictures don't exist.

Each is constructed from up to thirty separate photographs. After a month of taking pictures outdoors with a 35 millimeter camera, Ms. Gütschow scanned the pictures into her electronic archive and began the painstaking process of constructing her landscapes at the computer. "I don't work with an image in my head," she said by phone from Berlin. "I work from my picture files. I start by sketching on my computer. First the people. Then the trees. I might put two trees together. Then the foreground. I build it very quickly."

In the case of *Untitled (L.S.) #13, 2001* (page 114), the two trees do not exist together as they appear; she photographed each one separately on the same day in Rostock, near the German coast. The people were assembled from separate pictures, and the wall on which they are sitting was photographed at a railroad station. Four different images were used to create the sky.

While Ms. Gütschow does not construct her landscapes with preconceived images in mind, the work cunningly plays on our ideas about painting and photography. Her Edenic scenes intentionally pay homage to seventeenth-century landscape painting, in particular the work of Claude Lorrain and Jacob van Ruisdael, referencing this tradition to highlight an idealized version of nature. By working with photographic imagery, which creates a sense of verisimilitude, she underscores the artificiality of this romantic ideal.

"Two-hundred-year-old landscape paintings are not interesting to me," she said. "But to take something normally found in painting and transfer it to photography, that's what interests me. The landscape is just the door I use to enter the idea of perception."

Different perceptual effects arise from recording the world with photographs as opposed to interpreting it in paint. Allegiance to one approach or the other has long created tensions between the two mediums. But while Ms. Gütschow has set out to interpret the world, her goal is not to emulate painting. There is no pretense that her landscapes are

anything but photographic. They are C-prints mounted with the full white margin, crop marks in place for framing and all the technical information about the print lining the image vertically: its date, size, resolution, the kind of paper it's printed on, and the name of the lab where it was printed. This full disclosure of technical detail amounts to a declaration that this work is about twenty-first-century experience, not seventeenth- or eighteenth-century romanticism.

And yet. There is something elegiac about fabricating a utopian past in idyllic landscapes devoid of skyscrapers, billboards, and traffic. But the technical data printed on the side of these quiet scenes is an emphatic reminder of the electronic world that has supplanted a more innocent one. Civilization has advanced; we possess more knowledge, and with it a world-weary cynicism. Ms. Gütschow's pictures force us to consider a more serene world, while also reminding us that no contemporary experience is unmediated: technology touches everything.

It's hard to say whether the use of fabrication in current photography is a reflection of the zeitgeist, or merely idiosyncratic. Loretta Lux, another young German photographer, makes portraits of young children that are digitally inserted into her own delicately painted backgrounds to preternatural effect. Thomas Demand, yet another young German, makes photographs of uncannily true-to-life environments that he constructs out of paper and cardboard. The American Gregory Crewdson creates domestic scenes with actors and stage sets, using a production crew more typical of moviemaking than of studio photography. His pictures combine the look of advertising with that of Hollywood publicity stills. This high-concept work examines perceptual aspects of photography by posing riddles about how the images were made. Each is a kind of photographic trompe l'oeil. Those who consider photography factual terra firma might assume that digital technology has weakened the medium's hold on reality. No doubt it has made it easier to manipulate photographic images, making observable reality harder to identify in its hall of mirrors. But as Richard Avedon said, all photographs are accurate. None are the "truth."

In an essay for a group show in which Ms. Gütschow took part this year at the Museum of Contemporary Photography in Chicago, Ludwig Seyfarth wrote that "the more photography is treated as art, the less space is left to the unintentional: one is meant to sense the artist's attention to every photographic detail."

Of course, this has always been the case, whether photographers are making pictures on the street or in the studio. But more recently, conceptual work in all mediums has blurred the line between photographers who make art and artists who use photography. In Ms. Gütschow's case, she has carefully constructed narrative images from multiple sources, a process not apparent in the lyrical results. Her work comments as much on the trickery of photography as it does on the virtue of her subject. And by including the data on

the final print, she acknowledges the digital technology that was integral to her work—a perceptual layer that is crucial to our times. "In my work," she says, "ideal means not to exclude the ugliness; it means to construct reality."

Originally published in the *New York Times*, November 21, 2004.

As Unpretty as a Picture *On Eric Fischl*

To paint from a photograph is one thing, but to establish a photographic vocabulary within the realm of painting is quite another. Eric Fischl has been doing this over the course of his career, beginning with *Bad Boy*, the painting that catapulted him to art-world stardom in 1981. In it, a young boy watches a lascivious woman lying naked in bed as he slips his hand into her purse on a table behind him. Mr. Fischl caught a moment in a way that photography catches moments—as evidence, with observation, in stark existential relief.

Still, it isn't the "decisive moment" he is after, nor is it the optical precision a photograph can provide; it's the way photographic imagery reflects the contemporary world back to us that he has isolated in the formal characteristics of painting. The informality of his subjects, their physical relationships to one another and his organization of the canvas have the underpinnings of a 35 millimeter universe.

Never has the influence of photography on Mr. Fischl's work been more evident than in The Krefeld Project, a suite of new paintings commissioned by the Museum Haus Esters in Krefeld, Germany. These paintings depict scenes that the artist orchestrated in the museum, formerly a residence, designed by Ludwig Mies van der Rohe in 1928. Mr. Fischl brought in modernist furniture, hired two actors and photographed them over four days in 2002 as they staged unscripted domestic scenarios throughout the house. With more than two thousand pictures, he moved the figures from one image to another in Photoshop, reimagining the domestic tableaux in a set of final constructed photographs from which he made this series of paintings. The paintings were exhibited last fall in the rooms in which the fictional scenes took place, and the photographs were shown at the Mary Boone Gallery in New York last month. The catalog is just now being distributed in this country by D.A.P.

Over the course of its 165-year life span, photography has had a complicated relationship with painting. As photography in the nineteenth century depicted the world with greater visual accuracy, painting veered from Realism to Impressionism. As the Post-Impressionists ventured back toward the representational, a group of photographers known as Photo-Secessionists experimented with a painterly, out-of-focus style. In the 1960s, the Photo-Realist painters concerned themselves directly with optical precision, making bravura paintings that were daunting in their fidelity to the look of photographic imagery.

Mr. Fischl has engaged this history directly. In an interview last year with the writer Frederic Tuten, he explained: "One of the reasons I looked to photography was that when modernism threw the figure out of painting, the figure went into photography. Where else would I go?"

You can see in his work the 35 millimeter vocabulary of photographers like Nan Goldin, whose subjects carry out their lives in between activities, sprawled on couches, lingering

in bedrooms. He often places the viewer not parallel to the picture plane, but standing where a photographer might as he paused to capture the scene he'd just happened upon. His paintings are informed by the constructed imagery of Philip-Lorca diCorcia and Tina Barney, in which staged pictures have the look of spontaneity, the people illuminated in midsentence, midaction, frozen in piqued alienation.

Still, Mr. Fischl is very much a painter. In *Dining Room, Scene 2*, 2003, a man and a woman linger at a table where something intimate seems to have just taken place. He looks like a socialized beast in elegant but unbuttoned evening wear, the belly of the animal exposed, his stance menacing, willful. She sits coiled, perhaps postcoital, hidden and protected by the chair, her gesture mirroring the neon spiral on the wall behind her. Light rakes the wall, highlighting the distance between them; Marilyn Monroe and another glamorous woman look over his shoulder—fantasies of his, perhaps, conquests in his mind.

Mr. Fischl's work has always been an examination of the middle class. "In a way," he has said, "it is the most interesting aspect of American life. It's the biggest, filled with ambition, the class of transition that tries so hard to uphold the value of the culture. It's tragic and compelling."

In the case of The Krefeld Project, the subjects—with their elegant furniture, and Gerhard Richter (surely a visual nod to Mr. Richter's use of photography for his own paintings), Andy Warhol, and Bruce Nauman on the wall—hover at an elevated cultural plateau. But though the cultural signifiers might have changed, the chance we are given to peer into their (constructed) lives, into these most intimate, ambiguous, charged scenes, is familiar: in terms of the psychological terrain the paintings cover, the couple could be latter-day incarnations of John Updike's tony suburban characters, Joan and Richard Maple, or even Edward Albee's George and Martha. We seem to be intruding on very personal moments, privy to the aspects of this relationship that a novelist might describe or a hidden surveillance camera might record.

Mr. Fischl depicts real-life scenes that are quotidian in nature, photographic in dialect, but existential in the broadest sense, showcasing lives that are attractive and well-accessorized, but nonetheless appear hollow, purposeless. Mr. Fischl has tapped into that essential photographic quality—the ability to harness the fleeting moment, to divide life into milliseconds of experience—to make pictures that render not only how individual experiences feel, but how contemporary experience looks. It's hard enough for photographers to pull this off, but all the more impressive that Mr. Fischl has attempted it while undertaking a marriage of these two competing mediums.

Originally published in the *New York Times*, January 25, 2004.

Moments in Time, Yet Somehow in Motion *On JoAnn Verburg*

Time doesn't exactly stand still in JoAnn Verburg's photographs. Not that her single images, diptychs, and triptychs are set up to create narrative sequences in which one thing leads to another, as with Eadweard Muybridge's motion studies of a man jumping or a horse running. Instead her portraits, still lifes, and landscapes generate a state of prolonged experience.

That sense of a continuum is repeatedly underlined in *Present Tense*, an aptly titled exhibition of her work that opens Sunday at the Museum of Modern Art with more than sixty pieces spanning her thirty-year career.

Ms. Verburg first made a name for herself in the late 1970s with *The Rephotographic Survey Project*, an exhibition and book on which she collaborated with Mark Klett, another photographer, and Ellen Manchester, a photo historian. They gathered more than 120 images by William Henry Jackson, Timothy O'Sullivan, and others of a largely uninhabited Western landscape in the nineteenth century, then proceeded to rephotograph each place.

With maps, compasses, and the guidance of a geologist from the United States Geological Survey, they located the general spots where the original photographers stood. They brought cameras, lenses, and film that approximated the technology of their nineteenth-century predecessors and waited for weather conditions that replicated the light in the original photographs.

The resulting then-and-now comparisons showed what the passage of time had done to those vistas. Surprisingly, what endured—the same trees, boulders, and riverbeds—was often just as poignant as the changes to the landscape over time.

Susan Kismaric, a curator of photography at the Museum of Modern Art who organized the exhibition, writes that the one-hundred-year interval between the two images in each set constructs an arbitrary beginning and end, like two randomly chosen moments. In the wall text she notes that this conceptual exercise "galvanized Verburg into investigating ways of making photographs that would depart from photography's 'decisive' or, as she puts it, 'aHa!' moment," captured in a single image. Ever since, she writes, Ms. Verburg has explored ways of extending time in photography.

Growing up in northern New Jersey, Ms. Verburg first became aware of photography while watching slide shows of family pictures taken by her father. Then, at six, she shot her first roll of film. Her subject was a polar bear in the water at the Baltimore Zoo, whose name, she recalled in a recent telephone interview, was Splash. Her father, a chemist, worked for GAF, a manufacturer of photographic papers, which gave her easy access to film. Still, throughout her childhood Ms. Verburg drew with pencil more often than she took pictures.

Later, when she was studying at Ohio Wesleyan University, a friend showed her *The Americans*, the landmark book of photographs shot by Robert Frank while he traveled the

country in the mid-1950s. "I had always thought of art as drawing and painting and sculpture," she said. "It was the first time I realized that photography could be art."

During her graduate studies at the Rochester Institute of Technology she served for two years as an intern at the George Eastman House, where she was exposed to its collection of four hundred thousand photographs, including vintage work in every photographic process and printing medium. In her master's thesis she wrestled with issues of time and motion in photography through serial imagery, themes that have become a constant in her work.

As a visiting artist at the Walker Art Center in Minneapolis in 1981 her interest shifted from the documentary possibilities of photography to what the medium can reveal about perceptual experience. Collaborating with other visiting artists—dancers, musicians, and performance artists like Trisha Brown, David Byrne, and Robert Wilson—she began to think of performance as a counterpoint to photography.

"Performance disappears as you look at it," she is quoted as saying in the exhibition catalog. "It is unique and unrepeatable, and each viewer who sees it sees it from a different vantage point and therefore has a different experience from every other viewer."

Her early multiple-image pieces with these dancers and musicians are a photographic exploration of live performance. In one sequence some faces are right side up, others upside down, and still others sideways. In another, faces are lined up side by side, yet some are at eye level while others are not. But here the subjects are not the ones performing for the camera; Ms. Verburg uses the photographic images themselves in pairings and alternating vantage points to simulate the experience of live performance.

In 1983 Ms. Verburg moved from Boston, where she had run an artists' program for Polaroid, to Minneapolis, where she has lived since. She began to photograph her friends, arranging them, as she explained in an email interview, "into still lifes that were supposed to look as though they hadn't been arranged."

Some posed for her in an indoor pool. She would set up her 5-by-7 or 8-by-10 view cameras, weighing her tripod down on the edge of the pool so her camera, pointed down at the water, wouldn't fall on her subjects. The sessions would last several hours as she would first draw her subjects, then watch them in the ground glass and eventually make her exposures.

The water adds a layer between subject and viewer; its fluid lines create an analogue to movement and animate the picture surface.

"I liked the look of the waterline, which was a sort of drawing line, creating not only a plane—like the plane of the film, the plane of focus, the plane of the glass in the frame in the gallery—but also a dividing line separating my world from their different underwater world," Ms. Verburg said in the interview, referring to *Untitled (Sally and Ricardo)*, 1983.

Ms. Verburg's husband, Jim Moore, a poet to whom she has been married since 1984, has been a consistent if not always willing subject. She works around his writing schedule

and his moods. With camera in hand one day, "I was looking at the way light was bouncing off the mirror in a room where Jim was asleep on the bed," Ms. Verburg said. "I turned around to look at him, and without moving or even opening his eyes he said, 'Don't even think about it.'"

"I definitely feel as though I am using him for purposes of my own that have little to do with Jim (qua Jim)," she said by email. At the same time, she added, "there is a way in which my portraits of him have probably allowed me to open up more to him, observe him more closely and connect with him more deeply." Her triptych *3xJim*, 1989, was made in a crumbling, light-filled attic apartment that the couple rented for several summers in Spoleto, Italy, and it is a work that comes close to a narrative sequence. "I didn't plan to photograph Jim again and again," she said. "But I did want to continue doing figurative work of some sort, and there he was in the next room."

While in Italy Ms. Verburg had noticed differences between late Byzantine and early Renaissance madonnas. While they were similar from one mosaic to the next, the faces of the earlier Byzantine figures had otherworldly expressions that the later ones did not.

"*3xJim* brings these two versions of portraiture together," Ms. Verburg said. In the image on the left he seems to be focusing on something elsewhere, she explained; in the center image he seems to share the same time and place with the viewer.

"Finally, in the third photo, on the right, he engages the viewer in the present tense," she said.

Ms. Verburg spends most of her days in Minneapolis in her studio, but she makes a distinction between the production work she does there—scanning her film, editing images, researching—and the creative work she does in other places, mostly in Italy or Florida, where she and her husband spend extended periods of time.

Italy has been a rich source of inspiration. *Exploding Triptych*, 2003 (page 108), is part of a series of photographs of olive trees that began with a simple snapshot near a house she and her husband rented in the countryside near Spoleto. "There was something I wanted to pursue—I didn't know what exactly—a freshness or airiness, a sense of vitality," she said.

Ms. Verburg doesn't set out with a particular idea of what she wants to photograph. She finds her way into a subject or a theme, "like a dog who circles a few times to make a nest before she lies down in a ball to sleep," she said. "With the olive tree photos, the best state of mind I can be in is to be without expectations and to be ready to go to work not knowing what the work will be or if I will later like what I have done."

As ever, she eventually gravitated to the same theme of time and space in that series. As she spent more time photographing in the olive groves, her interest in color grew. She started photographing in the early morning or at dusk, when "the light shifted from blue to yellow to reddish-magenta to purple, and I had to be ready before the yellow light disappeared, or I was too late."

The 5-by-7 view camera Ms. Verburg uses to photograph olive trees is designed with the lens mount and the film holder connected to each other with an accordionlike bellows. They are traditionally parallel to each other so that every detail during exposure is given equal focus. The bellows enables Ms. Verburg to tilt the lens and the film away from each other to alternate the focus within an exposure or, as she said, to extend "space within the image."

"When I'm under the darkcloth working, what I'm doing is a little like what I used to do with clay or wire when I studied sculpture: torquing the image and squeezing it and stretching it into being more lively or wacky or improbable," she said. In her sharp and finely detailed pictures of olive trees, the out-of-focus nature of some branches and leaves gives them a sense of motion, as if a breeze might be blowing through the picture.

Ms. Verburg also extends space and time with multiple panels of the trees. To create a stable horizon line from one image to the next, she uses tracing paper on the ground glass, drawing the horizon line in the first exposure so that she can align the second, third, and fourth, maintaining a continuity that adds to the sense of movement.

"I let myself go where my impulses draw me, and although I don't end up printing much of what I shoot, pictures often lead to other pictures," she said. "Every time I went to the olive orchards, I felt that it was my job to try to figure out how not to know—that is, to be in a state of figuring something out on the spot.

"Living—being alive—is a present-tense enterprise."

Originally published in the *New York Times*, July 15, 2007.

Robert Polidori: In the Studio

The absence of photographic equipment in Robert Polidori's Chelsea studio is conspicuous. But the fifty-five-year-old photographer, known for his bold, color-saturated architectural images from regions far and wide, never intended to use the space for taking pictures.

Instead he uses the clean, utilitarian studio for the subsequent stages of a photographic process that begins once the picture is taken and the digital wizardry gets under way.

Considering the preparation involved in his two recent New York exhibitions—one at the Metropolitan Museum of Art and another at Edwynn Houk Gallery on Fifth Avenue—as well as his editorial responsibilities as a staff photographer for the *New Yorker*, it would be fair to say that his studio is a busy place these days, even though an atmosphere of calm efficiency prevails.

Aside from a bank of windows through which ample morning light streams into the room, the spare white walls conjure the feel of a commercial gallery between shows. Polidori, rising from his desk, is dressed for a professional meeting; the muted earth tones of his shirt, sport jacket, and suede shoes exude a casual, Continental élan. He may have been born in Montreal and raised in cities across the United States, but he speaks with an indeterminate accent that sounds vaguely Balkan.

Across the room from Polidori's desk, two 40-by-50-inch color photographs of interiors in London and New York are fastened to the long white wall. In keeping with the artist's signature style, the electric colors and clarity of these geometrically composed images are strikingly graphic. The details pop. On these particular works, there are meticulously drawn circles to indicate where digital manipulation is needed to augment the color.

Polidori is quick to point out that his work is not about architecture but habitat. "By habitat I refer to the sociological forces that affect architecture," he says. While architectural photography documents a building or structure, Polidori is interested in how the building functions in relation to people. Given that there are no people in his photographs, he thinks that there is more than a tinge of pathos in his work.

"We have lived beyond our means economically as well as ecologically," he says, talking in philosophical terms about the future of the planet. "Pathos is a natural response."

As Polidori talks, his technicians toil at several computers, executing the digital alchemy that has replaced the chemical processes of the former darkroom era. On one side of the studio, floor-to-ceiling shelves line the walls with archival boxes in which his prints are stored.

Polidori has deftly straddled the world of journalism and fine art. On assignment for the *New Yorker*, for which he often photographs buildings, his work can comfortably accompany a piece of reporting. Or his images can stand on their own in a gallery or a

book, whether it's his well-known series of photographs documenting Havana's grand and poetically deteriorating buildings or scenes of devastation along the Pripyat River near Chernobyl taken sixteen years after the nuclear accident.

With a measured intensity that frequently underlies his conversation, Polidori relates the efforts that went into *New Orleans After the Flood*, his Met exhibition that chronicled the ruins of Hurricane Katrina (accompanied by *After the Flood*, published by Steidl). The work was made over the course of eight months on periodic trips to New Orleans, where he lived for two years as a teenager.

Never mind the permeating stench in those post-Katrina rooms that proved to be a true test of his will. In purely practical terms, the absence of electricity in such dark spaces required long exposures that were, at times, between five and eight minutes. He found himself counting to three hundred or more for each one. And because the carpets were still damp and water damage had caused the floors to sag, he had to steady his 5-by-7 camera by hanging SealLine Dry Bags filled with bricks from the center of his tripod, leveling it with other bags under each leg.

"Rooms are metaphors and catalysts for states of being, a look into the soul," Polidori says. "The great majority of these inhabitants are now living somewhere else, in a state of interruption." He refers to the interior spaces as "exoskeletons" forcibly shed by the people who lived in them.

As for his pictures of the exterior damage, the violence of the storm on the urban landscape is at once stupefying and breathtaking. Polidori maintains that his pictures raise unanswerable questions about the forces of nature that created an aftermath of such surreal dimension.

An image pinned above his desk from *New Orleans After the Flood* shows a blue house almost intact except for the curvature of its facade, as if liquid had solidified and conformed to the shape of a car jutting out underneath its frame. Another car is on its side in the backyard. "I left enough room around the house in the frame to induce its context," he says, pointing out that the two cars are symmetrical, like visual rhymes. Asked about the signature geometry of his photographs, he says that the formality of his framing is purposeful. He calls it a "classicist pictorial grammar based on the laws of perspective."

"When I'm framing," he adds, "it's almost like I'm reacting with a set of perceptual tools. After I take the picture is when I can really observe it. I don't take one picture a day; I take fifty. I photograph to see if it looks like what I remember. I'm not a stylist; I'm more interested in the meaning of the composition."

As for the meticulous detail in his pictures, Polidori claims that there is no pleasure in taking them as mere documents. With such visual bounty, he says, "you keep both the eye and the mind occupied." He notes his surprise when he finds details in his pictures that he didn't see while he was photographing them.

The kind of optical clarity evident in his work usually results from rigorous technical training, so it's remarkable to learn that Polidori had no formal photographic education. He came to photography through a love of cinema.

After one unhappy year at the University of South Florida in Tampa, he fled to New York in 1969 and spent the following three years involved with the renowned Anthology Film Archives in the East Village. Polidori took film courses around town and casually began to photograph rooms in 1973. But it wasn't until 1983, when he bought a 2¼-inch square-format camera, that he concentrated solely on photography.

Polidori has always photographed exclusively in color, which, he says, "is a complex mode of transcription, another adjective or adverb that can be modified." Referring to the technological process by which he coaxes every gradation of color from his images, he suggests that over the past fifty years or so color in nature has been grayed down: pollution has muted not only light but also color.

"Dirtying the color is part of reality and I should accept it, but it's like a record album not well recorded," Polidori says. Heightening the color in his images is a way to penetrate and clarify the subject—a kind of wish fulfillment to make up for the vibrancy of color that he believes we currently lack.

"I use negative film," he says, explaining the stages of his process. "I don't use digital cameras because I don't think they're quite there yet. I scan all my film here in the studio. Scanning is one of the most important components of the process."

While Polidori attempts to control the lighting during exposure, digital technology— the computer program Photoshop, in particular—allows him greater control afterward. "My digital files become my originals, as opposed to the negative, because they are the greater realization of my idea," he says. "I relive the shooting twice, first when I make the actual exposure, then, again, in the Photoshop process. I can realize the way I want the picture to look much better than I could with chemistry in the darkroom."

He brings the digital files to his lab, spending hours during the primary phase of the printing process, in which the digital information is transferred onto large-format Fuji Crystal Archive resin-coated photographic paper. The prints are made with dye rather than pigment, he says, and the vibrancy of color is in the nature of the dye. "When I make a print, it's an idealized view of the reality I photographed."

Perhaps his most succinct statement about what motivates him to photograph decay and destruction is in the afterword to his book of photographs of the abandoned buildings around Chernobyl, *Zones of Exclusion: Pripyat and Chernobyl* (published in 2003 by Steidl): "I felt personally compelled to confront and witness this ongoing tragedy that no ritual can heal."

Originally published in *Art+Auction*, January 2007.

A Young Man With an Eye, and Friends Up a Tree *On Ryan McGinley*

In the beginning Ryan McGinley was known for pictures of his young downtown Manhattan friends. By day he photographed them running, skateboarding, moving, always in motion. By night they were partying, having sex, taking drugs, living fast.

"For me the reason to go out to a party was to photograph," Mr. McGinley said about those early pictures, which are as playful as they are voyeuristic, straddling a line between exuberance and disorientation.

Motion is a visual aspect of his work, and his career has been equally fast moving. At twenty-four he had his first show at the Whitney Museum of American Art; the next year P.S. 1/MoMA exhibited his new work. Now Mr. McGinley, not yet thirty, will be honored as Young Photographer of the Year next week at the International Center of Photography's Infinity Awards dinner. So much attention so fast hasn't seemed to faze him.

"I'm just a photographer, not a movie star," he said during a recent conversation in his bright, meticulous studio on the Lower East Side, adding that it's not as if he is recognized by strangers walking down the street. "I've worked really hard. I've devoted my life to this. I'm not feeling any expectation from anybody else. I'm doing it for myself. I'm making the art for me first. I'm making it because these are the pictures I want to see. I'm making pictures that don't yet exist."

The Chelsea gallery owner John Connelly included Mr. McGinley in *Bystander*, a 2002 show he organized at the Andrea Rosen Gallery to spotlight the next generation of photographers. The participants included young photographers who documented the spontaneous activities of their friends in their own environment, a decided contrast to the constructed imagery of Gregory Crewdson, Philip-Lorca diCorcia, and Jeff Wall.

"I saw something more casual, immediate, and sincere," Mr. Connelly said about Mr. McGinley's work. "One picture, of the bicycle taken from above, stuck in my mind. I wanted to put it in the show."

Reviewing that show in the *New York Times*, Holland Cotter wrote that "it will be good to see more" of Mr. McGinley's work. The treatment of gay male bonding "feels refreshingly direct and immediate, autobiographical without being narcissistic," Mr. Cotter added. "Among other things it's part of a new approach to the visual depiction of gay life in art."

The skateboarders, musicians, graffiti artists, and gay people in Mr. McGinley's early work "know what it means to be photographed," said Sylvia Wolf, the former curator of photography at the Whitney, who organized his show there. "His subjects are performing for the camera and exploring themselves with an acute self-awareness that is decidedly contemporary. They are savvy about visual culture, acutely aware of how identity can be not only communicated but created. They are willing collaborators."

Mr. McGinley began taking pictures during his junior year as a graphic design student at what was then the Parsons School of Design. "I became obsessed with photographing," he recalled.

Obsessive might also describe Mr. McGinley's rigorous method of working. From 1998 to 2003, when he lived with friends in Greenwich Village, he took Polaroid pictures of anyone who visited. He wrote the name of his subject, the time, and the date on each Polaroid, then fastidiously placed them on the wall. Eventually the apartment walls were covered with tidy Polaroid grids.

Now every one of his Polaroid portraits is archived by date in three hundred black binders that line the shelves of his studio.

In 2000, while still a student at Parsons, he mounted a do-it-yourself show of his pictures—called *The Kids Are All Right*—at 420 West Broadway, a SoHo building that once was home to the Castelli, Sonnabend, and Mary Boone galleries. At the time the building was being renovated, and Mr. McGinley used an empty area under construction for his show.

Employing his graphic design skills and technological proficiency, he produced a desktop book with fifty of his photographs. He sold fifty books at the show for $20 each and sent another fifty to artists he admired—including Larry Clark, Nan Goldin, Jack Pierson, and Wolfgang Tillmans—and to magazine editors.

The enterprising idea struck him as logical. "No one knows who I am, so I'll send out my books," he said.

Index magazine responded with an assignment to photograph the musician Momus in Berlin.

"I was so nervous," recalled Mr. McGinley, who was only twenty-one at the time. "It was the first time I had to take photographs of someone I didn't know, and it was scary trying to make it look like pictures of my friends. First I asked if he would take his shirt off, and then if his girlfriend would take off her clothes down to her underwear." They did.

Time and experience have made him bolder. *Esquire* recently assigned him to shoot Robert Frank, known as a photographer who waits for the moment. Mr. McGinley, who shoots as much as he can in the belief that "editing is just as good as shooting," said he was aware that Mr. Frank was irritated by him. "I just started shooting, and I could tell the sound of the shutter going off was driving him nuts, like the sound of a machine gun." Paradoxically Mr. McGinley is a beneficiary of the way Mr. Frank changed photography in his day: the authentic moment, the sense of motion, the anarchy of form within the composition.

Ms. Wolf, who became aware of Mr. McGinley when a curatorial assistant at the Whitney put a copy of *The Kids Are All Right* on her desk, said his use of printed material is typical of his techno-savvy generation. But his graphic design background, she added, sets him apart from other artists. "The attitude of getting your work out there," she noted,

"straddling photographic art and graphic art, certainly got his work in front of me."

Mr. McGinley's early work and desktop books anticipated the YouTube-MySpace phenomenon of intimate visual diaries created for public consumption. While the confessional and voyeuristic nature of his work may be representative of his generation, what distinguishes him from a personal blogger or online visual diarist is the rigor of his artistic output and his ambition.

"I'm interested in reaching the masses with my work," he said. "It's one of my goals."

The work he began after the Whitney show was significantly different. In 2003 he rented a house in Vermont and invited groups of friends from New York, some of whom he had met at downtown clubs, to spend a week at a time in the country. With his guests as models in a variety of unexpected situations, his images captured their spontaneous behavior.

"I put a trampoline in the middle of a field," he said, giving one example. He photographed the group walking naked from the house through the woods to the field and then jumping on the trampoline. For another series he spent an afternoon clearing branches from a tree and that night directed his friends to sit together naked in it. And he used an underwater camera to photograph his friends in the lake.

Like his earliest works these images were documentary. He was a fly on the wall. But then he began to direct the activities, photographing his subjects in a cinéma-vérité mode.

"I got to the point where I couldn't wait for the pictures to happen anymore," he said. "I was wasting time, and so I started making pictures happen. It borders between being set up or really happening. There's that fine line."

The last two summers Mr. McGinley made pictures on cross-country trips, driving with groups of eight friends, plus two assistants, in two vans. He did research to plan the cinematic settings—including swimming holes and bungee-jumping sites—in which he placed his friends. He assembled booklets with pictures from old physique and nudist magazines to show his models and get them in the mood to pose comfortably and spontaneously for the camera. During the road trips Mr. McGinley shot twenty or thirty rolls of film a day while his two assistants filmed the entire process.

The group of friends changed at each coast, as did the route they traveled between New York and California. Mr. McGinley paid each model a day rate and paid for everyone's food and lodging, as well as the flights home. "The trips are like small film productions," Mr. McGinley said. "For a three-month trip it comes close to $100,000 for everything."

The activities in which he places his subjects, and the sense of motion he captures in his pictures, might have a source in his own activities as a teenager: "I was a snowboard instructor after school, and I was skateboarding at twelve or thirteen," he said. "I'd come into the city to skateboard downtown in the Financial District, and I'd end up at Astor Place."

The communal experience, a theme running through all of Mr. McGinley's work, mirrors his New Jersey upbringing as the youngest of eight siblings. "I grew up very Ameri-

can," he said. "There were always people around. We're totally a touchy-feely family."

Recalling how much he enjoyed those familial moments, Mr. McGinley talked about the spontaneity he seeks to project in his images. "My photographs are a celebration of life, fun, and the beautiful," he said. "They are a world that doesn't exist. A fantasy. Freedom is real. There are no rules. The life I wish I was living."

Originally published in the *New York Times*, May 6, 2007.

PLATES

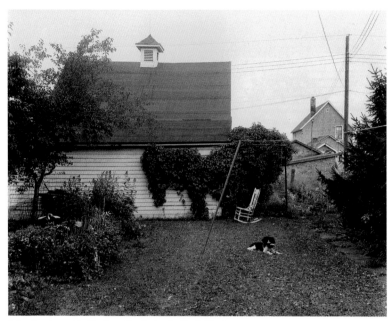

John Szarkowski, *Mathew Brady in the Back Yard*, 1952

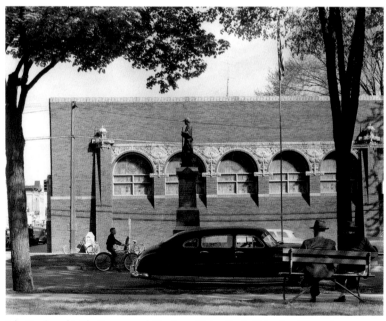

John Szarkowski, *The Farmers and Merchants Union Bank, Columbus, Wisconsin, 1919*, 1954

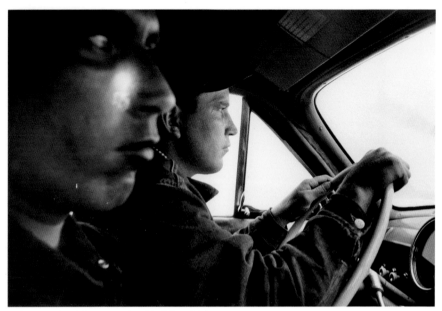

Robert Frank, *U.S. 91, Leaving Blackfoot, Idaho,* 1956

THAT CRAZY FEELING IN AMERICA when the sun is hot on the streets and the music comes out of the juke-box or from a nearby funeral, that's what Robert Frank has captured in tremendous photographs taken as he traveled on the road around practically forty-eight states in an old used car (on Guggenheim Fellowship) and with the agility, mystery, genius, sadness and strange secrecy of a shadow photographed scenes that have never been seen before on film. . . . After seeing these pictures you end up finally not knowing any more whether a jukebox is sadder than a coffin.

—JACK KEROUAC, from the introduction to *The Americans*

Robert Frank, *Rodeo, Detroit*, 1955

Robert Frank, *Funeral, St. Helena, South Carolina*, 1955

Cornell Capa, Senator John F. Kennedy's
hands while campaigning for the presidency,
California, 1960

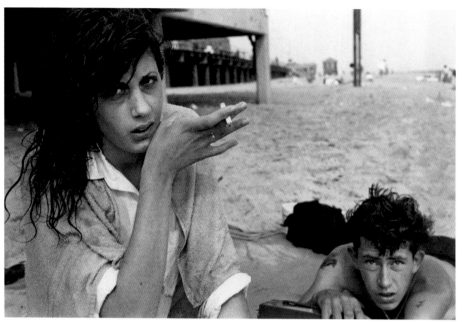

Bruce Davidson, from the series Brooklyn Gang, Coney Island, New York, 1959

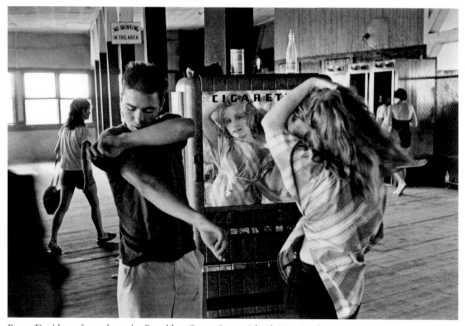

Bruce Davidson, from the series Brooklyn Gang, Coney Island, New York, 1959

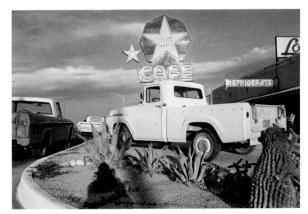

Lee Friedlander, *Texas*, 1965

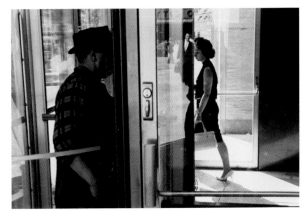

Lee Friedlander, *New York City*, 1963

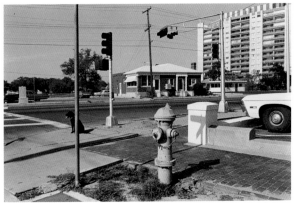

Lee Friedlander, *Albuquerque, New Mexico*, 1972

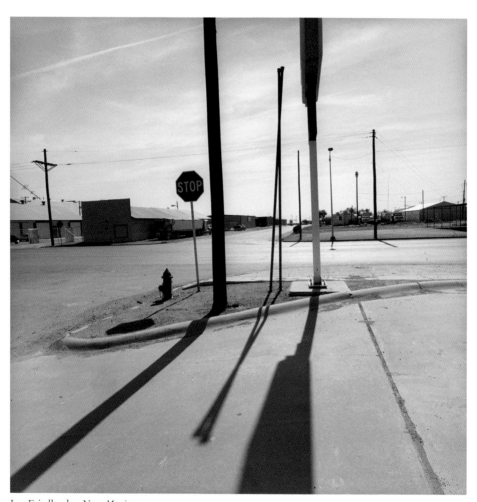

Lee Friedlander, *New Mexico*, 2001

Garry Winogrand, *Los Angeles*, 1964

Garry Winogrand, *Dealey Plaza, Dallas*, 1964

Henry Wessel, *Santa Barbara, California*, 1977

Henry Wessel, *Tucson, Arizona*, 1974

Stephen Shore, *West 9th Avenue, Amarillo, Texas*, October 2, 1974

Stephen Shore, *Natural Bridge, New York*, July 31, 1974

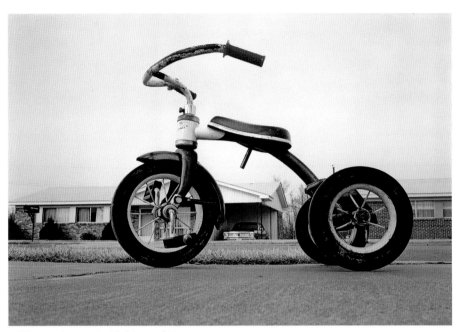

William Eggleston, *Untitled (Memphis)*, ca. 1970

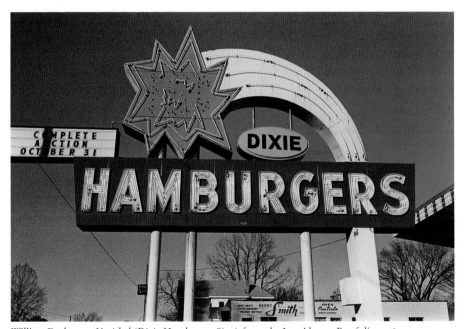

William Eggleston, *Untitled (Dixie Hamburger Sign)*, from the Los Alamos Portfolio, 1965–74

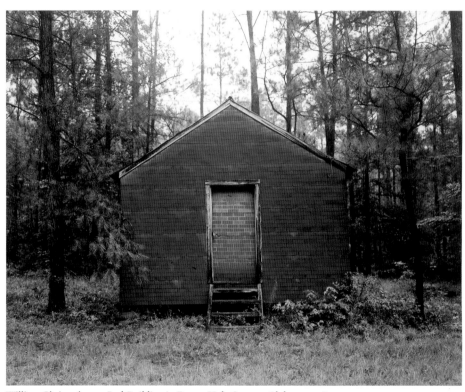

William Christenberry, *Red Building in Forest, Hale County, Alabama*, 1983

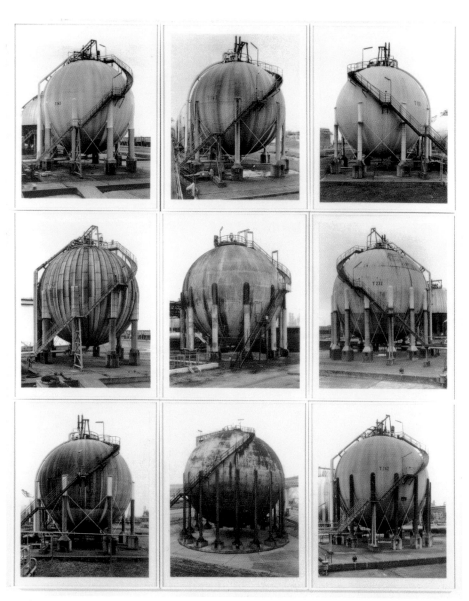

Bernd and Hilla Becher, *Gas Tanks (Round)*, 2000

Robert Adams, *Newly Occupied Tract Houses, Colorado Springs*, 1974

Robert Adams, *Tract House and Outdoor Theater, Colorado Springs*, 1974

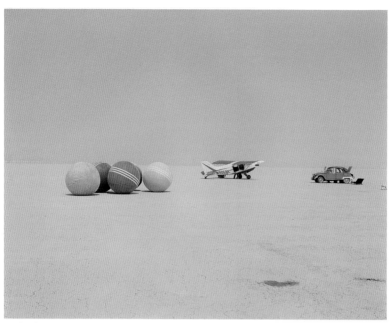

Richard Misrach, *Desert Croquet #3 (Balls, Plane, Car), Black Rock Desert, Nevada*, 1987

Joel Sternfeld, *After a Flash Flood, Rancho Mirage, California*, July 1979

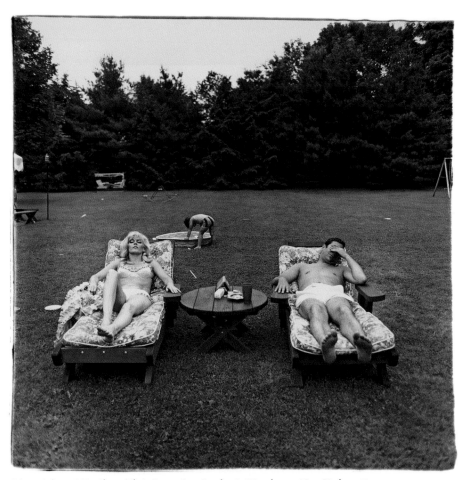

Diane Arbus, *A Family on Their Lawn One Sunday in Westchester, New York*, 1968

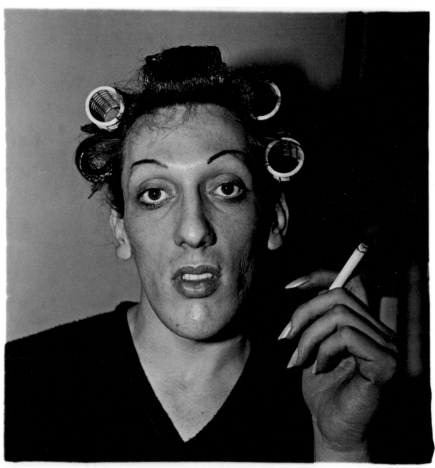

Diane Arbus, *A Young Man in Curlers at Home on West 20th Street, N.Y.C.*, 1966

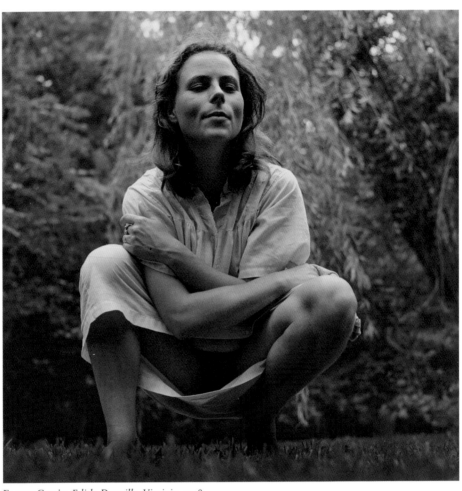

Emmet Gowin, *Edith, Danville, Virginia*, 1978

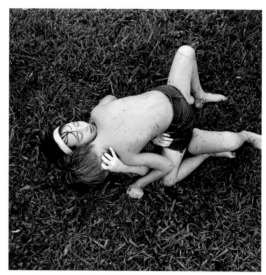

Emmet Gowin, *Nancy and Dwayne, Danville, Virginia*, 1970

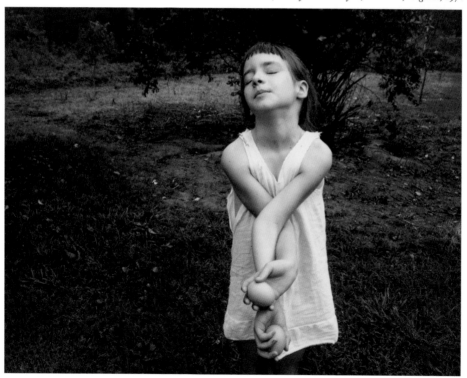

Emmet Gowin, *Nancy, Danville, Virginia*, 1969

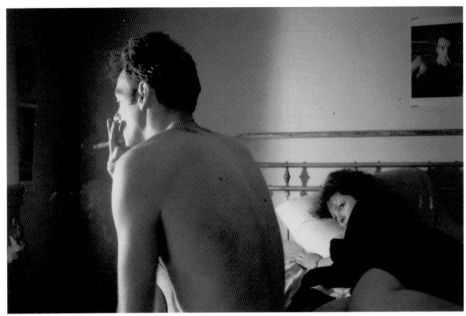

Nan Goldin, *Nan and Brian in Bed, New York City*, 1983

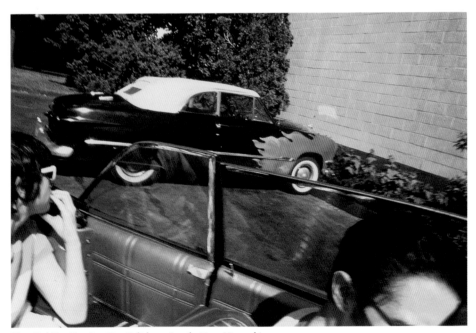

Nan Goldin, *Flaming Car, Salisbury Beach, New Hampshire*, 1979

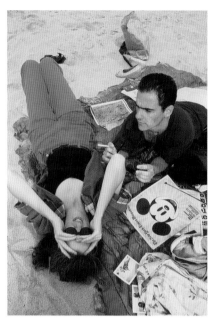

Nan Goldin, *C.Z. and Max on the Beach,
Truro, Massachusetts*, 1976

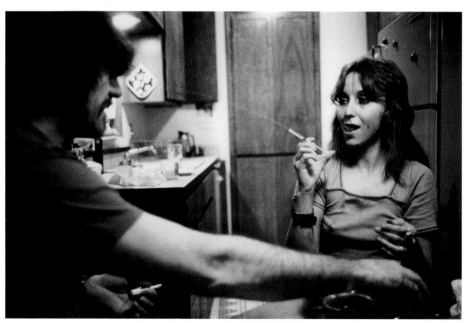

Larry Clark, *Jack and Lynn Johnson, Oklahoma City*, 1973

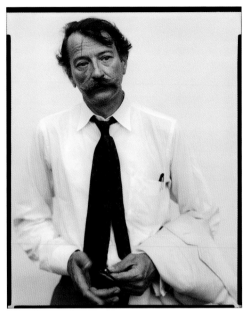

Richard Avedon, *John Szarkowski, Curator,*
New York, July 30, 1975

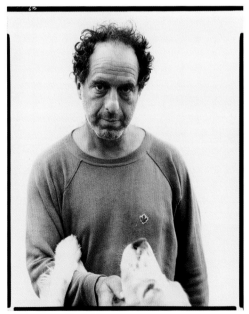

Richard Avedon, *Robert Frank, Photographer,*
Mabou Mines, Nova Scotia, July 17, 1975

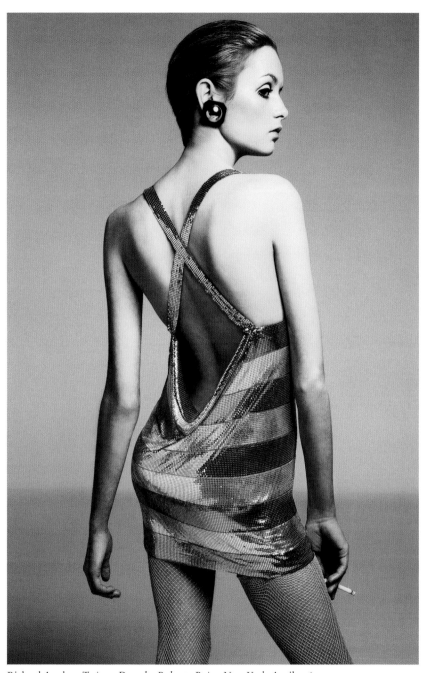

Richard Avedon, *Twiggy, Dress by Roberto Rojas, New York*, April 1967

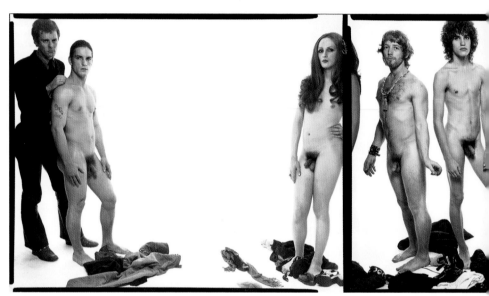

Richard Avedon, *Andy Warhol and Members of The Factory: Paul Morrissey, Director; Joe Dallesandro, Actor; Candy Darling, Actor; Eric Emerson, Actor; Jay Johnson, Actor; Tom Hempertz, Actor; Gerard Malanga, Poet; Viva, Actor; Paul Morrissey; Taylor Mead, Actor; Brigid Polk, Actor; Joe Dallesandro; Andy Warhol, Artist,* New York, October 30, 1969

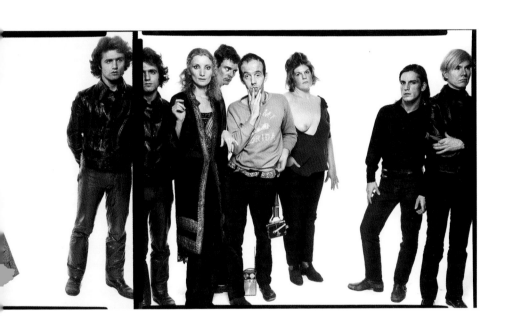

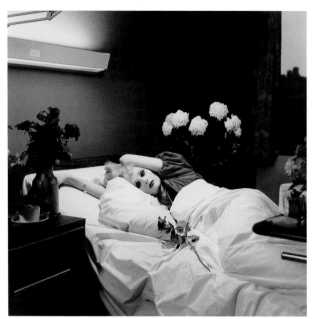

Peter Hujar, *Candy Darling on Her Death Bed*, 1974

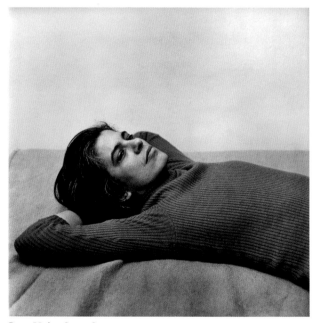

Peter Hujar, *Susan Sontag*, 1975

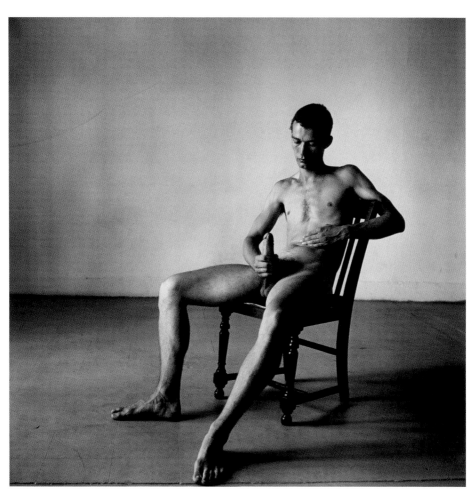

Peter Hujar, *Bruce de Sainte-Croix (Seated)*, 1976

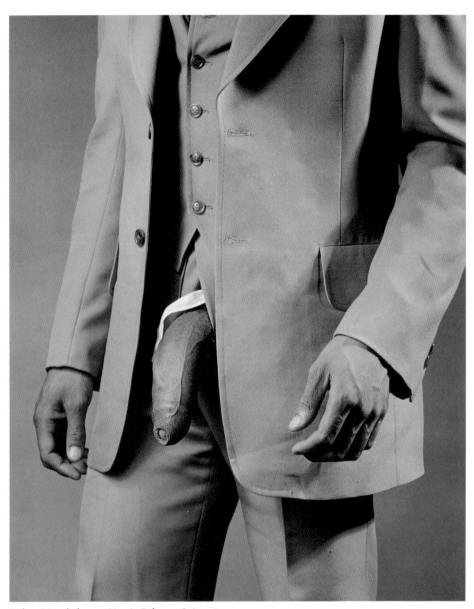

Robert Mapplethorpe, *Man in Polyester Suit*, 1980

Robert Mapplethorpe, *Untitled (Sam Wagstaff)*, 1973/75

Robert Mapplethorpe, *Untitled (Patti Smith)*, 1973/75

Cindy Sherman, *Untitled Film Still #7*, 1978

Cindy Sherman, *Untitled Film Still #11*, 1978

Larry Sultan, *My Mom Posing for Me, Palm Springs*, 1984

Larry Sultan, *Sharon Wild*, 2001

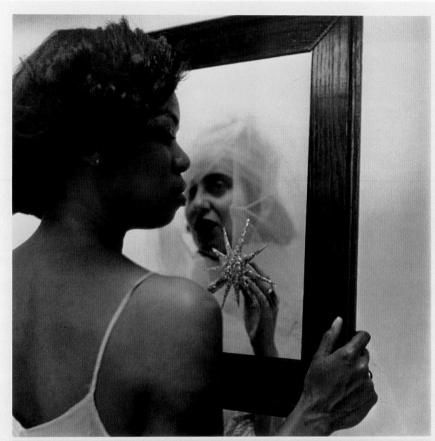

**LOOKING INTO THE MIRROR, THE BLACK WOMAN ASKED,
"MIRROR, MIRROR ON THE WALL, WHO'S THE FINEST OF THEM ALL?"
THE MIRROR SAYS, "SNOW WHITE YOU BLACK BITCH,
AND DON'T YOU FORGET IT!!!"**

Carrie Mae Weems, *Mirror Mirror*, 1987

Martin Parr, *Conservative "Midsummer Madness" Party*, 1986–9

Tina Barney, *The Young Men*, 1992

JoAnn Verburg, *Exploding Triptych*, 2003

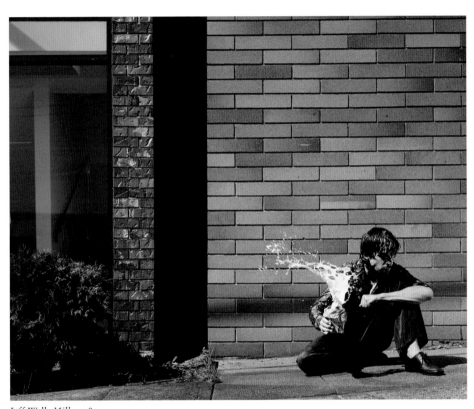

Jeff Wall, *Milk*, 1984

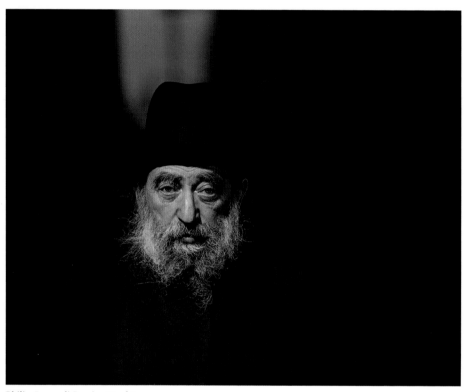

Philip-Lorca diCorcia, *Head #13*, 2001

Gilles Peress, Demonstration in favor of the leading opposition figure Ayatollah Kazem Shariatmadari, Tabriz, Iran, 1980

Gilles Peress, Victims of the shah and CIA on a signboard at the U.S. Embassy, Tehran, Iran, 1979

Gilles Peress, Mountain village, Kurdistan, Iran, 1979

Tyler Hicks, Saddam Hussein statue with burning building, 2003

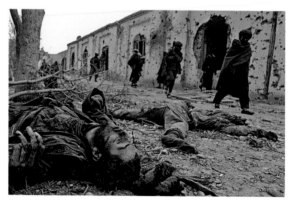

James Hill, Qala Jangi fortress, Afghanistan, 2001

Edward Keating, Brandon Benzo outside a store in Lackawanna,
New York, 2002

Carrie Boretz, Bunny Budman and the waiter (Central Park Conservancy women's luncheon), 1993

Beate Gütschow, *LS#13, 2001, C-print, 42½ x 33½ in.*

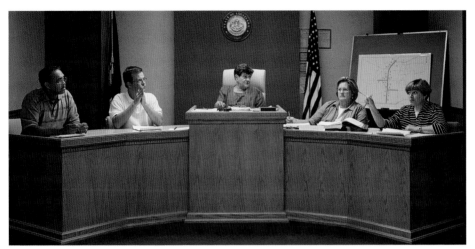

Paul Shambroom, *Maurice, Louisiana (population 642) Village Council, May 15, 2002 (L to R): Paul Catalon, Lee Wood, Barbara Picard (Mayor), Mary Hebert (Clerk), Marlene Theriot*

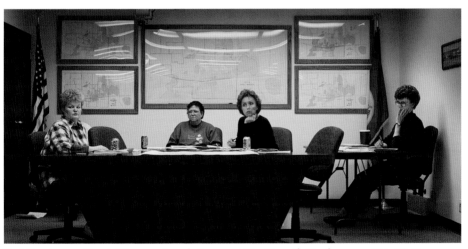

Paul Shambroom, *Dassel, Minnesota (population 1,134) City Council, March 15, 1999 (L to R): Nancy Nicholson, Ava Flachmeyer (Mayor), Jan Casey, Sherlyn Bjork (Deputy Clerk)*

Andreas Gursky, *Prada II*, 1997

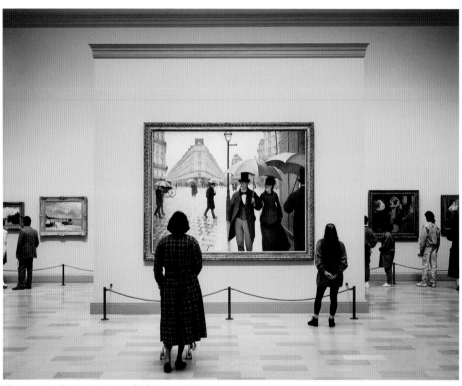

Thomas Struth, *Art Institute of Chicago 2*, Chicago, 1990

Katy Grannan, *Ghent, New York*, 2000

Katy Grannan, *Van, Red Hook, Brooklyn*, 2003

Jack Pierson, *Self Portrait #4*, 2003

Ryan McGinley, *Kiss Explosion*, 2005

Ryan McGinley, *Dakota Hair*, 2004

Ryan McGinley, *Highway*, 2007–8

Photojournalism

Photojournalism: a breed of photographic imagery assigned or conceived to capture news-worthy events or to document conditions in the world expressly for publication in a news-based journal. At its foundation lies an unwavering adherence to fact. The photojournalist will shoot an event as it transpires without altering its anatomy with his or her presence. The "camera as witness" is, perhaps, the profession's essential rule of thumb.

Photojournalism had a golden age—loosely from the 1930s until the early 1980s—with the popularity of news magazines such as *Time* and *Newsweek*, and picture magazines such as *Life, Look, Paris Match, Stern*, and the *Sunday Times of London*. Photojournalists coveted assignments from these publications to shoot picture essays that could be laid out as running narratives across several magazine spreads.

For spot news, international news organizations have always relied on wire services such as the Associated Press or Reuters with worldwide networks of photographers who cover local events on a daily basis. Sometimes those local events reach global proportion, as in the case of President John F. Kennedy's assassination in Dallas in 1963. Wire photog-raphers transmit their images (for many years with facsimile technology over telephone lines—hence the term "wire service") to regional bureaus from which the pictures can be distributed to newspapers and magazines internationally.

The wire services have always provided workaday news pictures, but undeniably, two organizations set the gold standard in the field of photojournalism in the twentieth cen-tury: Time-Life, a journalistic monolith, and Magnum, a photography collective.

Time, Inc. (the corporate parent of Time-Life) published *Time, Life, Fortune, Sports Illustrated*, and eventually, *People* magazine. Margaret Bourke-White, Robert Capa, Walker Evans, and W. Eugene Smith were among the early staff photographers who set the tone for photojournalists throughout the century; eventually staff photographers for *Life* included Larry Burrows (who brought the Vietnam war home in unflinching detail), Alfred Eisen-staedt, Philippe Halsman, Gjon Mili, and Gordon Parks, among many notable others. These photographers worked in service of the company's editorial approach, and, often, their material carried the Time-Life signature in their pictures: clarity of subject matter, strong composition, bold graphic effect, and often, a touch of wit. While the pictures could be arresting, the view of American society and international affairs presented by *Life* maga-zine, in particular, carried a patina of filtered reality.

Magnum, founded in 1947 by Robert Capa, Henri Cartier-Bresson, George Rodger, and David "Chim" Seymour, was created as an alternative for photographers who wanted to control not only the subject matter they covered but also the way in which it would be

presented. As a collective, Magnum photographers generate their own editorial content and sell it to news organizations. The roster of distinguished Magnum members over the years has included, among many others, Cornell Capa (who coined the term, "the concerned photographer," which may well sum up the Magnum approach), Bruce Davidson, Elliott Erwitt, Joseph Koudelka, Susan Meiselas, James Nachtwey, and Gilles Peress. It is worth noting that Magnum photographers often worked for Time-Inc. publications.

Intention is what distinguishes the photojournalist from the artist. A photojournalist takes pictures that fulfill an editorial requirement and answer the essential journalistic questions: who, what, where, when, and why. An artist makes pictures in exploration of an idea. There are, of course, crossover photographers: Henri Cartier-Bresson, who gave definition to "the decisive moment"; Bruce Davidson, whose pictures of a Brooklyn street gang in 1959, for example, are among the most poetic about disaffected youth; Gilles Peress, whose photographs of Iran during the hostage crisis in 1979–80 document a culture with singular visual intelligence (Peress was among the first staff photographers for the *New Yorker*, in 1995, a milestone for a magazine that had never before acknowledged the photographic image); and James Nachtwey, whose war pictures from Chechnya, Kosovo, Israel, and Rwanda are paramount examples of the "camera as witness."

The *New York Times* began to set a new standard for photojournalism after its transition to color photography in 1997. Since 2000, the paper has invested more resources in its photographic coverage, sending staff photographers around the world and expanding its display for pictures, both in print and online. Among the paper's photographers who are setting the tone for photojournalism in the twenty-first century are Stephen Crowley, Tyler Hicks, James Hill, and Chang W. Lee.

In recent years, the boundaries between fact and interpretation have become increasingly porous, and the bedrock of truth on which the photojournalistic image resides is less secure today than it has ever been. The easy potential to falsify images electronically undermines confidence in the truth-telling capability of the medium. Yet, the benefits of digital technology for photojournalists are many: less equipment to cart around; instantaneous transmission of images from almost anywhere on the globe; vast electronic archiving and storage. But news organizations are ever more susceptible to the danger of publishing doctored images, or visual fiction, particularly from unvetted sources in the field. Here is where technology poses the greatest challenge to the integrity of photojournalism.

Page One: A Conversation with Philip Gefter, Picture Editor of the *New York Times'* Front Page

BY VÉRONIQUE VIENNE

Every day of the week, at 4:30 p.m. precisely, twenty or so of the best-informed journalists in the world assemble in a conference room on the fourth floor of 229 West 43rd Street in Manhattan. They meet to determine what the most important news of the day will be in tomorrow's *New York Times*. The Page One meeting, as this august gathering is called, is a thirty-minute ritual during which editors of the "World's Most Authoritative Newspaper" (nearly all of them men, incidentally) choose not only the top stories, but also the two or three photographs that will appear as emblems of what is happening in the world on their front page.

One of the participants at this meeting, Philip Gefter, was appointed Page One picture editor in 1999. Like the other editors at the Page One meeting, Gefter is fully aware that the careful balance of words and images on this 22-by-13.6-inch sheet of paper will be scrutinized by readers, among them the most prominent leaders and thinkers of our time; he brings to this gathering the sum total of his professional expertise as well as his personal convictions about art, objectivity, and truth—though not necessarily in that order.

Gefter makes a point of distinguishing between pictures that are simply "illustrative" of a news event, and pictures that are "edifying"—that is, pictures that are not merely additions, but illuminating in themselves, integral to the report. "A photograph on the page can edify when it opens a window on a story rather than simply being proof of the story," he explains.

It was after seven years of comprehensive orientation in the *New York Times* newsroom that Gefter faced the austere Page One challenge. He had received his BFA in painting and photography from New York's Pratt Institute, and then taught history of photography at the San Francisco Art Institute and at New York University's Tisch School of the Arts. When he first joined the *Times* in 1992, he worried that he might be a little too flamboyant for them. No stranger to the gallery scene, he had curated a number of photography exhibitions, written critical essays, and penned quite a few published and unpublished short stories. In fact, just prior to accepting his first assignment at the *Times* as a picture editor for the newly redesigned Metro Section, he had been a guest on the *Phil Donahue Show*, talking about a controversial book he was writing on "the difference between sleeping with men and women."

An important part of his job at the *Times*, Gefter soon found, was to be able to spell out concisely the who, what, when, where, and why of each picture. Though he was an

accomplished wordsmith, who had secured his credentials as a picture editor at a number of national publications (including *Forbes*, *Geo*, *Fortune*, and the *San Francisco Examiner*'s Sunday magazine), Gefter had to learn from scratch the science of caption writing for the *Times*. One of the early captions he composed at the Metro desk (where he stayed for eighteen months before moving on to other sections—the Week in Review, the Business section, and the Foreign desk among them) was to accompany a Thanksgiving photograph of a turkey milling around a turkey farm. "The melancholy days before Thanksgiving," he wrote ironically. Soon after, a post-mortem memo was circulated; next to the picture of the gallinaceous bird was a stern admonition: "We should not ascribe anthropomorphic feelings to farm animals."

That was almost a decade ago. Today, Philip Gefter is a seasoned journalist who doesn't take lightly the task of selecting and captioning news pictures. Last August, during the heat of the presidential campaign, he explained how privileged he feels to be part of the Page One process, and how five days a week he methodically puts together words and images for what he says is "probably one of the most important meetings in America that day."

Véronique Vienne: How would you describe your role at the *New York Times*?

Philip Gefter: Sometimes I feel that I am the curator of the Pictures of the Day. Over the course of eight to ten hours, I monitor all the photographs and all the available information regarding the events of the day—in real time, as they happen.

VV: How many photographs do you look at?

PG: Hundreds, daily. Basically, I have access to all the news pictures from around the world—the pictures and their captions, right there, on my desktop. All the wire pictures, from Reuters, Agence France-Press, and Associated Press. That's one level of images. Then there are the photographers that are assigned by the *Times*—by all the news desks, whether Metro, National, or Foreign. Their photographs are entered into our computer network, and they appear on my screen. If I check all these pictures first thing when I arrive, and before I go into the Page One briefing at noon, during which we preview the top news of the moment, I can stay on top of new pictures as they come up through the day.

VV: How many photographers provide pictures to the *New York Times*?

PG: We have more than twenty-five local staff photographers. They are working all the time. They are being fed assignments by reporters, by news editors, and by any of the thirty or so picture editors from various desks. We give them up to fifty or sixty assignments a

day, including what we call "day pictures," a newspaper tradition: these photographs are supposed to capture the "mood of the day"—a slice of life—and sometimes there is an appetite for them on the front page.

Often, too, there are front-page feature stories that we assign. I will work with various picture editors on these projects. If I feel that the images for the story are inadequate for the front page, I can ask for a reshoot, or suggest a second look at the take. Occasionally, like in the case of the series How Race Is Lived in America, the picture selection for the front page is handled by the editors who oversee the project.

Last but not least, there are all the so-called generic pictures I have archived with the idea that they might be useful someday. Like the Agence France-Press photograph that ran recently, showing people watching an eye operation live, on multiple screens in a mall. I had found it about a year ago. It turned out to be perfect on the front page for a story on the business of eye surgery from the Science section.

VV: How many stories do you read before the 4:30 meeting?

PG: By the time I get to the Page One meeting at the end of the afternoon, I have read all the stories being offered for the front page from the respective desks—a dozen or more—and I have assembled the pictures I think work best for them. I then know what's important in terms of the news; I know what's relevant. But that's not enough. I have to be able to talk about the pictures, not in terms of a visual language per se, but in terms of the information they provide. If I do so, the poignant editorial details will always increase the chances of pictures making it to the front page.

VV: How do you *talk* a picture to Page One?

PG: I operate on the principle that words are cerebral and pictures are visceral. For many word-people, it seems as if a photograph gets filtered through a mental process before it is registered as an image. That's why it's important for me to provide thorough information about the pictures first. Letting the editors know at once in what ways a particular picture is relevant to the story or the news—that's a critical part of my job.

Finding the right words to talk about images is something I have spent a lot of time working on. It takes focus and discipline, yet at the same time it's one of the most thrilling things I do. I think there was an attitude at the *Times*—at many publications—that the picture desk was more a service desk than a journalistic equal. I have seen that attitude change. And, while it has been a long process, I want to give credit to my boss Margaret O'Connor, the director of photography, and to her deputy Mike Smith. Their efforts to engage a dialogue about pictures in the newsroom are paying off. I am aware that every

time I go into the Page One meeting, I am representing everyone at the picture desk. I try my best to introduce the pictures with as much accuracy of detail, efficiency, and relevance as possible.

VV: How do you accomplish that? Do you write all the information down?

PG: All afternoon I think about how I can best present the ten or twelve images I have selected to show at the 4:30 p.m. meeting. I scribble notes as I go along, rewriting them and refining my thinking about each picture. Thirty minutes before the meeting, I sit down and script what I am going to say, word for word. By the time everyone gathers in the Page One conference room—well, it's showtime.

VV: Who attends the Page One meeting?

PG: There are about twenty people in the room—each one the head of a department or a section—the National Editor, the Metro Editor, the Foreign Editor, as well as the Science, Culture, Business Editors, and so on. Add to these the newspaper's Executive Editor, Managing Editor, Deputy Managing Editors, and Assistant Managing Editors—what we call "the masthead."

VV: And everyone at this meeting must be extremely well-prepared.

PG: Absolutely. Each editor presents the most important stories of the day from their department. When it's my turn, I show my gallery of images on an electronically projected desktop. A veritable slide show. After this meeting adjourns, only a half-dozen people remain, including me. And that's when the front page is drawn, by hand, on a green layout pad—when the stories are placed on the page according to their importance, and when the final two or three pictures are selected.

VV: Are the more complex issues hashed out? Do questions come up about the objectivity of the paper?

PG: Yes, of course there are discussions. But, as a picture editor, I walk a delicate line. I choose carefully the discussions I enter and the editorial points I venture to argue. Here's an example—do you remember in July of 2000 the picture of [Senator Bill] Bradley endorsing Gore? That morning, in the noon meeting (the preliminary Page One meeting) one of the editors objected to the wisdom of featuring the two men on top of Page One. He said, "It's not necessarily an important event."

"What do you mean?" I blurted out. "When McCain endorsed Bush, we put that picture on top of Page One."

"It's not the same thing," he said. "If McCain hadn't endorsed Bush, it could have cost him the nomination. If Bradley doesn't endorse Gore, it's not going to have the same consequences."

So I joked: "Are you speaking as a Republican or as an editor?"

As it turned out, not only did the picture run on the top of Page One, but the subtext of that event was right on the surface. From their body language—from the way their hands met—you could see the tension between Bradley and Gore.

The point is, objectivity is something everyone at that meeting—in fact everyone at the *Times*—gravitates to. Without objectivity you have no credibility. This is my mantra.

VV: Is there a strategy to the juxtaposition of headlines and photographs? You recently ran a friendly portrait of George W. Bush above a headline that read: "The Few, the Rich, the Rewarded Donate the Bulk of G.O.P. Gifts." Readers decode the front page for subliminal cues. Was that coincidental?

PG: The paper isn't put together like a novel, where every part refers to the whole. The person writing a headline for the top of Page One may not be aware of the final picture chosen for that story. Sometimes, too, as in the case of a political convention, we might update a picture from edition to edition without changing the headline. In that case, the only thing we change is the caption.

As for subliminal cues, everybody brings their own frame of reference to the reading of photographs in the *Times*. While I might think that our use of a particular image gives a pretty balanced view of the G.O.P. candidate, I have friends who email me: "Why are you giving such a free ride to George W. Bush?"

There can be a lot of innuendo in pictures, political or otherwise. Editors, like readers, scrutinize the expression on a subject's face in photographs, as well as their body language, to glean the meaning of the moment. We all aspire to objectivity—though, obviously, it's a relative thing. I may feel, for instance, that the *New York Times* has given Clinton a hard time, while you may feel that we are publishing very flattering pictures of him. So where does the truth lie? Between a headline and a picture? I'd say it's a rhetorical question.

VV: What are your thoughts about the extent of sports coverage on Page One of the *Times*?

PG: Sports has become big business, in every sense of the word. The ownership of teams is in the hands of powerful individuals. The spectacle of sports is big business—it sells a lot of products. It has affected our culture and the *New York Times* is aware of that. I cannot

say that sports is one of my enthusiasms, and for that reason, I can't be objective in my appraisal of our use of sports pictures.

One argument for sports coverage on Page One is that we have to let our readers know that we are breathing the same air they do.

VV: How does the juxtaposition of photographs on the front page come about? Do you have the leisure to consider the impact of the various pictures together, as a whole?

PG: It's easy for visual people to create narrative connections from one picture to another. In the case of Page One, though, picture decisions are driven by the mix of stories, and the mix of stories is a result of—well, an impenetrable calculus.

The top picture is often given over to the most important news event of the day. Short of that, it refers to a story inside the paper. Occasionally, it's a stand-alone picture depicting something of public interest or it's good enough to deserve top billing on its own visual merits—and in both of the latter cases it runs with only a kicker and a caption.

The bottom picture might go with a feature story, one that could run today or tomorrow or the next day. Our only concern in thinking about both pictures—top and bottom—is that they cover different bases. That's really it. So, for readers out there who think that the photographs on the front page on any given day are chosen for their subtextual relationship to one another—I'm afraid that's reading too much into it.

VV: What is your main concern when choosing photographs for the front page?

PG: I care a great deal about presenting what's true and accurate in the world. Regardless of my own personal beliefs, I want the fairest representation of what happened today. Though I have a predilection for photographs that tend toward the existential, I am able to sacrifice them if they don't capture what's relevant about a news event.

VV: Is this objectivity something you learned at the *New York Times*?

PG: At the beginning, I suppose, my reputation at the *Times* was somewhat "artsy." To this day, because of my fine-arts training, I am always cognizant of straddling a line between photojournalism and art photography. I can't help drawing on references from the entire history of photography when I look at pictures. It's what informs my selection process. Then, too, pictures with a cultural subtext are of particular meaning to me—that is, pictures that reflect the ongoing nature of art in culture.

When I was the weekend supervisor of the picture desk, for instance, we were able to publish on the front page a photograph taken at a Van Gogh show at the National Gallery

in Washington, D.C. It just happened to be a perfect image—people looking at paintings hanging below a quote by Van Gogh that read: "I should like to do portraits which will appear as revelations to people in a hundred years' time."

One of my own considerations when looking at pictures for the front page is that they have some historical resonance. I want people in the future who look at copies of today's *New York Times* to be given a sense of what life is like now. That is a responsibility I feel strongly about.

VV: Does color on the front page affect your aesthetic appreciation of the photographs?

PG: Initially, I was suspicious of color on the front page—I was a purist, of course. Well, I was wrong! Now I confess that I love color photographs that look like paintings. In fact, I find myself cropping pictures with the composition of eighteenth-century neo-Classical paintings in mind.

Take for example the picture of Clinton that ran on top of the front page on Friday, March 24, 2000. He is sitting on a sofa with flowers around his neck, quietly listening to three traditionally dressed Indian women. It has the effect of a Mannerist painting: the colors of the saris, the context of the village square, the formal attitude of the women, the ease of the President. Still, aside from all that, and more to the point, this particular picture shows the odd juxtaposition of the world's most powerful man sitting down to a meeting with a few local village women in India—and that's what made it worthy of the front page.

Another of my favorite photographs with a painterly signature was that of young black girls dancing at a school performance. When presenting it at the Page One meeting, I gave all the specifics, and then added: "It's the photographer's homage to Degas." Joe Lelyveld, the Executive Editor, appreciated that. "Use 'Homage to Degas' as a kicker," he said. It ran on the top of Page One. In my description of the picture, I had chosen to highlight the cultural connection instead of stating the obvious. If I had emphasized the positive depiction of African-Americans, that would have seemed like an appeal to political correctness.

VV: Your job is a balancing act between facts and poetry?

PG: Well, let's just say that bringing to the front page photographs that work both journalistically and visually—and making them large enough to preserve their integrity—that's always my goal. And if I can do that, if I can contribute to an awareness of the cultural life of this country, then I am happy.

Originally published in *Aperture* magazine, Winter 2001.

VÉRONIQUE VIENNE is the author of a series of essay books, including *The Art of Doing Nothing*. She also writes about design, photography, and lifestyles for magazines such as *Metropolis*, *Graphis*, *House & Garden*, *Town and Country*, and *Martha Stewart Living*.

History's First Draft Looks Much Better With Pictures

So many historic events immediately summon an indelible photographic image. The intransigence of the cold war, embodied by Richard Nixon poking his finger into Nikita S. Khrushchev's chest. The assassination of President John F. Kennedy, forever linked to a young son's salute. The brutality of the Vietnam War, crystallized in Eddie Adams's photograph of a South Vietnamese police chief holding a gun to a man's head.

A new book, aptly titled *Things as They Are: Photojournalism in Context Since 1955*, surveys the quest to chronicle world events without altering the situation on the other side of the lens. But rather than single images—the usual "best of photojournalism" approach—the book is made up of 120 photo-essays published in the second half of the twentieth century. The essays appear as they did in the original magazine and newspaper layouts, giving a fuller historic record of how the photographs, along with the text, shaped our view of the world.

Things as They Are is being published in the United States next month by Aperture and World Press Photo, a non-profit international organization of photojournalists that is celebrating its fiftieth anniversary. It was published in Europe last October by Chris Boot Ltd., and in May it will receive the International Center of Photography's Infinity Award for best photography book of 2005.

"Before the first press pictures, the ordinary man would visualize only those events that took place near him, on his street or in his village," the photographer Giselle Freund observed in her 1974 book, *Photography and Society*. "Photography opened a window. As the reader's outlook expanded, the world began to shrink."

It is one thing to read about the circumstances of our time; it's another to see them. Even if the subject is unfamiliar, the visual language is immediately recognizable. In 1954 Henri Cartier-Bresson was the first Western photographer allowed into the Soviet Union after Stalin's death. His goal was to photograph "human beings in the streets, in the shops, at work, and at play, anywhere I could approach them without disturbing reality." Both *Paris Match* and *Life* bought the rights, and in 1955 *Paris Match* devoted twenty-four pages to his photographs. *Things as They Are* opens with this essay, a first glimpse at life behind the Iron Curtain.

Also in 1955 Walker Evans, then the picture editor at *Fortune*, assigned Robert Frank to do a picture essay on the Congressional, the train that shuttled between New York and Washington. Today, that eight-picture essay, which appears in the book, looks more like an indictment of conformity than an ode to "the man in the gray flannel suit."

A picture may not be worth a thousand words, but a picture and a good caption are worth a thousand and ten. The image is only as valuable as the information it provides.

Some pictures accompany long texts written by reporters or by the photographers themselves, as when Don McCullin provided his account of an American counteroffensive during the Vietnam War for his twelve-picture spread in the *Sunday Times of London*'s magazine. But often only short captions—the who, where, and what—are needed to make the editorial image work.

The book makes clear how the history of printing and photographic technology influenced the development of the genre. The *London Illustrated News* began using photographs in 1842, followed a year later by *L'Illustration* in France and the *Leipziger Illustrirte Zeitung* in Germany. In 1886 *Le Figaro* began publishing photographic essays by Gaspard-Félix Tournachon (aka Nadar) and his son Paul. With the invention of the rotogravure at the turn of the century, newspapers started publishing Sunday picture supplements. In 1904 the *London Daily Mirror* began using photographs daily, equating photography with information in their trademark motto: "See the News Through the Camera."

The introduction of handheld cameras in the 1920s—the Leica and the Ermanox in particular—gave photographers a new "fly on the wall" freedom. Erich Salomon, who makes a brief appearance in the book, was among the first to make these new kinds of photographs for publication, most notably at The Hague while European officials negotiated the establishment of the League of Nations and were caught by his camera gossiping and dozing.

In the first half of the twentieth century, it was the major magazines that brought the world into American homes. In the 1930s Edward Steichen at Condé Nast and Margaret Bourke-White at *Fortune*, and later at *Life*, established a photographic style that served both advertising and editorial content. Their bold lines, sharp lighting, and simple compositions set the visual tone for photojournalism itself.

While Condé Nast and Time-Life lavishly supported their photojournalists, the Farm Security Administration sent photographers, from Dorothea Lange to Arthur Rothstein, across the country to document Depression-era America. Then with the birth of the cooperative photo agency Magnum, founded by Robert Capa, Cartier-Bresson, and others in 1947, photojournalists began to determine their own subject matter and establish independent visual styles.

As television technology improved in the 1960s, allowing news film to be broadcast shortly after the actual events, it provided competition for news magazines. The shooting of Lee Harvey Oswald in 1963 was seen on television as it occurred. But when events fly by in real time, their permanent record becomes all the more valuable, something to scrutinize for the gestures and expressions—like the shock and pain that contort Oswald's face—that define the moment forever after.

In the early 1960s, *Esquire* magazine became a platform for New Journalism, and subjective experience began to inform reporting, just as it did with photography.

Diane Arbus, who went on to do many *Esquire* assignments, was first published there in 1960. Her debut was made up of photographs and interviews profiling six people well outside the conventions of society. They are reprinted in *Things as They Are*. The very look of those portraits—blurred, grainy, and raw—also challenged the conventions of polished magazine photography.

This new type of magazine work was what John Szarkowski, a curator at the Museum of Modern Art, later identified as a significant development in photography as a whole in his 1967 landmark exhibition *New Documents*. "In the last decade," he wrote at the time, "a new generation of photographers has directed the documentary approach toward more personal ends. Their aim has not been to reform life, but to know it."

This is evident in many of the essays from the 1960s that appear in *Things as They Are*. Visually explosive pictures by the Japanese photographer Shomei Tomatsu, published in 1960 in the magazine *Chuo Koron* (Central Review), capture profound changes in an ancient city south of Osaka after it became home to an American military base. Bill Eppridge brings a film noir sensibility to his 1965 *Life* montage of a middle-class New York couple whose heroin use leads them into robbery and prostitution.

War has a set of rules all its own. In Vietnam a combination of editorial resources, versatile equipment, and color film coincided, and the war was covered photographically as none had been before. Larry Burrows, working for *Life*, made many of the most memorable photographs of the conflict. "An advocate for the individual soldier and the victims of war rather than for any political point of view, his stories were full of emotion and gritty detail," Mary Panzer writes in *Things as They Are*. He died in a helicopter crash in Vietnam in 1971.

Don McCullin, who photographed the war for the British press, went on to cover other conflicts with the same unflinching eye. His images of escalating tensions in Northern Ireland, where his camera roamed among armed British troops and young Catholic rebels, were published in 1971 in "The Siege of Derry" in the *Sunday Times of London*.

In the late 1970s Susan Meiselas went to Nicaragua, prompted by the murder of Pedro Joaquín Chamorro, publisher of *La Prensa* and an opponent of the country's military dictatorship. She had been a photographer in search of a subject; when his death united opposition to the government she chronicled the rise of the Sandinistas. The *New York Times Magazine* picked up her photographs, which have become icons of that revolution.

In photojournalism, the subject is considered more important than the aesthetics of the image. While clarity, composition, and exposure have always been taken into account, it is news value that drives the profession. But in the 1980s and '90s, photographers like James Nachtwey and Gilles Peress established distinct visual styles in their coverage of war-torn regions like Bosnia and Chechnya; the way they observed their subjects, discerned in what they chose to shoot and where they stood, added new layers of information to the editorial image.

Getting the facts right is at the heart of good journalism; the more accurate the reporting, the closer to the truth. So, too, with photojournalism, even though digital technology has now created the potential for greater ambiguity when it comes to photographic fact versus fiction. For the truth-seeking, socially motivated "concerned photographer," fact-finding has always driven the pursuit of "the decisive moment"—what Cartier-Bresson long ago described as happenstance turning into visual logic before the lens. *Things as They Are* is a record of decisive moments that underscore not only the history of the last half-century but of photojournalism, too.

Originally published in the *New York Times*, March 26, 2006.

Reflections of New York's Luckiest: *Look* Magazine

In his 1949 essay "Here Is New York," an ode firmly grounded in the city's varied lore, E. B. White concluded the first paragraph, "No one should come to New York unless they are willing to be lucky." Taking inspiration from that canny insight, two curators at the Museum of the City of New York have served up a copious slice of New York's cultural life in the mid-twentieth century.

Currently on view at the museum, *Willing to Be Lucky: Ambitious New Yorkers in the Pages of Look Magazine* presents 130 photographs of artists, dancers, actors, architects, showgirls, boxers, and eccentrics. All of the images have been culled from the Museum of the City of New York's collection.

The curators, Donald Albrecht and Tom Mellins, focused on the way *Look* chronicled New York as "a city populated by outsiders," Mr. Mellins said in an interview, as well as "an incubator of invention, including self-invention."

Mr. Albrecht said that "people who didn't fit in anywhere else could find a home" in New York. And *Look*, whose editorial approach was "more lighthearted, more left-wing," than that of its competitor, *Life*, was willing to portray them, he said.

"*Look* never shied away from the goofy human-interest story," he added. "The flame eater, the knife thrower, the tank diver shared space with accomplished artists like Salvador Dalí or socialites like Gloria Vanderbilt."

One of the standouts turns out to be the photographer rather than the subject: Stanley Kubrick, who was born in the Bronx and sold his first picture to *Look* in 1945, when he was just seventeen: an image of a newsstand with headlines announcing Franklin D. Roosevelt's death. That earned him a job as a staff photographer at *Look*, where he worked for the next five years.

On one assignment he photographed the boxer Walter Cartier (also a Bronx native), who played a crucial role in Mr. Kubrick's shift to filmmaking. Cartier became the subject of Kubrick's first movie, a sixteen-minute 1951 newsreel, *Day of the Fight* (and soon gave up boxing for acting).

With his series on boxers and showgirls, Kubrick emerges as the dark heart of the show, Mr. Mellins said.

The magazine established a day-in-the-life approach to its profiles, following people as they went about their daily activities. Kubrick's day of the boxer Rocky Graziano is presented with strips of negatives, sprockets and all, blown up and mounted on the wall. Those pictures depict Graziano's movement through time in a cinematic style that presages the work of the future filmmaker.

In one picture Kubrick himself is reflected in a mirror while photographing a showgirl

putting on her makeup. The intensity with which he looks at her is contradicted by the nonchalant way he holds the camera away from his face.

The two hundred thousand photographs in the museum's *Look* magazine collection were acquired through the efforts of Grace Mayer, who was curator of prints from 1932 to 1959, before she went to work for the Museum of Modern Art.

The magazine gave the Museum of the City of New York the negatives, contact sheets, and small prints from all of its New York assignments from 1938 to 1964. The magazine folded in 1971, and the bulk of its five million images are in the archive at the Library of Congress in Washington.

The curators of the current show combed through the well-catalogued assignment notebooks for images reflecting their central idea. While the show focuses on figures and places that were on their way to becoming legends, Mr. Mellins said, the photographs have an edge; the curators did not intend to cast a nostalgic gloss on the past.

"There is a flip side to being lucky, and that is a tolerance for being unlucky," he said. "That too gets to something about the city—resilience. There is a story here about that as well—coping."

Still, many of the subjects in the show had a leg up by the time they were photographed. In a shot from 1950 the producer Mike Todd appears on his spacious terrace overlooking the city, smoking a cigarette while talking on the phone, the front page of *Variety* in the foreground. Born Avrom Hirsch Goldbogen in Minneapolis, he was a high school dropout who worked at plenty of odd jobs in New York before producing *The Hot Mikado* at the 1939 World's Fair. That propelled him to a career as a Broadway producer, although he may have been most famous for being Elizabeth Taylor's third husband.

The magazine followed seventeen-year-old Gloria Vanderbilt as she prepared her wardrobe for her 1941 wedding to the Hollywood agent Pasquale DiCicco. One picture shows her at a fitting with a retinue of fashion designers behind her. Hands on hips, she looks quizzically into the mirror. Although the intimacy of the picture gives the impression of an authentic moment, people outside the frame have, as always, carefully set up the shot: a hallmark of feature photography of the era.

Look started out as a tabloid publication but shifted focus after World War II to become a pictorial magazine for the whole family. Its coverage ranged beyond celebrity profiles to cultural events and to social and political issues like the Vietnam War.

During the 1950s *Look* documented the transformation of Park Avenue between Grand Central Terminal and 57th Street from a residential thoroughfare to a canyon of modern glass-and-steel office towers. In a 1957 picture by Arthur Rothstein seven architects stand before their models, lined up as if they were the personification of the buildings themselves, which included Lever House, the creation of Gordon Bunshaft.

The exhibition makes the point that magazine editors, art directors, and photographers

have long collaborated with their subjects to orchestrate images that advanced careers. It is much the same in New York today, especially the bleak reality that a willingness to be lucky doesn't always mean you win.

Originally published in the *New York Times*, December 26, 2006.

Reading Newspaper Pictures: A Thousand Words, and Then Some

Once, in conversation with a veteran newsroom colleague, I argued a case for using a particular picture solely on its visual merits: it is droll, well-composed, and speaks volumes about the class divide. "Just look at the gulf between the dowager and the waiter constructed by the stone walk," I said. "And the relationship of her upside-down top hat to the tray tucked neatly under the waiter's arm." My colleague wasn't convinced, and he humored me with this thought: "A picture may not be worth a thousand words, but a picture and a good caption are worth a thousand and ten." Meaning that the visual information in the picture had little or no relevance until a caption writer underscored it with an explanation—in the case of this image by Carrie Boretz for the *New York Times* (page 113): "The Women's Committee and the Board of Trustees of the Central Park Conservancy held their 11th annual Frederick Law Olmstead Awards Luncheon in the Conservancy garden at 104th Street in Central Park, New York City." As I pondered the epigrammatic wisdom of my colleague's comment, it became clear to me that, for him and so many other newsroom editors, a picture only comes to life once it is substantiated with the relevant editorial facts. It was the first time I realized that, far from being a question of taste, this is a matter of simple sensory mistrust.

Many people approach the act of looking at photographs with an inherent blind spot. They need to know what it is before they can appreciate how it looks. I have observed in more than a few colleagues that looking at photographs is not an immediately visceral experience, but a cerebral process through which a picture registers first as a jumble of words that sifts through the filter of their brains before they can see what they're looking at. For these individuals, the process of looking at photographs is once removed, something akin to a second language.

For many newsroom editors, the written word is the primary language; the photograph is a foreign tongue, and thus subject to interpretation—and so the greater the potential for inaccuracy. In the newsroom, then, pictures are considered a less reliable source of credible editorial information. As a picture editor, I experience this hierarchy of words and images as a form of prejudice, and in the face of it I resort to quoting Oscar Wilde: "It is only the shallow people who do not judge by appearances."

Every picture carries the burden of its context: a newspaper picture provides information; an advertising image sells a product; a photograph on a gallery wall affords contemplation. The context is the language in which the picture needs to be read.

As I make my daily picture selections for the *New York Times*, I am confronted regularly with this conundrum: the *best photograph*—in terms of composition, narrative, metaphor, tone, and so on—is not always the right choice. In choosing pictures for the newspaper, the

first consideration must be whether and how the picture addresses those essential questions of journalism: *who, what, where, when, and why*. At the same time, I look for pictures that serve two objectives: *what it's about* and *how it looks*. When these two elements come together—a perfect marriage of content and form—then an unusual thing has taken place and my job, for the time being, is done. Of course, this does not happen every day.

There is no greater mystery than the truth revealed: the more direct a statement, the broader its scope. In language, a sentence in which the subject is laden with adjectives loses its shape and thus its impact. Anyone can write a good sentence or a bad one, and still impart the same information—just as you can take a good picture or a bad picture of the same situation. If we were to parallel sentence syntax with picture composition, the anatomy of either form is simple enough: subject/verb/adverb, etc. The structure of the sentence reveals the writer as much as the structure of the picture reveals the photographer. A writer decides what to say and in what tone of voice, just as the photographer decides where to stand and when to shoot, choices that determine the quality of the image and reveal much about the intelligence of the photographer.

In the end, a picture might record facts, but without structure the facts are there as nothing more than evidence. What I tend to look for is evidence with *observation*.

A picture of a tea set taken by Edward Keating is at once straightforward and poetic. The delicate pieces seem particularly fragile covered with dust. The dust renders the feeling that the set is old, a memento of some kind, a still life taken out of time. As you look closer, though, you realize that *everything* here is covered in dust, the crumpled papers surrounding the tea set as well as the fabric behind it. The pervasive dust suggests ominous possibilities: this artifact of a genteel age might have been left there after a bombing or a fire, who knows how many years ago.

Now read the caption and see how the facts amend that first impression: "A tea set in a Cedar Street apartment in lower Manhattan was still covered with dust from last week's collapse of the World Trade Center buildings. The residents have not yet returned to the apartment."

Again, the context in which a picture is seen determines the expectation about its contents. In this case, the picture was published in the *New York Times* on September 19, 2001, a week after the attacks on the World Trade Center. It was immediately clear to readers of the paper that this picture was related to the September 11 coverage. These facts give the picture greater poignancy, and, to my mind, amplify what is inherently poetic about the image. Because of the visual simplicity, I believe that this picture's iconographic significance will deepen over time.

Here is a sentence describing the scene in another picture: "A man in a suit stands behind the counter at a diner." To the point, like the photograph itself. As you look at this

picture, though, more information surfaces: the man leans forward and talks to the woman facing him. A woman eating lunch at the counter seems perturbed. Layers of visual information begin to tell a deeper tale, and a story comes to life within the frame. On the surface, it's odd that a man in a suit would be standing behind the counter of an old-fashioned diner. The protagonist, his surroundings, the facial expressions of the people at the counter all come together, incongruous though these elements might be. The counter delineates a cushion of space around the protagonist, and also serves as a kind of buttress for the diners. The face of the woman in the foreground pulls an invisible barrier across the frame to the woman with white hair at the other end of the counter, a barrier that the man in the suit seems to push against with his gesture.

At this point, you may or may not recognize the protagonist. When this picture was made, he was not yet the most famous figure in the world. With more information about the circumstances of this photograph, the meaning grows. The caption: "George W. Bush, a candidate for President of the United States, campaigned at a diner in Iowa before the Republican primary." (Photograph by Stephen Crowley, the *New York Times*, January 21, 2000.) So *that's* who it is. That's why he's wearing a suit. No wonder there are other photographers taking his picture. This, as they say, is a *photo-op*.

The picture's handsome architecture puts the information together in a way that constructs a narrative arc. Even stripped of the knowledge that it's Bush on the campaign trail, the picture continues to unfold on a more existential level. The man at the center of attention clearly does not belong there. He has caused the people eating to make faces; they may feel that they're being exploited. That, at least, is my interpretation of this Norman Rockwell–like tableau.

A picture by Chang W. Lee for the *New York Times*, which ran on May 21, 2002, has a much more whimsical subject. There is nothing conventional about the composition; there are no linear cues to direct you from subject to verb, so to speak. It requires imagination to ascertain what exactly is taking place. The bold, red stripes initially draw you in, as does the odd perspective. The man is pointing with an expression on his face not unlike those of the two animals; the animals seem to be responding to what he's doing. On a purely visual level, the stripes seem to be linking the man's actions to the animals' behavior. Striped tent? An animal trainer? It's plainly a circus environment. But, still, what's the man doing? You might never guess: "Carlos Svenson, an animal trainer at the Big Apple Circus, teaches Jasper the horse and Smokey the dog to smile." As a photographic subject, animals always tend to draw an affectionate response, and while this picture of Jasper and Smokey has its own compositional logic and visual charm, it takes on greater meaning when you learn what it is they're doing. The thousand and ten words.

If statecraft is a kind of ballet, then the two world leaders in a picture by Stephen Crowley (*Times*, May 24, 2002) are dancing a pas de deux. We know who they are: President

Vladimir Putin of Russia and President George W. Bush of the United States. The ceremonial nature of this moment is obvious from the gilded surroundings and the flags behind them. Bush and Putin are in perfect lockstep as they take their seats; in fact, they appear virtually interchangeable in mood, dress, and gesture. The editorial point of that day's story was the like-mindedness of the two leaders as they signed an agreement, and the photographer intelligently waited for a moment reflecting that important detail. The published caption read: "President Vladimir V. Putin of Russia and President Bush at the signing ceremony yesterday for a treaty that mandates sharp cuts in nuclear arms." This picture exemplifies a visual phenomenon I describe as the subtext revealed within the *pre-text*—a phenomenon that Crowley is particularly adept at capturing.

Another picture offers a visual one-liner if ever there was one. A cluster of photographers aims at a reluctant subject. That subject turns away to the lone photographer who made this picture, as if to say: "Get me out of this ludicrous situation!" The layers mount as you contemplate the subject, Woody Allen, the deadpan auteur-comedian, in a scene that could have come out of one of his own movies. It's reasonable to conclude that the actual subject of this picture is not Allen, but the media cluster. The caption: "American filmmaker Woody Allen is photographed before the screening of his film 'Hollywood Ending,' which opens the 55th Film Festival at Cannes." (Photograph by Christophe Ena/Associated Press, May 15, 2002.) Life imitating art imitating life: a perfect simulacrum.

A photograph by James Hill, taken for the *New York Times* and published on November 29, 2001, is graphic in its content, strangely geometric in its form (page 112). A battle scene, corpses, figures walking along a bullet-riddled wall. We are not used to looking at dead people; it feels as if we are violating a taboo as we stare at the picture. The cloaked figures in the background have the aura of death surrounding them, walking past the corpses like the march of time as the dead stand still.

This picture is a good example of the intelligence of the photographer being manifest in the frame. Hill chose to level his eye to the ground, rendering the corpses the immediate subject. He shot beyond them, to include the context of the battle scene and the perpetrators themselves. He framed the massacre carefully: as the figures march out of the frame, the balance of the picture shifts to the right, yet the dead man in the foreground remains the anchor; the other body a bridge to the walking figures—a bridge between life and death.

This picture was published twice in the *Times*, once the day after it was taken, and again a month later in a special section called "The Year in Pictures." I mention this because the two captions differed significantly; the information had changed over time, in content but more particularly in context. The first read: "The bodies of Taliban prisoners lay strewn across the inside of the fort at Qala Jangi as troops belonging to the forces of General Abdul Rashid Dostum walked by." The second caption, written after a month during which more information had surfaced: "In a 19th-century fortress in northern Afghanistan, Alliance

fighters spent three furious days in November quelling a rebellion of hundreds of Taliban prisoners, several of whom lie dead here. An early victim of the uprising was CIA officer Johnny Michael Spann, who had been interrogating John Walker Lindh, discovered at the fort as the first known American Taliban fighter."

The first caption reported news; the second caption reported history. Pictures sometimes take on new sets of meaning with time.

More recently, imagery from the war in Iraq saturated the media, but no picture captured the fall of Iraq more poignantly for me than one taken by Tyler Hicks for the *Times*, and published on April 9, 2003 (page 112). While not the signature image of the statue of Saddam Hussein toppled by American soldiers, this picture takes on metaphoric significance: the marble statue of a fallen tyrant upholds the appearance of normalcy, despite the ravages of war that surround it. Destruction here is amorphous: smoke and flames merge into an unarticulated field of pure color against which the rigid outline of a once-powerful leader stands—hollow-white, in contrast—its demise implicitly anticipated. "A statue of Saddam Hussein stands in front of the National Olympic Committee building as it burns from a U.S. military attack in Baghdad, Iraq."

The difference between art and journalism begins with intention. Art derives from a contemplation of ideas, while journalism reports on facts and events. When a fact is reported (or photographed) in such a way that it becomes an observation as well, it takes on meaning beyond the burden of proof. The fact becomes, then, something witnessed, something experienced. Defined. These pictures were taken for editorial purposes, each as a record of a moment or an event. Each tells a story in a self-contained narrative that observes the evidence, and renders the experience of that observation our own.

Originally published in *Aperture* magazine, Winter 2003.

Cornell Capa, Photojournalist and Museum Founder, Dies at Ninety

Cornell Capa, who founded the International Center of Photography in New York after a long and distinguished career as a photojournalist, first on the staff of *Life* magazine and then as a member of Magnum Photos, died on Friday at his home in Manhattan. He was ninety.

His death was announced by Phyllis Levine, communications director at the International Center of Photography in Manhattan.

Mr. Capa had three important incarnations in the field of photography: successful photojournalist; champion of Robert Capa, his older brother, among the greatest war photographers; and founder and first director of the International Center of Photography, which, since it was established in 1974, has become one of the most influential photographic institutions for exhibition, collection, and education in the world.

In Mr. Capa's nearly thirty years as a photojournalist, the professional code to which he steadfastly adhered is best summed up by the title of his 1968 book, *The Concerned Photographer*. He used the phrase often to describe any photographer who was passionately dedicated to doing work that contributed to the understanding and well-being of humanity and who produced "images in which genuine human feeling predominates over commercial cynicism or disinterested formalism," he said.

The subjects of greatest interest to Mr. Capa as a photographer were politics and social justice. He covered both presidential campaigns of Adlai Stevenson in the 1950s and also became good friends with him. He covered John F. Kennedy's successful presidential run in 1960, and then spearheaded a project in which he and nine fellow Magnum photographers documented the president's first hundred days, resulting in the book *Let Us Begin: The First One Hundred Days of the Kennedy Administration*. (He got to know the Kennedys well; Jacqueline Kennedy Onassis would become one of the first trustees of the International Center of Photography.)

In Argentina Mr. Capa documented the increasingly repressive tactics of the Perón regime and then the revolution that overthrew it. In Israel he covered the Six-Day War. The vast number of picture essays he produced on assignment ranged in subject from Christian missionaries in the jungles of Latin America to the Russian Orthodox Church in cold war Soviet Russia, the elite Queen's Guards in England, and the education of mentally retarded children in New England.

His work conformed to all the visual hallmarks of *Life* magazine photography: clear subject matter, strong composition, bold graphic effect, and at times even a touch of wit. In his 1959 essay about the Ford Motor Company, for example, one picture presents a bird's-eye view of seven thousand engineers lined up in rows behind the first compact car, which all of them were involved in developing: a single Ford Falcon.

"I am not an artist, and I never intended to be one," Mr. Capa wrote in *Cornell Capa: Photographs*, his 1992 book. "I hope I have made some good photographs, but what I really hope is that I have done some good photo stories with memorable images that make a point, and, perhaps, even make a difference."

It was because of Robert Capa that Cornell became a photographer. He was Cornell's mentor, along with Henri Cartier-Bresson and David Seymour, and on his coattails Cornell Capa first became affiliated with *Life* magazine. In 1947, Cornell Capa's three mentors founded Magnum Photos, which he would join after Robert was killed on assignment in Indochina in 1954.

"From that day," Mr. Capa said about his brother's death, "I was haunted by the question of what happens to the work a photographer leaves behind, by how to make the work stay alive."

The International Center of Photography was born twenty years later, in part out of Mr. Capa's professed growing anxiety in the late 1960s about the diminishing relevance of photojournalism in light of the increasing presence of film footage on television news. But for years he had also imagined a public resource in which to preserve the archives and negatives of "concerned photographers" everywhere. In this regard, his older brother's legacy was paramount in his thoughts when he opened the center, where Robert Capa's archives reside to this day.

Born Cornel (with a single *l*; he later added a second) Friedmann on April 10, 1918, in Budapest, he was the youngest son of Dezso and Julia Berkovits Friedmann, who were assimilated, nonpracticing Jews. His parents owned a prosperous dressmaking salon, where his father was the head tailor. In 1931 his brother Robert, at seventeen, was forced to leave the country because of leftist student activities. In 1935 his eldest brother, Laszlo, died of rheumatic fever.

Cornell initially planned to be a doctor, joining Robert in Paris in 1936 to start medical studies. But first he had to learn French. Robert, who had become a photojournalist in Berlin before settling in Paris, had befriended two other young photographers, Cartier-Bresson and Seymour. To support himself, Cornell developed film for the three and made their prints in a makeshift darkroom in his hotel bathroom. Soon he abandoned plans to be a doctor. He also adopted his brother's new last name, a homage, in variation, to the film director Frank Capra.

In 1937 Mr. Capa followed his mother to New York City, where she had joined her four sisters. When Robert came for a visit and established connections with Pix Inc., a photography agency, he helped get Cornell a job there as a printer. Soon after, Cornell Capa went to work in the *Life* magazine darkroom.

In 1940, Mr. Capa married Edith Schwartz, who assumed an active role in his professional life, maintaining his negatives and archives, and also those of his brother. They had

no children, but she provided a home away from home for hundreds of the photographers they came to know. Mr. Capa wrote that Mrs. Capa, who died in 2001, "deserves so much of the credit for whatever I have accomplished."

After serving in the Photo Intelligence Unit of the United States Army Air Forces during World War II, Mr. Capa was hired by *Life* magazine in 1946 as a junior photographer.

"One thing *Life* and I agreed on right from the start was that one war photographer was enough for my family," he wrote. "I was to be a photographer for peace."

The historian Richard Whelan wrote in the introduction to *Cornell Capa: Photographs* that Mr. Capa "often quoted the words of the photographer Lewis Hine: 'There are two things I wanted to do. I wanted to show the things that needed to be corrected. And I wanted to show the things that needed to be appreciated.'" That is what Mr. Capa dedicated his life to doing.

Originally published in the *New York Times*, May 24, 2008.

The Portrait

It is easy to think of the legacy of portraiture in photography as a visual pantheon that extends back in time to Nadar's refined artists and writers in nineteenth-century France, Julia Margaret Cameron's romanticized poets and thinkers in nineteenth-century England, Berenice Abbott's stalwart expatriate circle of artists and writers in 1920s Paris, and August Sander's typological portraits of professionals at every level of German society in the early twentieth century. In the 1930s and '40s Edward Steichen, Cecil Beaton, and Horst P. Horst all made highly stylized magazine portraits of their accomplished contemporaries, often fashionably dressed and glamorously posed in context of elegant accoutrements.

As satisfying as it is to discover what Sarah Bernhardt looked like, or Charles Darwin, or Coco Chanel, the conundrum we are left to ponder about the nature of portraiture is whether the portrait is one of the subject or, in fact, a portrait of the photographer.

John Singer Sargent's bravura portraits of society figures of the late nineteenth century exemplify the genre in painting—lifelike representation of the individual, details that depict a class and an era, accomplished brushwork, daunting spontaneity. But when looking at the infamous Madame X, you wouldn't say, "Oh, what a risqué portrait of Virginie Gautreau"; rather, you respond to the "exquisite Sargent."

Andy Warhol's multiples of Marilyn, Jackie, and Liz depict the first-name basis female icons of mid-twentieth-century American culture, but haven't these photo-based portraits become, over time, Warhols first?

The history of portraiture in photography is written on accomplished subjects, but Diane Arbus changed that in the 1960s. She photographed individuals who were in no way established by society's standards; in some cases, she photographed the affluent as if they were outsiders. While her portraits are intimate and emotionally layered, her subjects are often considered bizarre, as with *A Young Man in Curlers at Home on West 20th Street, N.Y.C.*, 1966 (page 89). But, again, the question is whether that bizarre quality derives from Arbus's subjects, or whether it is a characteristic of the way she photographed them.

Richard Avedon transformed the portrait altogether in the 1960s by distilling the frame to nothing but the subject. The confrontational effect between subject and viewer is the result of Avedon's intention to remove any trace of the camera between subject and photographer, exemplified in his portraits of Robert Frank (page 94) and John Szarkowski (page 94). His life-sized, wall-length, head-to-toe group portrait of Andy Warhol with members of The Factory (page 96), taken in 1969, was a pivotal moment in portraiture, not least because of its confrontational size, but also because of its matter-of-fact nudity.

Robert Mapplethorpe experimented with the Polaroid camera in the early 1970s and made

a series of modest and poetic portraits of his friends, some of whom, like Patti Smith (page 101) or Sam Wagstaff (page 101), would later become notable for their own accomplishments. Mapplethorpe would go on to make formal portraits of his famous and infamous friends that have more in common in gesture, attitude, and drama with Horst P. Horst than with the spare descriptive clarity of Avedon; still, comparisons are drawn between Mapplethorpe's portraits and flower studies, and between his flower studies and his erotic nudes.

Peter Hujar, also working in the 1970s, made portraits of his demimonde circle of friends, including Candy Darling (page 98) and Susan Sontag (page 98) who were already well known in the world at large. Hujar studied with both Arbus and Avedon, and their influence is evident in equal measure in his emotionally intimate—and sometimes playful—visually formal portraits. Like Mapplethorpe, Hujar made nude figure study portraits, typified by his image of a man contemplating his erection (page 99).

In the 1980s, Thomas Ruff presented a series of wall-sized head shots, taken in the utilitarian style of the I.D. photo used for passports and driver's licenses. The faces are blank, emotionless, and the body of work addresses the typological nature of the portrait itself, as well as the anonymity of the individual.

Cindy Sherman's Untitled Film Stills, first shown in 1981, are an exercise in self-portraiture as much as a conceptual exploration of representation and identity. The images replicate the look of movie stills of the 1950s and 1960s, and Ms. Sherman appears in each one dressed to emulate a generic actress in a leading role. While playful in their staging, they represent the circumscribed range of female archetypes presented to Ms. Sherman's generation, and from which she was able to model an identity of her own.

Jack Pierson added another conceptual layer to the portrait/self-portrait dichotomy in his 2003 series, Self Portrait, in which a selection of his portraits of friends and acquaintances are intended to compose the artist's identity. The question of the photographic portrait as a portrait of the artist is brought full circle here.

The veneer of artifice in Katy Grannan's portraits reflects a twenty-first-century collective self-consciousness about representation. Her subjects, like Arbus's, are strangers to her, found by placing classified advertisements for models. The photographic sessions are collaborative; she encourages her models/subjects to determine the context and the manner in which they want to be photographed. The staginess of Grannan's portraits underscores her subjects' active participation in how they are represented, as well as her own understanding about the loss of innocence, or spontaneity, in the photographic portrait.

The trajectory of portraiture in the last half century begins with the authentic representation of the individual, and proceeds toward calculated artifice, reflecting the growing self-consciousness we, as a species, seem to manifest about pervasive media scrutiny, abstraction, and misrepresentation in an image-saturated world.

Defining Beauty Through Avedon

Richard Avedon honored women. For nearly half a century, taking photographs for the top two fashion magazines in the world, *Harper's Bazaar* and *Vogue*, women were the subject and the target of his insistent, yet sympathetic gaze. From the models in his fashion tableaux to his later, unembellished portraits of artists, writers, intellectuals, socialites, and hardscrabble workers in the American West, his regard for the fully realized individual remained constant.

At first, Avedon practiced taking fashion pictures of his beautiful younger sister, Louise, and throughout *Woman in the Mirror* (Abrams), a new collection of Avedon's pictures, that respectful posture turns all women into the potential sister—an undeniably beautiful, but deeply kindred spirit. There is an erotic component to some of these pictures, but he seems less concerned with men's arousal than with the subtle cues women take from one another, a view that places sexuality in a larger constellation of human qualities.

After being discovered by Alexey Brodovitch, the art director of *Harper's Bazaar*, Avedon began taking photographs for the magazine in 1947, the year Dior introduced the New Look and just two years before Simone de Beauvoir's *Second Sex* was published. The New Look was modernity incarnate and the sculptural lines and cosmopolitan flourishes were perfect for Avedon, who seized upon it to make cinematic images in which the models inhabited the clothes like characters in a movie. And, as if Simone de Beauvoir were looking over his shoulder, Avedon's photography animated women with spirit and determination.

Through Avedon's eyes, female beauty is not viewed with distrust, as a collection of wiles and veils that can manipulate, obfuscate, or seduce. In one photograph, the model Liz Pringle stands effortlessly poised in a boat, with the manner of an heiress in a breezy movie from the 1950s. She holds a cigarette and looks our way with the sly grin of a secret shared, as if we are among her closest friends. You know the picture is all about the clothes, but the soignée sophistication of the scene is what draws you in.

He had many muses, among them Dovima, whose name alone conjures an exotic creature of myth. (In fact, Dorothy Virginia Margaret Juba created her name from the first two letters of each of her given names.) In one Avedon picture, she wears a dress by Jacques Fath, and it appears as something sacred and ceremonial, Dovima assuming the stature of a pageant queen.

His photograph of Penelope Tree is as much a portrait of the real society girl as it is a model wearing the latest fashion. The pants suit was a new concept at the time, the bell bottom an emerging style; his picture is playful and free-spirited, and she strikes a Pippi Longstocking note—unconventional but all grown up, cosmopolitan and top-of-the-moment, out in the world on her own terms.

And his portrait of the writer Renata Adler is stripped of decoration, leaving the anatomy of her face, the intransigence of her posture and the gravity of her braid to represent a modern-day Athena, goddess of the intellect, taking our measure as much as we take hers.

"Dick had a very particular taste for what he thought was a beautiful woman," said Norma Stevens, executive director of the Richard Avedon Foundation. Paging through the book in her New York office, she stopped at a portrait of a seemingly downtrodden young woman from his series In the American West. "To him, Debbie McClendon's fragility and tenderness resembled a Botticelli."

Movie history has permanently married Richard Avedon to Audrey Hepburn thanks to *Funny Face*, starring Fred Astaire as the fashion photographer Dick Avery, who is based on Avedon. In the book, *Richard Avedon: Made in France*, Judith Thurman writes that *Funny Face* is an artifact of a remote, lost civilization. Three of its purest pleasures have not dated: Hepburn's face, Givenchy's couture, and Astaire's dancing—all pertinent, the dancing, in particular, to Avedon's work.

She equates Astaire's buoyancy to Avedon's pictures, the classical discipline with which the dancer, like the photographer, made the artificial and rehearsed seem effervescent and spontaneous.

Avedon distilled a variety of elements into a simple and distinct visual signature: the element of surprise, for example, in his most famous picture of Dovima with the elephants at the Cirque d'Hiver in Paris, the large, bulbous creatures forming a backdrop of unharnessed animal instinct against which the elegance of high fashion stands in dramatic relief. Or glamour in his picture of Sunny Harnett, the top model in her day, at a posh European casino; he made her shimmer like a Hitchcock blonde in a Madame Grès dress. Or wit in his picture of Carmen stepping off the ground, as if by wearing a Pierre Cardin coat you, too, could be walking on air.

He played a stunning hand with visual onomatopoeia as well: his portrait of Katharine Hepburn with her mouth opened elicits the very sound of her distinctive accent; his portrait of Louise Nevelson, with her heavy eyeliner and sculptural jewelry, turns her into one of her own works of art; and his portrait of Marella Agnelli, in which her elongated neck conjures Modigliani, her entire form as graceful as a Brancusi.

Despite decades of imitators, Avedon has proved inimitable. His curiosity fueled his imagination. He anticipated the tone of each era with a sophistication that was precision-cut in the stratosphere of art, fashion, and culture at which he so naturally, and tenaciously, hovered. He never stopped experimenting with the photographic image and, always, his pictures reflect a regard for women that was truly debonair.

Originally published in the *New York Times*, September 18, 2005.

Self-portrait as Obscure Object of Desire *On Jack Pierson*

A new book of photographs by Jack Pierson features fifteen images of beautiful men, arranged to suggest the arc of a lifetime—beginning with a young boy and progressing to old age with men in various stages of undress. There's nothing surprising about that; Mr. Pierson has been photographing beautiful naked men for years. In this case, though, the photographs are offered under the title *Self Portrait*. But none of the images is of the artist himself.

Mr. Pierson has fashioned an autobiography from a collection of images of unidentified men. His photographs affect the casual look of a vacation snapshot, one you might expect to find clipped to a page of a personal diary. Often there is an implicit, offhand eroticism to his pictures of men, as if something sexual is in the cards, or might have just taken place.

While there is a canny intimacy to these new pictures, languorously attuned to the temporal glamour of ordinary moments, the subject of this self-portrait series is desire—when it begins, how long it lasts, what it tells us about ourselves or, at least, about the artist.

Mr. Pierson is part of a group of photographers known as the Boston School—David Armstrong, Philip-Lorca diCorcia, Nan Goldin, and Mark Morrisroe, among others. All of them knew one another in the early 1980s and photographed their immediate circle of friends in situations that were, or appeared to be, casual or intimate. Mr. Pierson was often the subject of Mr. Morrisroe's photographs, and the object of Mr. Morrisroe's desire. The photographs in this self-portrait series take their cue from the template of pictures of the artist taken twenty years ago. In an attempt to establish a mythology of self, Mr. Pierson is presenting new photographs of other men in the manner of his own portrait, claiming their appearance to represent his own identity. The book is published by the Cheim & Read gallery in Chelsea, where an exhibition, *Jack Pierson*, features other works of his.

Self Portrait is the flip side of what Cindy Sherman accomplished in her series Untitled Film Stills. Dressing up to enact a wide variety of female archetypes, Ms. Sherman photographed herself in fictional scenes alluding to Hollywood films. That body of work expresses an idea about the way identity is formed by the cultural forces all around us; yet, despite Ms. Sherman's insistence that her "film stills" are not self-portraits, the series flirts with the very idea of identity and self-portraiture. Mr. Pierson, by eliminating his own likeness from his *Self Portrait*, comments on the same postmodern idea about the cultural construction of the individual, but in this case the work suggests that assumed identities both define and obscure the individual in society.

The idea of the constructed identity is nothing new. In an age of cosmetic surgery and online communication, it's easy to customize our appearance or hide behind an invented persona. How often do we look at a picture in a magazine and imagine ourselves with that

haircut, in those sunglasses, on that beach? No matter how strong our own sense of who we are, the lust for some idealized version of ourselves is invariably summoned in the barrage of images endlessly flashing before us. Mr. Pierson's self-portrait series attests to this, underscoring at its core his own erotic impulse to be as desirable as those he desires, to become the very object of his own attraction.

In naming his pictures of others *Self Portrait*, Mr. Pierson also owes a nod to the Dada legacy of provocation. The catalog of *The First Papers of Surrealism*, a 1942 group exhibition in New York organized by Marcel Duchamp and André Breton, used the self-portrait as a symbolic equivalent in photographs and drawings of completely unrelated or unknown people. Titled with the names of the participating artists, these ready-made portraits, or found faces, took on new meaning in place of other expected identities.

In an essay for a show of portraits at PaceWildenstein gallery in 1976, Kirk Varnedoe wrote, "If, in the extremes of modern portraiture, the artist sees the other almost wholly as himself, so in the self-portrait he often sees himself as somebody, or something, irrevocably 'other.'"

Portraiture has always revealed as much about the artist as the subject. If you think about the difference between portraits by Richard Avedon and Robert Mapplethorpe, each photographer has a signature style. Remove the names of their subjects and you're left with a collection of portraits that become as much a self-portrait as the artist's own likeness. In effect, Mr. Pierson has taken that idea one step further by omitting the names of his subjects, assuming their identities, and calling his collection *Self Portrait*.

Picasso, unsatisfied with the face of his portrait of Gertrude Stein after eighty sittings, painted one based on a mask of an Iberian sculpture. When people protested that the portrait did not resemble the subject, he is said to have commented: "Everybody thinks she is not at all like her portrait, but never mind. In the end, she will manage to look just like it."

Originally published in the *New York Times*, December 18, 2003.

Is That Portrait Staring at Me? *On Fiona Tan*

Standing face to face with prisoners might be a threatening prospect, but that didn't stop Fiona Tan, a film and video artist, from seeking more than three hundred felons to pose for her.

First she had to persuade various Departments of Corrections to sign on to her project. It took three months of pleading correspondence, in which she relied only on her credentials as an internationally exhibited artist. One prison in California and three in Illinois finally relented, and Ms. Tan was escorted to the dormitories, dayrooms, and workshops where she recruited her subjects last summer for the video portraits in *Correction*, now on exhibit at the New Museum in New York.

One female inmate agreed to participate upon learning the work would be shown in Chicago. "That's great," Ms. Tan said the inmate told her. "My mom lives there so she can come and see me!"

Ms. Tan, who lives in the Netherlands, conceived the idea for the piece after reading an article in *NRC Handelsblad*, a national daily newspaper there, comparing the American prison population with others around the world. "While in the late 1960s the population of inmates in American prisons numbered close to two hundred thousand, the number now exceeds 2.2 million," she wrote in a statement for the exhibition catalog. *Correction* was commissioned by the Museum of Contemporary Art in Chicago as part of a collaborative program with the New Museum and the Hammer Museum in Los Angeles.

In Ms. Tan's video portraits, the inmates and guards are stationary, taking our measure as much as we're taking theirs. She posed her subjects as still as possible during the taping sessions, and they stand head-on, staring directly into the camera, centered within the frame. They are displayed on six flat-panel video screens, for twenty to fifty seconds each; three hundred inmates and prison guards appear over the course of three hours. Movement is almost imperceptible as you watch—you're never quite sure you just saw the blink of an eye or the twitch of a muscle.

The screens hang in a circle, with benches for the viewer in the center. The circular configuration is a deliberate reference to the Panopticon, a spherical prison plan designed by the utopian philosopher Jeremy Bentham in the late eighteenth century as a way to centralize the surveillance of prisoners. (Though the Panopticon was never built, it has lived on as a symbol of ubiquitous Big Brotheresque surveillance.) Each portrait can be viewed in mirror image on both sides of the screen—inside or outside the circle. Recordings of actual sounds heard in prisons—ventilation fans, human voices, slamming doors—play on speakers in the room.

The relationship of subject to viewer is central to Ms. Tan's work, and the title *Cor-*

rection applies as much to the viewer's experience as to the subject's: while inmates are in prison to "correct" their behavior, the portraits may alter viewers' preconceptions as well. The viewer participates in a kind of stare-down with the subjects. This type of extended eye contact with strangers incites primitive transgressive feelings: it's a dare; it's a threat; it's erotic.

Time is one of the keys to *Correction*: the idea of "doing time" in prison is emphasized by the video portrait format. The subjects are standing still, but since time is passing in the portrait, the subjects are trapped in their poses, trapped in the frame. Francesco Bonami, senior curator at the Museum of Contemporary Art, said of the work: "Time passes, but it never passes. Time is wasted; time is neverending." In an earlier project, *Facing Forward*, Ms. Tan explored the ways white colonials had viewed natives of Papua New Guinea. The piece was based on archival film material from an early-twentieth-century expedition in which groups of locals were asked to stand still before the film camera, as if the filmmakers weren't aware that people could be filmed in motion.

"I am interested in the twilight zone between film and photography, the gray area," Ms. Tan said in a recent telephone interview. The documentary film from Papua New Guinea provides a revealing parallel to nineteenth-century photographic portraiture: technologies like the daguerreotype required the subject to maintain a perfectly still pose for the duration of an exposure, which could take up to a minute. While today's portraits can be taken in fractions of a second, the idea of holding a pose for the video camera over time brings us full circle.

In her last project, *Countenance*, shown at Documenta 11 in Kassel, Germany, in 2002, Ms. Tan presented two hundred filmed portraits of residents of Berlin. She was inspired by August Sander's magnum opus, People of the Twentieth Century, an exhaustive photographic catalog of archetypes of German society between the 1920s and the 1940s. Sander's societal categories ("The Farmer," "The Woman") seemed archaic to Ms. Tan, because of his male-centric choices and the professions that have emerged since then. Her portraits included female bakers, single fathers with children, and media professionals, filmed the same way Sander photographed his subjects—positioned head-on, staring at the camera, centered in the frame.

Moving images almost always cross horizontal planes, so Ms. Tan's decision to rotate the frame vertically underscores the photographic foundation of her video portraits. "I don't consider myself a photographer," she said, "but I consider photography to be at the base of my work." To arrive at a format for the standing portraits in *Correction*, she filmed photographs out of the pages of a photography book and projected them on the walls of her studio to see what the proportion would be like.

Ms. Tan is not alone in using film and video to explore the conventions of still photography. In recent video portraits by the photographer Thomas Struth, each subject posed

perfectly still for an hour before Mr. Struth's video camera, head and shoulders framed in square format. Evidence of time passing is visible only in strands of hair that flutter in the breeze, or in the light as it changes at the end of a day. Another photographer, Rineke Dijkstra, took portraits of teenagers in a rock club in Liverpool that present the same subject in split-screen still and video images.

"A filmed photograph stretches time, and in those often uncomfortable moments a lot happens," Ms. Tan said. "The viewer can see the embarrassment, the bewilderment and anger, or the curiosity and shyness due to the confrontation with the camera."

Photography and video both reflect the world as it looks to us, but when it comes to the way we experience the results, the two are different species. A photographic portrait captures a moment in time, and our response to it is shaded by the amount of time passed since it was taken. A video portrait records the passing of time, engaging us in an active, perpetual here and now. Ms. Tan's work insistently blurs that line—and, in the process, sharpens it.

Originally published in the *New York Times*, April 10, 2005.

A Pantheon of Arts and Letters in Light and Shadow *On Irving Penn*

Irving Penn photographed so many prominent cultural figures of the twentieth century that, over the years, he came to be regarded as an equal among them. But his stature grew not just because of his venerated subjects—he advanced the genre of portraiture. His formal rigor, graphic daring, and studied simplicity brought the portrait to a new level of representation. The rich, mottled tones with which he crafted his portraits are less about creating mood than about rendering pure physicality. With bold, contrasting light, he cast his accomplished subjects in nothing less than monumental terms—as if each one is chiseled, for the ages, in stone.

The ninety-year-old photographer has been actively securing his own legacy in recent years, methodically placing bodies of his work in several important museum collections. In 2002, he donated eighty-five one-of-a-kind platinum prints to the National Gallery in Washington, D.C., and the museum subsequently exhibited the work in a large show, *Irving Penn: Platinum Prints*, in 2005. Earlier this month, the Getty Museum in Los Angeles announced their acquisition of 250 Penn prints from his blue-collar series of portraits called The Small Trades. The museum purchased 125 of the prints, and Penn donated the rest. The same arrangement was made with the Morgan Library and Museum in New York last year; Penn donated thirty-five portraits, and they purchased an additional thirty-two for their collection, currently on display in the museum's inaugural exhibition of photographs.

It's fitting that the Morgan, known as a preserve for the very best of the humanities, would choose Penn's visual pantheon of arts and letters for its first photography show. Some of the greatest writers, artists, and musicians of the last half-century posed for Penn; among those in the Morgan show are W. H. Auden, Francis Bacon, Marcel Duchamp, Carson McCullers, Igor Stravinsky, and Tennessee Williams.

Penn is the natural heir to Cecil Beaton and Edward Steichen, both of whom photographed cultural figures central to the early half of the twentieth century for *Vanity Fair* and other lavish publications of the day. Beaton and Steichen shared an element of theatricality in their portraiture. Each of them constructed for their subjects a public persona out of ambient lighting, elegant clothing, and props—chaise lounges, grand pianos, bouquets of flowers, swank cigarette holders. But while Penn followed in the footsteps of Beaton and Steichen, he established a style all his own. Penn, for the most part, banished the accoutrements. He relied on manner, attitude, and countenance to represent a subject's legacy.

At the beginning of his career, Penn would not have gained access to such a significant group of artists and writers without his affiliation to *Vogue*. Alexander Liberman hired Penn to work for *Vogue* in 1943, initially as an art director. Within a year, however, Penn

had published his first cover photograph for the magazine, and his career as a photographer was launched.

Penn made a portrait of Jean Cocteau during a 1948 trip to Paris for *Vogue*. Each thread of Cocteau's tie, vest, and suit is etched in light and shadow; the patterns and the texture pop out in vivid, tactile detail. The drape of his coat over an extended arm adds drama and balance to the composition. Cocteau is dressed in the sartorial attire of a dandy, which, by all accounts, he was. There is an air of flamboyance about him, until you look at his face. His dead-serious expression registers the fierce intelligence of a keen observer, as if he is taking our measure while deigning to allow us to take his.

Penn believed that the portraitist must appear as a servant to the sitter, nurturing and encouraging the sitter's self-revelation. At the same time, he once told a reporter that while many photographers consider the subject to be the client, "my client is the woman in Kansas who reads *Vogue*. I'm trying to intrigue, stimulate, feed her. My responsibility is to the reader. The severe portrait that is not the greatest joy in the world to the subject may be enormously interesting to the reader."

One of his severest portraits was of French novelist Colette, whom he shot in her apartment in Paris in 1951. Her third husband, Maurice Goudeket, wrote in his 1956 memoir that Colette "had an astonishing and revelatory forehead. She knew it and never agreed to show it." Goudeket was shocked when he saw Penn's portrait of her in *Vogue*. "Her forehead was almost entirely open to view. It was huge, meaningful, touched with genius. It was a startling image, but it was also an act of treachery, an intrusion upon her inmost being. It laid bare all that Colette liked to conceal—and doubtless something about herself of which not even she was aware."

Back in New York that same year, Mr. Penn devised a backdrop for portraits in his downtown studio by placing two tall stage flats together to create a narrow corner in which to photograph his subjects. Penn invented the corner, he has said, because he felt unequal to his famed subjects. Perhaps the novel backdrop had associations to his youth, when students were made to stand in a corner as punishment for misbehaving in class. Whatever the inspiration, it was clearly designed to give the photographer the upper hand during these sittings.

It's easy to imagine that Penn's subjects might have felt backed into that corner and thrown off guard. Truman Capote, for example, hardly the shrinking violet, wrapped himself in his coat and stood on a chair—cloaked, beseeching, trapped. Georgia O'Keeffe was uncomfortable in the corner. She later felt that Penn's portrait diminished her in the space, and she hated it. She asked him to destroy it. He refused.

Surprisingly, given the artistic accomplishments of the people he photographed, Penn wasn't one to study the work of his subjects before he shot them. Responding to a question sent in an email about how he prepared for his sittings, he wrote: "A knowledge of

a sitter's artistic accomplishments generally contributed flavor to the sitting but was not absolutely necessary." Nor did he offer his sitters much in the way of instruction. Penn was not known to direct people or to make small talk, though he once admitted to asking his sitters on occasion: "What does it feel like to realize that this eye looking at you is the eye of 1.2 million people?"

In a published description of his 1957 session with Picasso in Cannes, France, Mr. Penn said he considered the artist "a great presence, deeply aware of his own image, he peered silently at the reflection of his head in the camera's lens, occasionally altering the attitude." Picasso's penetrating eye resides at the center of Mr. Penn's portrait of the artist, elegantly framed between the lines of his hat and coat as the rest of his face recedes in shadow. The frame, divided into sections, bares the geometric abstraction of the artist's Cubist period. That Picasso was scrutinizing his own reflection in the lens of Penn's camera is a delicious detail. We are given a true glimpse of his focused concentration, as if he were indeed peering intently into our eyes.

Of course, for every Picasso there is a Braque, for every Pollock, a de Kooning. Penn, too, was not alone at the top of his profession. Richard Avedon also worked for Mr. Liberman at *Vogue*. The rival photographers vied for pages, position, and subject matter. They even occasionally made portraits of the same people. While the two of them kept upping the ante in terms of imagination, style, and technique, each one succeeded in establishing a distinct visual signature. Avedon distilled the picture frame to nothing but his subject against a white backdrop—wrinkles, bad teeth, and all.

Penn simplified the picture frame, too, but he used light in sculptural terms. Penn's 1983 photograph of Philip Roth recalls Rodin's *The Thinker*, or, even, his majestic *Balzac*. You can study the lines of Roth's face, as if for clues about the syntax of his sentences. The curls in Colette's hair suggest the way her ideas bristle. The bulbous shape of Francis Bacon's face echoes the forms in his paintings. Penn may not have made himself a student of his subjects, but he must have known exactly who his subjects were and the extent of their accomplishments. Their stature is what he always seems to render with an uncanny eye to history—theirs, and, perhaps, his own.

Originally published on Slate.com, February 29, 2008.

A Photographer's Lie *On Annie Leibovitz*

How would you define the alchemy that transforms personal experience into significant art? Take Alfred Stieglitz's photographs of his wife, Georgia O'Keeffe, at their home on Lake George. The pictures levitate with meaning, not because of her fame and accomplishment —although that adds an element of historic weight, but, rather, because of the honesty of the pictures, their intimacy, unadorned and without sentiment. A glimmer of the relationship between subject and artist is captured within the frame, and the moment becomes poetic. The same is true of Harry Callahan's photographs of his wife, Eleanor. Although she was neither well-known nor accomplished, what was shared between the Callahans is evident in the photographs. The enigma compels us to look at his pictures of her.

Emmet Gowin's pictures of his wife, Edith, are at times antic, at times tender, more often than not poetic, as well. His diaristic images capture an intimacy between artist and subject, as if he were documenting in visual terms the honor, desire, and playfulness between them as much as he is rendering his wife as every woman, and his own experience as every man's.

The impulse of a personal diary is to harness what is true, not only about events that actually transpire but, also, what those events impart about life itself. If the subject (or circumstance) is accurately described, and the observer's emotional responses are honestly rendered, then the essential ingredients are in place to realize a particular brand of artistic intention. Proust, by measure of example, turned the record of his personal experience into what is arguably the greatest novel of the twentieth century.

Annie Leibovitz seems to have had a similar ambition. Her book, *A Photographer's Life, 1990–2005* (Random House) is a kind of visual diary that combines her personal photographs of her family—lover, parents, siblings, and children—and her professional portraits. But, in her attempt to integrate the two bodies of work under the umbrella of the personal chronicle, she has succeeded only in creating a marriage of perverse opposition. In effect, this publication is two very different books in one. And because of its coffee-table size and high-production quality, one wonders if commerce dictated the idea of this unlikely merger.

Such fertile content! And, yet, the book fails to achieve the artist's intention to reveal something, uh, well, true, in the existential sense, about her indubitably outsized life. Certainly the book promises to reveal something authentic about Leibovitz's experience, as well as about life in our time, too. Without a doubt you will find glimpses of the truth; however, they appear not because of the artist's efforts but in spite of them.

Starting with Annie Leibovitz's relationship to Susan Sontag, a mythic figure in the intellectual life of the second half of the twentieth century: By all estimates, Annie and

Susan were lovers. They had, by any other name, a lesbian relationship. But, here's how Leibovitz describes their relationship in the book's introduction: Susan Sontag, "who was with me during the years the book encompasses." That's it? Leibovitz's understatement in the essential description of this obviously intense fifteen-year relationship seems to actively deny the emotional connection between them.

Throughout the book, there are pictures of Susan Sontag naked in the bath, Susan Sontag naked in bed, Susan Sontag sitting across the table, lying on the couch, lounging in fancy hotel rooms, taking a walk, riding her bike, sightseeing, hooked up to intravenous tubes in hospital rooms, and, finally, laid out, quite explicitly, dead. The pictures provide irrefutable evidence of the deep experiences the two of them shared. The situations in which Annie Leibovitz photographed Susan Sontag were truly intimate. The pictures are even diaristic insofar as they capture unofficial, unscripted, deeply inner-sanctum moments. Some of them are touching; others are surely not pretty. Still, you almost feel something palpable about what transpired between them.

But, just as the idea emerges that this might be a genuine record of their experience together, you turn the page, and, wham! From the soft-grain, Tri-X, black and white, naturally lighted authenticity in which Ms. Sontag is consistently rendered throughout the book to the high-production, saturated color portraits of Arnold Schwarzenegger on the ski slopes in Sun Valley, or George Bush, Dick Cheney, Condoleezza Rice, Donald Rumsfeld, et al., in the Oval Office. Or Demi Moore, Brad Pitt, and Nicole Kidman in various incarnations of the staged, clever, and unrevealing Annie Leibovitz portrait that has become her trademark.

Interspersed with the intimate pictures of the *übermensch* star of her personal life are commercial pictures that are anything but intimate. The emotional frequency that one expects to carry through in the pictures of Sontag—as well as in the sections with Leibovitz's parents, siblings, and children—is mitigated with, well, commercial breaks. And this brings me to a gnarly observation: the snapshot aesthetic that Leibovitz employs for the documentation of her private life is only afforded the serious look of authenticity in juxtaposition with the celebrity portraits. Take the commercial work away, and what remains are snapshots that lack the artfulness that the simple truth within such moments might have yielded.

"We took care of each other," Leibovitz told a reporter for the *New York Times* about Susan Sontag. "I had great respect and admiration for her, and I wanted to make everything possible for her, whatever she needed. I felt like a person who is taking care of a great monument."

In these pictures, Susan Sontag, the monument, is uncovered, and, at times, in fact, revealed in some very undignified moments. Fine. One would at least expect to glean some essential truth about Sontag from these pictures. But, again, the pictures have the appear-

ance of authenticity without the honest interaction between subject and artist in which emotion is contained and expressed. Leibovitz consistently subjugated her eye to an idea. The idea of Susan Sontag behind the scenes. Again, such fertile soil.

There are repeated grids throughout the book in which a cinematic quality is registered about moments when Sontag is sitting across the table or in the passenger seat of a car, and, as well, with Leibovitz's parents in the kitchen or at the beach. After a while, the motif becomes a conceit, and, finally, an obfuscation. Instead of revealing something, the grids only seem to compensate for Leibovitz having missed the single decisive moment.

As well, in pictures of Leibovitz's parents, siblings, and children, you expect to learn something about the family from which this highly successful commercial photographer emerged, something true about families. Think of Larry Sultan's photographs of his parents in *Pictures from Home*. But her pictures echo the *Life* magazine approach: the situations express something about the people, but the people don't come through as distinct individuals in some relationship with the artist. Her pictures of her family render them stereotypical of "every family." *Life* magazine mastered the "glimpse" into the lives of others while never quite delivering the deeper truths about why we should care. The result was a collective lie about American culture in general that served an all-purpose myth about the value of convention and conformity.

Given the autobiographical nature of Leibovitz's book, the expectation is that her chronicle of the people close to her would yield a level of intimacy that reveals something about human experience—not generically but poetically. But it does not.

One glaring example of the artificial nature of this book is a picture of a very pregnant and naked Demi Moore (used on the cover of *Vanity Fair*) and, also, a picture of a very pregnant and naked (fifty-one-year-old) Leibovitz taken from a similar angle by Sontag. Are we to draw some parallel between the personal and commercial, as if to engage a visual dialogue between Demi Moore pregnant and Annie Leibovitz pregnant? Is this a way to signal across the pages the affinity between subject and artist?

Trying to make order out of a complex existence is one thing; trying to make art out of life is quite another. It requires emotional continuity, without which there is no spiritual core. In *A Photographer's Life*, Annie Leibovitz does not bear her soul; she asserts her ego. And, that's really too bad. Given all she had to work with—her talent, her subjects, her resources—the book ends up a false claim and a wasted opportunity. Could there be a life lesson in that?

Originally published in *Dear Dave* magazine, Summer 2007.

Embalming the American Dreamer *On Katy Grannan*

Katy Grannan finds models for her portraits by placing classified advertisements in local papers: "Art models wanted: Female photographer seeks people for portraits. All ages. All types. No experience necessary. Will pay." But she's not looking for adventure. "I was uncomfortable approaching people I didn't know," she said on the phone from Berkeley, California. "Out of that trepidation I started to place ads."

More than seventy of these pictures—made primarily in New York City, upstate New York, Massachusetts, and Pennsylvania—are to be published next month by Aperture Foundation in *Model American: Katy Grannan*. Although each subject was a stranger to Ms. Grannan, none of the pictures seem formal or distant. What comes across instead is an unlikely blend of intimacy and artifice.

Initially Ms. Grannan, thirty-six, who commutes regularly from her home in Berkeley to New York, was surprised by how many people answered her ads, and by the similarities in their living circumstances. In the small towns in upstate New York where the ads appeared for her first series, Poughkeepsie Journal, many of the respondents were young women in their twenties who had just moved back home after college.

"I noticed the similarity to my own experience—a lot of common ground," said Ms. Grannan, who was a graduate student in photography at Yale at the time. For one thing, she said, that region of New York reminded her of the suburbs of Boston, where she grew up. She would meet a model, she recalled, "feeling like I was meeting an old friend, or at least empathizing with a time in someone else's life from which I had just emerged."

The young women all lived in the same kinds of houses—decorated with similar carpeting, wood paneling, and framed landscape paintings—and many made the appointments to be photographed when their parents would not be home. This added a secretive adolescent element to the portrait sessions, as if, Ms. Grannan said, the girls weren't ready to be adults yet.

Their eagerness to be photographed also had a quality of rebellion, which led to a conspiratorial intimacy between photographer and subject, like that of fast friends in high school.

For each session, Ms. Grannan arrived with a 4-by-5 camera, lights, and a fan. A fan? "When I was a kid," she explained, "my friends and I used to imitate glamour pictures by setting up a fan and putting on lots of makeup." She would spend several hours with each model, asking questions and letting each one describe her life as they walked around the house looking for a spot to take the picture. In the process, the models showed her clothing or pointed out objects that were meaningful to them.

In the case of *Ghent, New York*, 2000 (page 119), the first thing Ms. Grannan noticed about the young woman's home (which she shared with her mother) were dozens of birds in cages. After some discussion, the model ran upstairs to put on her mother's old prom

gown. In this mundane environment, with the glare of photographic lighting against wood paneling, the model struck a classical pose in her elegant dress, graced by the bird on her hand: a suburban teenager transformed, for the moment, into a John Singer Sargent heiress.

Ms. Grannan says she thinks that her models volunteered as a way to assert their individuality against their seemingly bland surroundings and circumstances. The portrait sessions required a leap of faith, trust, and risk by the subjects; what motivated them, she mused, could be a longing for new experience and for transformation, combined with naïveté and a streak of exhibitionism. Many of her models opted to pose naked, as in the portrait of one young woman in the Poughkeepsie Journal series who stands like Venus on the half shell in her living room. She was posing nude in defiance of the wishes of her boyfriend, who was not present. "She began posing in a way that came too close to imitating *Playboy* poses," Ms. Grannan said. "I asked her just to stand in front of me and walk toward the camera."

In Ms. Grannan's pictures, the subjects are captured between a fantasy of what they aspire to be and who they really are. "I always liked Stendhal's definition of beauty being a promise of happiness," Ms. Grannan said. "It implies something that is always out of reach."

The first photograph in this body of work, *Untitled*, 1998, was taken after Ms. Grannan walked through the house with her eighteen-year-old subject and looked through her closet. They picked an outfit—a little girl's dress that suggests an emotional age at odds with the model's chronological age—and chose a spot outdoors. What emerges in the portrait is a porcelain-skinned doll superimposed on—and out of proportion with—her backyard surroundings. Ms. Grannan often plays with this disparity between subject and background. With the camera positioned below the girl's waistline, she looms large in the environment and is also somehow apart from it.

As an influence, Ms. Grannan cites one of her teachers at Yale, Philip-Lorca diCorcia, whose color photographs, though highly premeditated, look as though he just happened upon the scene. The tension between artifice and spontaneity gives his work a hyperrealistic clarity—and for the viewer, a sense of entering his pictures in medias res. The same can be said of Ms. Grannan's pictures, which have a posed, frozen feel, but also the immediacy of a snapshot.

Even more significant an influence, Ms. Grannan said, is Diane Arbus. Ms. Grannan's models are far more conventional than Arbus's dwarfs and transvestites, of course, but her way of capturing them in mock performance exposes them in ways that defy our expectations.

Richard Avedon liked to say that all of his portraits were self-portraits. The same could be said of Ms. Grannan's pictures, which reflect an unusual biographical detail: she comes from a family of undertakers, and many of her figures look virtually embalmed. (The Gran-

nan Funeral Home has been in business in Arlington, Massachusetts, for decades.)

"My great-grandmother lived in the funeral home in an apartment above the viewing rooms," she said. "We'd visit on Sundays after church, and I was always obsessed with the knowledge that there was a dead body beneath us. So many times, I'd sneak down there and have a private viewing—usually a body in an open casket, surrounded by lots of flowers, ready for visitors later in the day."

In her highly collaborative portrait sessions, she tries to identify with her model. But, at a certain point, she steps back and isolates some quality of experience—aspiration, delusion, weakness—and holds it at arm's length, as if it were something universal that supersedes the subject, suspended in photographic relief.

"The work isn't an invitation to gawk or judge," she said. "We all share aspects of the photographs—physical and psychological scars, desire, vulnerability, etc. I want to find that common ground, whether it evokes sympathetic understanding or intense discomfort or, hopefully, both."

In her most recent series, Mystic Lake, Ms. Grannan abandoned domestic environments. Instead of the leafy wallpaper and other decorative elements she found in her models' homes, the landscape itself became the backdrop. *Paul, b. 1969* was photographed in a wooded location about five minutes from where Ms. Grannan grew up. To her, he seemed the image of a tough guy from East Boston, where he lived—that extra amount of hair gel, saint medallions around his neck. Because it was a sweltering summer day, he removed his jeans to reveal long underwear, and he pulled up his shirt.

"I thought of Sally Mann's photograph of the very pregnant woman and her daughter, with the woman's dress or skirt pulled up over her belly," she said. "He didn't exactly look androgynous but his belly was huge and womanly."

Most of the men in Ms. Grannan's portraits seem feminized as in *Van, Red Hook, Brooklyn, New York* (page 119). Often they are leaning back or lying down, either naked or wearing clinging fabrics. Recently, in California, she has been photographing transgendered people. "I have been thinking a lot about how it is the ultimately courageous act—to be born one way and to feel alienated from one's own body, and then to live openly as someone new."

That sense of assuming a new identity—at least for the moment, in front of the camera—is palpable in her portraits. The title of her new book, *Model American: Katy Grannan*, underscores that notion: American stereotypes are transformed into a new breed of model Americans, through the collaboration of subject and photographer.

"Every person is a brand new idea for every single picture," Ms. Grannan said. But "looking at the book as I put it together, this reveals more about me than I ever realized."

Originally published in the *New York Times*, August 21, 2005.

The Collection

Photography collections are not a new phenomenon, but their fetishization has become more acute as the artistic value of the photographic image is better appreciated and the financial value of photography has grown. The photography collection comes in many forms and serves a multitude of ends, whether for a museum, a corporation, a government agency, or an individual. No matter how deliberative in intention or random in focus, the photography collection tells its own story about artists or practitioners, subject matter, culture, history, and, for those who really care, the medium of photography itself.

The museum collection exists as a cultural treasure, and the reigning examples are those of the Metropolitan Museum of Art, the Museum of Modern Art, and the J. Paul Getty Museum. Each institution is set up to preserve the finest examples of the medium, to maintain a bountiful archive from which to educate or edify the public, and to provide an invaluable resource for scholarly research. In curatorial terms, artistic achievement and historical relevance dictate acquisition for the museum collection, and, as a level of connoisseurship is often at play, determination of the finest example of any photographer or period or genre is calibrated to the sublime.

The corporate collection may lend an air of cultural high-mindedness to the company name. One of the best was the Seagram collection, with some seven hundred images, including work by Steichen, Stieglitz, Walker Evans, and Garry Winogrand, which hung on the corporation's office walls. The collection was sold at auction at Phillips, in 2003, for $2.9 million. At the time, Phyllis Lambert, who spearheaded the collection, told the *New York Times* that she was heartbroken about the sale: "It's part of a whole Greek tragedy."

The individual collection may derive from a personal passion for the photographic image, enthusiasm for particular subject matter, interest in the technical evolution of the medium, or recognition of the investment value of photography.

Among the most notable individual collectors, and one of the earliest, was Sam Wagstaff, who began amassing his collection in 1973. While he collected for his own aesthetic pleasure, his training in art history and his experience as a curator of contemporary art informed his decision-making; many of the images he collected happened to intersect with the best examples of the medium. His collection was sold to the J. Paul Getty Museum in 1984 for about $5 million, and served as the foundation for its collection.

Thomas Walther's collection of modernist photography included 328 works by 135 leading European and American photographers of the 1920s and '30s. When he sold it to MoMA in 2001, it was thought to fill in some gaps in the museum's collection, and to revise its thinking about the work of a number of photographers they had previously overlooked.

John Waddell also began to collect in the 1970s, and in 1989, he sold his collection of five hundred or so photographs by 180 American and European photographers who worked between the world wars to the Metropolitan Museum of Art for $2.7 million. The purchase was underwritten by the Ford Motor Company, which contributed $1.8 million toward the cost. These photographs at the Met now comprise the Ford Motor Company collection.

After purchasing Alfred Stieglitz's iconic photograph of Georgia O'Keeffe, entitled *Hands with Thimble*, 1920, Henry M. Buhl was inspired to begin his themed collection of hands. The photographs span the history of photography and the Guggenheim Museum exhibited works from his collection in a 2004 show called *Speaking with Hands: Photographs from The Buhl Collection*.

Richard Avedon collected photographs that appealed to him, as well, but there is no evident theme with which to define his collection. Still, what he gathered spanned the history of photography and the choices he made provided insight into his sensibility, and, ultimately, his work as a photographer: Most obvious in this regard would be the portraits he collected by Nadar (Gaspard-Félix Tournachon), August Sander, and Diane Arbus, and from which he borrowed or quoted in his own approach to portraiture.

One of the best ways to see the work of any individual photographer, or a body of photographs that address a particular subject, is in a book. Martin Parr famously collects photography books, some of which date to the mid-nineteenth century. A collection such as Parr's provides an in-depth version of the history of photography that resides at the level of artifact.

The Time-Life Picture Collection housed all the images taken by the company's staff and contract photographers and published in all Time, Inc. publications. My first real job was in this visual treasure trove of twentieth-century culture—as a picture researcher. I spent delicious hours in the files looking at pictures of 1940s movie stars at home, the McCarthy hearings, the Kennedys on the presidential campaign trail, as well as contact sheets of endless picture essays by W. Eugene Smith, Margaret Bourke-White, Walker Evans, and others. What a photographic education that turned out to be.

Today, that collection and others assembled by theme, like the Michael Ochs collection of twentieth-century musicians, and the Hulton Collection, which amassed the photographic archives of the British publications *Picture Post*, *Daily Express*, and *Evening Standard*, are now owned by Getty Images (no relation to the museum), the largest stock agency in the world and an invaluable conglomeration of imagery for commercial and editorial purposes.

The essays in this section explore the phenomenon of the photography collection, and the way institutional collecting has established a canon, private collectors have come to influence curatorial decision-making, investment collecting has distorted the value of work, and individual choice can be seminal in shaping art history.

What Eighty-five Hundred Pictures Are Worth

Last year, when the Metropolitan Museum of Art acquired the more than eighty-five hundred photographs in the Gilman Paper Company Collection—then arguably the most impressive private photography collection in existence—Malcolm Daniel, the museum's curator of photography, declared it "the most important thing" that had happened to his department in the history of the museum. "For at least the last fifteen years, the acquisition of the Gilman collection has been our number one priority and goal," he said.

And when the Museum of Modern Art acquired the Thomas Walther collection of high-modernist photography, in 2001, Peter Galassi, the Modern's chief curator of photography, said, "His collection splendidly demonstrates the importance of photographic modernism and simultaneously encourages us to rewrite its history."

These are only two in a series of recent transactions in which major photography collections amassed by one person, sometimes around a single idea, were placed in the hands of major cultural institutions. They are a clear indication of the growing influence of individual taste within that world—and of the ways that an institution can confer an official pedigree on a private buyer. They have attracted an increasing number of collectors to the photography market, who have in turn driven that market to new heights. But these transactions are also a window onto how private collectors with the time, resources, and incentive to pursue their passions can affect decisions that were once made solely by curators pursuing the overall needs of their museums.

Whether it is the romance of the photographic image or the allure of a choice investment that attracts a collector, new rules and newcomers alike have changed the photography landscape.

As a young executive at Seagram in the early 1990s, Trevor Traina, now a technology entrepreneur in San Francisco, was invited to choose a photograph from the company's important collection as decoration for his office. He chose a picture by Nicholas Nixon that looked out over midtown Manhattan, echoing the view from his desk. Then, in 2003, when Seagram was sold and its photography collection was auctioned at Phillips de Pury & Company, Mr. Traina sought that photograph and bought it.

Last year at Sotheby's in New York, he also bought *Identical Twins, Roselle, New Jersey*, by Diane Arbus, for $478,400, at the time the highest price yet paid for an Arbus. "While I will miss the money," he said, "to be able to buy one of the most important works in the entire medium for half a million dollars strikes me as the bargain of the century. I certainly can't be out there buying Vermeer, Rembrandt, or Caravaggio on my budget."

Now a trustee of the Fine Arts Museums of San Francisco, Mr. Traina lent work from his growing collection of 150 images to the de Young Museum when it reopened in Octo-

ber. "My hope is that my collection will have a certain critical mass at some point," he said, "that it will say something about me, and that I can help the museum in its endeavors in photography."

As museums and other institutions become more interested in individual collections, they are also working harder to land them.

Consider the Daniel Cowin Collection. Before his death in 1992, Cowin had amassed almost five thousand photographs, ranging from African-American vernacular images to modernist photography between the world wars. "This collection of African-American history is an amazing thing," Brian Wallis, director of exhibitions at the International Center of Photography, said. "No one had been collecting this stuff until he came along."

Cowin was a trustee of the center, which had long been promised his collection. Still, his heirs have yet to complete the transaction. The center is now showing the second consecutive exhibition of work from the collection. "Our original intention was based on the deal being wrapped up last May, and we planned back-to-back exhibitions of the Cowin collection in recognition of its importance," Mr. Wallis said, acknowledging that the negotiation has been awkward and tense. "These things can go on forever."

Even when donors commit to an institution, they are exercising more control over the terms of the bequest. Paul Sack, a San Francisco real estate developer, began collecting photographs in 1987. His first spark of interest was "hardly laudable," he said.

"My company occupied two floors of an office building in San Francisco," he explained. "For the executive floor, I purchased an interesting but desultory group of paintings and watercolors. For the back office floor, I thought I would be able to spend less money by purchasing photographs. Within a few weeks, however, I was hooked on photography."

Mr. Sack continues to fulfill his goal of acquiring at least eight vintage prints by significant photographers throughout the history of the medium, according to a specific theme: within every picture there must be a hint of a building that could have been privately owned or leased, whether it is a dot in the landscape or a wall in a portrait.

He helped start the San Francisco Museum of Modern Art's first photography accessions committee, and the Paul and Prentice Sack Collection is now in a trust to the museum. "Under the terms of the trust agreement," Mr. Sack explained in a recent email message, "SFMOMA must always devote at least thirty lineal feet of wall space to displaying prints from that collection." Last summer, the museum mounted a sprawling exhibition from the Sack Collection, which took up an entire floor.

Prominence is hardly all that art institutions can offer a collector. Trained as an art historian and museum curator, Sam Wagstaff began collecting photographs in the 1970s, driven by his knowledge of the medium's history; his very good, if very idiosyncratic, taste; and his desire to thumb his nose at the curatorial canon. In 1984, instead of donating his collection of some twenty-five hundred photographs to a museum—as had been the stan-

dard practice—he sold it to the J. Paul Getty Museum for a sum said to be in the neighborhood of $5 million. It was a watershed.

"Sam was an anti-museum collector," Weston Naef, curator of photographs at the Getty Museum, said over lunch recently. "As a result, he changed the process of how an exceptional photograph should be measured."

Wagstaff died in 1987, but his name is still golden among photography collectors; he remained true to his sensibility while, at the same time, valuing the medium at its best. And of course, he turned a very handsome profit.

William Hunt, a partner of the Hasted Hunt gallery in Chelsea, has been of the Wagstaff school of photography collecting for thirty years. "Somewhere in my head was this idea of souls and veils," he said about the first photograph he bought, *The Dream*, 1910, a haunting image by Imogen Cunningham, in which the eyes of the subject are veiled. All the twelve hundred or so pictures in his collection conform to that theme. His collection was exhibited last summer at Les Rencontres d'Arles, an annual photography festival in France, and he is now in negotiations with a publisher for a book of photographs on his collection—a way to position it for eventual purchase by an institution.

Asked what he looks for in a suitable picture, Mr. Hunt was wry. "It should make unrelated body parts of mine move simultaneously," he said. "It should be fresh and not remind me of any other picture. It's about magic."

In 1999, Sheik Saud Al-Thani of Qatar set a world record at Sotheby's when he bought a Gustave Le Gray seascape, *Grande Vague, Sète*, ca. 1857, for $840,370. A year later, he spent more than $15 million on 136 vintage photographs, including masterpieces by Man Ray and Alfred Stieglitz. His buying power alone is said to have tipped the balance in the photography market. But his interests, too, are shifting toward museum display. He has commissioned Santiago Calatrava to build a photography museum in Qatar.

But even the biggest collectors started somewhere.

Howard Gilman—and, initially, his brother and sister—who was behind the Gilman Paper Company Collection, began collecting in the mid-1970s with the idea of acquiring contemporary art. Some of the minimalist work of that period included photographs used by conceptual artists, and the photography collection grew out of that.

"There was no mandate for the collection," Pierre Apraxine, its curator, said by phone from a hotel room in London. "It was improvised. In Europe, when I started to see the first masterpieces of photography I didn't yet know anything about, it dawned on us—Howard and I—we could do something unusual with these newly discovered works. But the collection developed as we went along, like chapters in a novel."

Next month, Sotheby's will hold a sale of 130 photographs from the Metropolitan Museum's collection, including some from the Gilman collection that duplicate those already at the Met. One, *The Pond-Moonlight*, 1904, by Edward Steichen, is valued at

$700,000 to $1 million. (Only three prints are in existence—the third is in the collection of the Museum of Modern Art.)

Mr. Walther, whose collection was acquired by MoMA, was first drawn to photography in the late 1970s, when he attended a symposium at the George Eastman House in Rochester. Only a limited number of curators, dealers, and collectors were then interested in photography.

"We were a small family then," Mr. Walther said on the phone from Berlin, where he has a home. "We all knew we were on to something and that the general public didn't yet have an inkling. I knew that wonderful things had low price tags in relation to classical art. I was able to buy a Man Ray then for $7,000. It was a far cry from today."

Asked if there was a particular idea on which he based his collection, Mr. Walther said that if so, it was not conscious. "You go for certain qualities," he said, "and, miraculously, the photographs all seem to fit together in the end."

Perhaps it's the intrinsic modernity of the photographic image that makes it attractive to collectors; photographs offer a measure of recognizable, real-time history that other mediums don't provide. And they are still less expensive than paintings. But the attention that museums and other institutions are paying lately to private collectors plays an important role, too.

"In the past, it was just photography collectors who came into my gallery," said Edwynn Houk, of the Edwynn Houk Gallery in Manhattan, who made well over $1 million last year on a single show of original Mike Disfarmer prints. "Now, people who collect works in other mediums are also collecting photographs. That is becoming the norm."

And even if the market turns, Mr. Traina observes that the one person who will have gotten rich from his photography collecting is his framer. "I can tell you that my eyes are bigger than my stomach in that I ran out of wall space a long time ago," he said. "The only way I could get a bigger house to display all my photos is to sell them."

Originally published in the *New York Times*, January 1, 2006.

The Man Who Made Mapplethorpe: A Film About Sam Wagstaff

Tall, handsome, and rich would be one way to describe Sam Wagstaff, a legendary figure in the international art world of the 1970s and '80s. Urbane is another. Iconoclastic, certainly. And glamorous, without a doubt. But the word that keeps cropping up in *Black White + Gray*, a new documentary about Mr. Wagstaff by a first-time director, James Crump, that will be shown at the Tribeca Film Festival next week, is "visionary."

Mr. Wagstaff was one of the first private art collectors to start buying photographs, as early as 1973, long before there was a serious market for them. His photography collection came to be regarded not only for its scholarship. It was also original and unorthodox, and turned out to be extremely valuable. Mr. Wagstaff sold it to the J. Paul Getty Museum in 1984 for $5 million, a fortune at the time, establishing that institution's collection of photographs, now among the finest in the world.

But the Wagstaff mystique deepens around his relationship to Robert Mapplethorpe, his lover, to whom he was also mentor and career impresario. Mr. Mapplethorpe, twenty-five years his junior, was the bad boy photographer who scandalized the National Endowment for the Arts with his formal and highly aestheticized homoerotic photographs, which were given a retrospective at the Whitney Museum of Art in 1988, securing his legacy. Still, obscenity charges were brought against the Contemporary Arts Center, Cincinnati, when it mounted an exhibition of Mr. Mapplethorpe's work in 1990. Mr. Wagstaff himself affectionately called him "my sly little pornographer."

Mr. Mapplethorpe, a young artist from a working-class neighborhood in Queens, was making elaborate constructions with beaded jewelry when he and the patrician Mr. Wagstaff, who had been a well-known curator at the Wadsworth Atheneum Museum of Art in Hartford, Connecticut, met through a mutual friend in the early 1970s.

Throughout the film, interviews with more than a dozen people who knew them both provide an intimate and anecdotal picture of their lives, both individually and together. In particular, Patti Smith, the poet and rock star, offers tender descriptions of her friendship with both men.

Ms. Smith's friendship with Mr. Mapplethorpe began in 1967 when they were both art students at Pratt Institute in Brooklyn. They were living together near the Chelsea Hotel in the early 1970s when Mr. Mapplethorpe first brought Mr. Wagstaff to meet her. "Sam came in and seemed totally at home in my mess," she recalls. "We liked each other immediately. He had such a great sense of humor and had such a nonpretentious and nonsanctimonious spiritual air."

Dominick Dunne met Mr. Wagstaff when they were both young men in New York, and he talks about the dichotomy between Mr. Wagstaff's life in the closet in the 1950s and his

more public profile later with Mr. Mapplethorpe. "Sam Wagstaff was the New York deb's delight," he says in the film. "He was probably one of the handsomest men I ever saw. Tall and slender and aristocratic-looking. And he was funny. And he was nice. And the girls went absolutely nuts over him."

Gordon Baldwin, a curator at the Getty Museum, recalls in the film that Mr. Wagstaff was proud of his aristocratic background and says Mr. Wagstaff told him more than once that his family had owned the farms where the Metropolitan Museum is now, at the time of the Revolution. "It was pretty clear that he came from a starchy background," he said.

Still, Mr. Dunne notes how oppressive the taboos about homosexuality were for Mr. Wagstaff in the 1950s. Having had a privileged childhood on Central Park South and attended Hotchkiss with classmates like Dean Witter, of the brokerage firm, and Malcolm Baldrige, future secretary of commerce under President Reagan, Mr. Wagstaff seemed destined to become part of New York society.

He didn't like talking about that period in his life, Ms. Smith remembers. "He would say things with a painful tone in his voice about the suppression and oppression of a homosexual man in the 1950s," she said. "I never asked him about it because it was the one area I could really sense pain in him."

Mr. Wagstaff certainly made up for lost time. In the early 1970s, he "became an eager participant in the excesses of the age," says Joan Juliet Buck, the writer who narrates the film with a lofty voice, reading adulatory, if not lapidary, biographical prose that delivers the facts about Mr. Wagstaff's life in a tone aimed at, well, posterity. He was "always in rebellion against his conservative and upper class background," she notes.

"He often held drug parties in his Bowery apartment," Ms. Buck says at one point, as if holding her nose at the very idea. "He used drugs for sex and he liked the alternative perspectives they offered."

Philippe Garner, a director of Christie's in London and a friend of both men, says in the film: "My guess is that Robert gave Sam the courage to explore areas of his personality, to savor a darker kind of lifestyle than he would have done on his own. He unlocked a dark genie within him."

Despite Mr. Wagstaff's sybaritic activities and his relationship with Mr. Mapplethorpe, unconventional at the time, he managed to amass a world-class photography collection and also to shape the other man's career. From the humble Polaroids Mr. Mapplethorpe was making when they first met to his more provocative and refined photographs, which now command $300,000 a print at auction, the influence of Mr. Wagstaff's taste and aesthetic sensibility on his work is undeniable.

The film's title, *Black White + Gray*, has several meanings. Most, if not all, of the photographs in the Wagstaff collection were black and white. Most of Mr. Mapplethorpe's best-known work is black and white too, and many of his nude subjects were African-American.

But more specifically, the title refers to an exhibition called *Black, White and Gray*, organized by Mr. Wagstaff as a curator at the Wadsworth Atheneum in the early 1960s. The show included works by Barnett Newman, Ellsworth Kelly, Ad Reinhardt, and Jasper Johns, among others.

The show "sent shock waves through popular culture and heralded fashion's embrace of Minimalist aesthetics," Ms. Buck says in her narration. At the time *Vogue* magazine published an eight-page feature on James Galanos's couture, with Mr. Wagstaff's exhibition as the backdrop.

"Back in the 1960s, curators like Sam, Frank O'Hara, and Henry Geldzahler were much more like artists than a lot of curators on the scene are today," Raymond Foye, the publisher of Hanuman Books, an independent press, says in the film.

"He had a very special antenna to find what was new, what was good, what resonated with him," says Clark Worswick, a curator and photography scholar.

The film's narration tends to cast Mr. Wagstaff in nothing less than Olympian terms: "His aesthetic underscores an unequal vision grounded in passion, intelligence, sexuality, and clever financial speculation," Ms. Buck recites, as rare self-portraits by Mr. Wagstaff are shown. "He had few rivals in his time. And none at all today."

The intimate, never-before-shown photographs of Mr. Wagstaff and Mr. Mapplethorpe throughout *Black White + Gray* make great social anthropology, and the interviews with Ms. Smith, Mr. Dunne, and others give depth and warmth to an otherwise stiff, if earnest, portrait.

Both Mr. Wagstaff and Mr. Mapplethorpe died of AIDS, Mr. Wagstaff in 1987 and Mr. Mapplethorpe in 1989.

One snippet of footage shows a shy and endearing Ms. Smith reciting a short poem of hers in an interview on the BBC in 1971: "New York is the thing that seduced me. New York is the thing that formed me. New York is the thing that deformed me. New York is the thing that perverted me. New York is the thing that converted me. And New York is the thing that I love too."

Written before she met Mr. Wagstaff, this little gem nevertheless proves to be a fitting coda to the film—and to the man.

Originally published in the *New York Times*, April 24, 2007.

The Avedon Eye, Trained on Faces Captured By Others

Richard Avedon set the standard for portraiture and fashion photography in the second half of the twentieth century, so it is no surprise that his work is sought by serious collectors. But far less well known than his soigné magazine images is that when he died in 2004 he had amassed a significant photography collection of his own.

"From the time he was 10 and the owner of a box camera," Truman Capote wrote about Avedon in *Observations*, a book they collaborated on in 1959, "the walls of his room were ceiling to floor papered with pictures torn from magazines, photographs by Munkacsi and Steichen and Man Ray."

If those tear sheets suggested what Avedon's own pictures would become, the photographs he collected informed his later career.

The collection is now being sold to benefit the Avedon Foundation. Selected photographs will be shown for two weeks at the Pace/MacGill Gallery in Manhattan and at the Fraenkel Gallery in San Francisco. And a slender volume, *Eye of the Beholder: Photographs from the Collection of Richard Avedon* (Fraenkel Gallery), assembles the majority of the collection in a boxed set of five booklets: "Diane Arbus," "Peter Hujar," "Irving Penn," "The Countess de Castiglione," and "Etcetera," which includes nineteenth- and twentieth-century photographers.

The collection reflects Avedon's sensibility and enthusiasms, and offers a window onto a circle of friends who were as influential as he was. He and Arbus knew each other well, for example, as they were the same age and making portraits in Manhattan. His portraits and Penn's shared the pages of *Vogue* magazine for several years.

Avedon believed that portraiture was performance; it wasn't a question of the portrait being natural or unnatural but whether the performance was good or bad. "The point is that you can't get at the thing itself, the real nature of the sitter, by stripping away the surface," he wrote in *Richard Avedon: Portraits* (1993). "The surface is all you've got. All you can do is to manipulate that surface—gesture, costume, expression—radically and correctly."

His collection includes many important examples of portraiture as it developed through the history of photography. In the ninteenth century Nadar (Gaspard Félix Tournachon) photographed the artists, writers, and intellectuals of Second Empire France in a direct style that borrowed its simplicity of line from painting. Avedon's own portraits—also a pantheon of arts and letters, but including a chronicle of the abject and unknown—evolved from Nadar's.

A century of advances in technology allowed Avedon to do things Nadar could not, like capturing the finest detail with instantaneous exposures. Yet *Evelyn Avedon*, 1975, a

portrait of his wife, echoes the guarded tenderness of *Ernestine*, 1854–55, Nadar's portrait of his young wife that is in Avedon's collection.

Julia Margaret Cameron photographed family members and her accomplished friends—the artists, writers, poets, and thinkers of Victorian England—often as mythical figures. For a long time Avedon pursued Cameron's 1867 portrait of John Herschel, but he could never find a print beautiful enough to acquire.

A Cameron portrait he did acquire is *Stella*, 1867, which depicts Julia Prinsep Jackson, Cameron's niece and godchild, invoking the heroine of a 1591 poem by Philip Sydney, "Astrophel and Stella." Jackson, who would later become the mother of Virginia Woolf and Vanessa Bell, stares directly at the viewer in the same manner as do many of Avedon's subjects.

August Sander, also in Avedon's collection, approached his subjects with a clinical eye, composing a methodical catalog of professions and archetypes in the German society of the early twentieth century. Arbus admired the stark simplicity of Sander's portraiture, and you can see it in a comparison of two prints that Avedon owned, *Farm Girls*, ca. 1928, by Sander, and *Identical Twins, Roselle, New Jersey*, 1966, by Arbus. Even Arbus's titles—categorizing rather than identifying the subject—echo Sander's practice.

Avedon was the first to buy *A Box of Ten Photographs*, the 1970 portfolio Arbus assembled in an edition of fifty and packaged in a clear plexiglass box, designed by Marvin Israel, a friend of both Arbus and Avedon. For Avedon, Arbus crossed out the word *ten* on the cover sheet and wrote *eleven* above it, along with the footnote "especially for RA." The eleventh image, in a portfolio that includes some of her best-known images, was inscribed "At a Halloween party for mentally retarded women, a lady in a wheelchair, masked, 1969."

"He kept it under his bed," said Jeffrey Fraenkel, whose gallery in San Francisco represents Avedon's work, recalling how he was once shown the portfolio during dinner at Avedon's Manhattan home. "Dick showed me the Arbus prints, saying that she used to describe the box as 'almost like ice.'"

The influence of Nadar, Cameron, Sander, and Arbus is layered in Avedon's own portraiture: the famous, the accomplished, the offbeat, the downtrodden, all photographed both as individuals and specimens simultaneously. His contribution was to reduce the picture frame to nothing but the individual: straightforward, unadorned, with no distance between subject and viewer.

"I hate cameras," he once wrote. "They interfere, they're always in the way. I wish: if I could work with my eyes alone."

Peter Hujar, who was younger than Avedon, photographed his own avant-garde circle of friends with a combination of Arbus's eccentric intimacy and Avedon's graphic elegance. "Peter saw himself as a portraitist and believed that the camera could see things about peo-

ple that the naked eye could not," Stephen Koch, a writer and executor of the Hujar estate, said. "A portrait could show that."

In 1967 Hujar attended a photographer's master class offered by the New School at Avedon's studio, taught by both Avedon and Israel, in which Arbus was a guest speaker. For a while, Mr. Koch said, Avedon and Hujar were close, and their phone conversations would sometimes last until dawn.

Over time Avedon bought eight Hujar photographs. "It meant a great deal to Peter that his picture of a stripper, *T.C.*, 1976, hung on Avedon's wall next to Cameron's picture of her niece," Mr. Koch said.

Jacques-Henri Lartigue documented his French upper-class world with photographs like *Anna La Pradvina, Avenue du Bois de Boulogne*, 1911, which depicts an elegant woman draped in furs walking her two small, overbred dogs on a Paris street. It's just the kind of picture Avedon might have taken—it has the same panache as the fashion pictures he so carefully constructed to look authentic—and you immediately see why it's in his collection.

When Avedon first discovered Lartigue's work in 1963, he sent a letter to Lartigue in Paris: "The other day Mr. Szarkowski of the Museum of Modern Art in New York City showed me your photographs," Avedon wrote. "It was one of the most moving and powerful experiences of my life. Seeing them was for me like reading Proust for the first time. You brought me into your world, and isn't that, after all, the purpose of art."

He and Lartigue met in 1966, and Avedon later edited the book *Diary of a Century: Jacques-Henri Lartigue*, published in 1970 and still an essential reference.

Not long before he died, Avedon bought eighteen photographs of the Countess de Castiglione, mistress to Napoleon III, by Pierre-Louis Pierson, considered the most important collection of this series in private hands. Among them is one of the most famous portraits in the history of photography: *Scherzo di Follia*, 1863-66 (Game of Madness). The Metropolitan Museum of Art owns a later print, but Avedon's is one of only two known early prints.

The Countess de Castiglione collaborated with Pierson to construct her many guises in the photographs, with wit, flair, and a nod to the artifice of the creation, the same thing Avedon had done in his early fashion tableaus. In both his fashion work and his portraiture, Avedon explored the form of photography as much as the subject of his photographs.

"When I was a boy, my family took great care with our snapshots," he wrote in *Richard Avedon: Portraits*. "We really planned them. We made compositions. We dressed up. We posed in front of expensive cars, homes that weren't ours. We borrowed dogs. All the photographs in our family album were built on some kind of lie about who we were, and revealed a truth about who we wanted to be."

Originally published in the *New York Times*, August 27, 2006.

Photography Reveals Itself Between Covers

It seems that more photography books are being published now than ever before, and that the number of publishers with lists devoted entirely to photography has never been higher. Could it be that people are reading less and looking at pictures more, or has the rapidly rising price of photographs sent would-be collectors in search of alternatives? Whatever cultural forces are at work, books on photography are having their moment in more ways than one.

Among the new photography books is a substantial volume that takes on the subject of photography books themselves. *The Photobook: A History, Volume I* (Phaidon) approaches the photography book as if it were a medium all its own. It surveys more than two hundred books going back to photography's origins and includes information about the social issues and artistic climate of their day, as well as the circumstances of their publication. *The Photobook* begins with photography's introduction as a scientific tool and charts its progress as a form of creative expression—dual purposes that, over the years, grew into a nagging source of tension for photographers and scholars alike. How can a medium with so many utilitarian applications, the question goes, hold its own as a valid art form?

Martin Parr, one of the book's two authors, a photographer and a member of the Magnum photo agency, has been a serious collector of photography books for years. The volumes in *The Photobook* are drawn heavily from his own collection, the choices made with his coauthor, Gerry Badger, a photographer, curator, and critic in Britain. The selection includes many books that have come to define photography.

Mr. Parr was twenty years old, in 1972, when he bought his first photography book—Robert Frank's *The Americans*, which had first been published in the United States in 1959. A French edition had been published the previous year, but its photographs appeared as illustrations of essays by serious writers, making the book more of a documentary work. The American edition stripped the texts away, leaving only a new introduction by Jack Kerouac, allowing the pictures to tell the story. "It opened my eyes to the potential of photography," Mr. Parr writes in *The Photobook*. "It showed me that the medium can interpret feelings as well as describing places." He continues, "The combination of remarkable images and good design in a book that is beautiful to open and pleasurable to leaf through is an ideal way of conveying a photographer's ideas and statements."

Thumbing through a photography book and getting lost in the pictures is an intimate, sensate experience. It draws on a different part of the imagination than reading does. In the introduction to *The Photobook*, the photographer Lewis Baltz is quoted as saying that "you might think of photography as a narrow, deep area between the novel and film." In fact, it was the stepping-stone between the two mediums. In books, photographs assume a state of permanence, preserved on the page for the ages. But in series, they do more than

tell a story—they begin to tell how that story is told. And modern printing techniques have become so advanced that there is often little variation in quality between a fine photograph and its published version. In the barrage of moving imagery all around us, the photography book offers a welcome respite, a brief moment of extended contemplation.

The first commonly acknowledged photography book in *The Photobook* is *The Pencil of Nature*, published in Britain in the 1840s, by William Henry Fox Talbot, one of photography's inventors. Beaumont Newhall, whose 1964 book about the history of photography was definitive for many years, called *The Pencil of Nature* a manifesto, as well as an advertisement, an experiment, a calling card, an aesthetic achievement, and a polemic. "It was a show book, an account of the history of the invention and a demonstration of its accomplishment in the form of twenty-four actual photographs."

Many of the more idiosyncratic choices in *The Photobook* tell us just as much about the history of photography. Among them is *The Moon: Considered as a Planet, A World, and a Satellite*, by James Nasmyth and James Carpenter, published in London in 1874. Photographers of that period used large glass negatives that required a wet collodion coating. Since the plates could not be kept damp through long nighttime exposures, Mr. Nasmyth, an engineer, and Mr. Carpenter, an astronomer, built large-scale plaster models of the lunar surface, then lighted them in a studio to produce artificial moonscapes that could fool any unwitting eye. As ingenious as it was unscientific, *The Moon* says a lot about how photography was being used, or abused, in the nineteenth century.

Another curious book, *Facies Dolorosa* (The Face of Pain), was published in Germany in 1934 by Dr. Hans Killian, who photographed patients in bed and close up, labeling each image with the patient's illness. The photographs were meant for his medical research, but they show us moments between life and death with a haunting beauty that transports them into the realm of photographic art.

From *The Photobook*, questions arise about the way contemporaneously published photography books have influenced one another. Consider these books published within a four-year span: *Let Us Now Praise Famous Men*, by Walker Evans and James Agee (1941); *An American Exodus*, by Dorothea Lange and Paul S. Taylor (1939); and *You Have Seen Their Faces*, by Margaret Bourke-White and Erskine Caldwell (1937)—all collaborations between writer and photographer, all focusing on the impoverished conditions of the Great Depression. Were these photographers—among the most important of their generation—in competition with one another, or was each of them taking on the big subject of the era? The first of this type of collaboration was a book called *Roll, Jordan, Roll* by Doris Ulmann and Julia Peterkin (1933). That, too, was about rural poverty, in this case black laborers on a Southern estate. Was this book a template for the others?

The question comes up again with *Observations*, Richard Avedon's collaboration with Truman Capote, published in 1959, and *Moments Preserved*, by Irving Penn, published in

1960. Here are the two reigning fashion photographers of their day; both books were even printed at the same press in Switzerland. While *Observations* is a book of portraits with profiles of each subject, *Moments Preserved* includes a broader range of Penn's work; his many portraits, however, are accompanied by his own "observations" of those subjects. Again, coincidence, rivalry, or just a cultural moment?

Even *The Americans* came close on the heels of *The Europeans* (1955), Henri Cartier-Bresson's book of photographs of postwar life on the Continent—a coincidence that has been little noted.

More to the point today is the very publication of *The Photobook*. Several years ago, *The Book of 101 Books* was published in limited edition by Roth Horowitz Gallery in New York, a beautiful volume about photography books of the twentieth century. (A companion exhibition at the International Center of Photography is scheduled for this summer.) Both volumes cover similar terrain. *The Book of 101 Books* contains a number of titles not included in the *The Photobook*, but the latter goes into greater detail about photo propaganda books from the early twentieth century, and experimental photography books that came out of the Provoke period in Japan in the 1960s; it also promises a second volume, which will presumably fill in some of the gaps.

So, why would two such similar books appear in such close proximity? Maybe photography's stock is rising. In New York City alone, there are more than one hundred venues to view photography exhibitions. More and more artists are embracing photography and exploring its properties in new ways. Not to mention the intersection of technology and commerce: inexpensive digital cameras, cellphones, personal computers, and portable printers are enabling consumers to become prolific photo-chroniclers of everything around them.

When asked if he would rather see his own photographs on a gallery wall or in a book, Mr. Parr was unequivocal. "In a book," he said in a recent interview. "I love the sense of the package, a traveling idea. Someone can pick it up and the idea can explode in their face. The book is a perfect vehicle for photography." Something to keep in mind if you don't want to spend that $20,000 for an edition print by your favorite photographer.

Originally published in the *New York Times*, January 16, 2005.

Culture in Context: Photographs in Vince Aletti's Magazine Collection

For all the history collected in Vince Aletti's East Village apartment, he is a very modern man. In fact, everything about him defines modernity, particularly the rambling apartment in which he has lived for a quarter-century. Here is an elaborate installation piece that masquerades as a comfortable, if well-worn, private residence. The walls are layered with photographs, some by important figures, others anonymous; the vast majority are male nudes. Floor-to-ceiling shelves in every room are stacked with books: novels, history books, anthologies, art books, catalogs raisonnés, books of photographs.

But the pièce de résistance is really the maze of waist-high stacks of neatly piled magazines in Vince's living room. They range from the earliest issues of *Vogue* to *Interview* to *U.S. Camera* to *Flair*. Hundreds of collections of magazines are neatly assembled throughout his apartment, and while each magazine is a revealing artifact, collectively they compose an idiosyncratic archive in which slivers of history can be mined and savored for insights about the past. From this deep reservoir of printed matter, an inevitable progression can be charted to the current state of photography, fashion, graphic design—in effect, to culture today.

As the art editor and chief photography critic of the *Village Voice*, Vince must rigorously scrutinize contemporary image-making; but while this may be part of the job, it is no exaggeration to say that he collects magazines with the raptness of the possessed. Above the sink in Vince's kitchen is a Richard Avedon picture of Twiggy on the cover of *Vogue* from 1968, casually pinned to the wall. He says: "Avedon called me one day to say he was getting rid of boxes of *Vogue* tear sheets and wondered if I wanted them. Along with the two boxes of tear sheets, he sent several boxes of *Vogue* magazines from the 1970s, magazines I already had, so I gave them to the International Center of Photography, except for the few that had mailing labels on them with Avedon's name and address. Of course, I kept those."

He finds publications on eBay, at flea markets, in used bookstores, and by select word-of-mouth. His search for new material is unrelenting, disciplined, and meticulous. An inventory of one day's acquisitions includes a 1924 bound volume of *Harper's Bazar* (as the magazine's name was originally spelled), four 1960s *New Yorkers*, one issue of *Heavy Equipment: Tools of the Trade* ("For Adults Only"), and the April 2004 issue of the *Face*.

According to Vince, the photography in these publications is what interests him first and foremost. "Great photographers worked for magazines," he says. "You can't understand their work unless you see their photographs in *Vogue*, *Esquire*, *Harper's Bazaar*. It's about seeing [Avedon's] *Dovima and the Elephants* in its original context, as a picture in a magazine, made for that purpose."

His apartment is a visual obstacle course as well as a physical one; on top of one stack of old fashion magazines is a *Harper's Bazar* from 1928 with an Erté drawing on the cover. It's

hard to pass up a feature titled "Novelties of the Paris Season," by Baron Adolph de Meyer, in which the baron's discussion of the "Fundamentals of the Present Day Mode" is illustrated with his own elegant photographs. Turn around and your eye might fall to *10+MEN*, a luscious, high-gloss contemporary European quarterly lying on top of another pile. Flip through it and you'll find avant-garde fashion work by Collier Schorr, David Armstrong, and Luke Smalley. While there is no apparent connection between the two publications, the course of today's stylized, world-weary art/fashion photography can be traced right back to the à la mode formality of Baron de Meyer.

I sit at the round oak table in Vince's sun-filled dining room, paging through the January 9, 1968, issue of *Look* magazine. On the cover is an Avedon portrait of John Lennon, his face composed of psychedelic colors and shapes. The first feature in this issue is "Gallery 68: High and Low Art," Arnold Newman's photographs of artists in the context of their work: Frank Stella, Edward Keinholz, Claes Oldenburg, Tony Smith. Newman's portrait of Dan Flavin juxtaposes three pictures, and Vince notes the generous use of white space around the cross-shaped image that creates a Flavin-esque neon effect on the page. The issue's cover story on The Beatles is next, opening with Avedon's extravagant portraits of the Fab Four in vibrant solarized colors—a gatefold that unfolds to reveal a four-page-wide portrait of them in stark black and white. Allen Hurlburt, the art director of *Look* for many years, was known for such imaginative use of the photograph as an element of graphic design. *Look* was also a showcase for the best photographers of that period.

Vince considers the magazine a complete entity, cover to cover. "When it really works, every page contributes to what makes it a great magazine," he says. "The Avedon stuff alone makes this a great issue, but, then, not only is there the Arnold Newman portfolio, here is a Saul Steinberg portfolio. And, just when you think it's over—this Irving Penn portfolio." Titled "The Incredibles," Penn's feature is composed of crisp, well-articulated group portraits of Hell's Angels and "Minstrels," including Janis Joplin and Big Brother, The Grateful Dead, and others.

The work of certain photographers is particularly suited to the magazine context. Avedon and Penn, for example, seemed to conceptualize their photographs for the printed page. So did many others, including William Klein. The March 1960 issue of *Esquire* includes a portfolio of his work called "Roman Ragazzi: A Photographer's Personal View of the City." "Klein was really a magazine photographer," Vince says. "He knew how to work within the environment of the page, how to make a sequence of pages work for him. He's always doing something quirky, like the use of grain for this overall view of the city. The most famous picture from the series is that of an Italian man lying on the beach, and here is its first appearance in a magazine. I love seeing what it's next to, what it follows."

In the same issue of *Esquire* is a feature called "Teenage Heroes: Mirrors of Muddled

Youth," with photographs by Art Kane. On one spread, full-page pictures of Fabian and Frankie Avalon face one another. Fabian has a Band-Aid on his forehead and a shock of hair like an Indian headdress. Vince points out the brilliance of juxtaposing two good images: one black and white, one color. "I don't know if Art Kane cropped these," Vince says, "but the art director made a decision to give each picture equal weight. These are the two biggest teenage heartthrobs of the period. If you were to see these two pictures randomly shown at an exhibition, they wouldn't be much, but together on these pages, they're so strong."

L'Uomo Vogue, May–June 1995, is next. Vince turns to a feature called "The Boys of Summer," informal portraits by Steven Meisel of geeky teenagers wearing bathing suits in a rec room with plywood paneling. "Remember those grunge billboards and the TV spots that got pulled because they were thought of as child pornography?" Vince said. "These are the pictures that inspired that Calvin Klein jeans ad campaign."

To see photographs in their original sequence, on the magazine page that was their first springboard, reveals something of the machinery of time and history that transforms work from the everyday into the iconographic. As the source of cultural imagery, this single pile of magazines is stunning, both in terms of photographic styles that have been influential or imitated outright, and for the many individual images that have become canonical in themselves.

On the cover of *Vogue*, January 1950, is a now-famous image by Erwin Blumenfeld: the features of a woman's face silhouetted against the white background. "The layout of this period was so classic," Vince observes. "Lots of white space, blocks of type, the pictures integral to the design of the page. A magazine of this period has all the photography stars in every issue. Not only Irving Penn and the young Avedon, but Horst P. Horst, Cecil Beaton, Norman Parkinson, Herbert Matter."

By contrast, a decade later, an individual photographer might have several portfolios in a single issue of a magazine. The September 1962 *Harper's Bazaar* includes work by several important photographers: Brassaï, Francesco Scavullo, Martin Munkacsi, and Diane Arbus (she photographed children wearing outfits by Bill Blass). But Avedon has no fewer than three portfolios in this one issue. This, Vince says, is "partly what got me into fashion magazines—how many different features a photographer would do in one issue and the variety of work they could produce without duplicating themselves." Avedon's first portfolio in the issue is "Welcome to Lincoln Center," a sequence of portraits of conductors—Leonard Bernstein, Erich Leinsdorf, Eugene Ormandy, George Szell. (Lincoln Center had just been completed at the time.) Next is a portfolio of Paris fashions in which he took a classical, more elegant approach: Audrey Hepburn in Yves St. Laurent, Jeanne Moreau in Pierre Cardin. But the true highlight is the playful, visually experimental feature titled "Mike Nichols/Suzy Parker Rock Europe," a paparazzi-like sequence of snapshots following the fictionalized couple around the continent, a direct reference to *La Dolce Vita*, as well as to the media swarm around Elizabeth Taylor and Richard Burton, the biggest

stars at the time. "He used a tabloid photographer's approach, at times with grainy black-and-white pictures. But he's so *professional*," Vince says. "Even though each picture is completely staged to look as if it were a grab shot, you can see every detail of the clothes—which is, ultimately, the point. What imagination!"

The influence of Richard Avedon on contemporary photography is apparent as you look back through the magazines in which his work consistently appeared throughout the second half of the twentieth century—from *Bazaar* and *Vogue* to *Life*, *Look*, and later the *New Yorker*. He was original, experimental, stylish, and prolific, and his recent death only solidifies the importance of his contribution. Not only did he revolutionize the art of fashion photography (following Munkacsi's lead) by bringing the model out of the studio and into the world, he changed portraiture by distilling the frame to nothing but the subject. Generations of photographers have flattered him with imitation (or at least emulation) since he set those standards for both fashion photography and portraiture years ago. And there is no doubt that his influence will continue to grow.

Some of the most intriguing publications in Vince's collection are the rarefied, gorgeously produced journals aimed at the upper stratosphere of cultural sophistication. These magazines, published between the late 1930s and early 1950s, were generally short-lived, probably due to the high production costs (as well as the limited number of readers who can breathe the thin air at so lofty an altitude). These remarkable publications—*Show*, *Gentry*, *Flair*, *Junior Bazaar*, *Bachelor*, and *Portfolio* (this last produced by the legendary art director Alexey Brodovitch)—are time capsules of an era of evolving cultural enlightenment; they also provide an unabashed display of rigid and retrograde social snobbery. The most lavishly produced was *Gentry*, in which the fashion spreads include actual swatches of fabric attached to the pictures of suits. The Winter 1950 issue of *Portfolio* is the most experimental of all the magazines in this subsection of Vince's collection. This visually striking issue features "Xerography: New Visual Effects with Powder and Electricity," with pictures of "xerographs," an obvious evolution from the "rayograph" and a glimpse of photocopying in its embryonic stage; "Trademarks," by designer Paul Rand; "The Good Looking Package" (with wrapping papers from Bonwit's, Henri Bendel, Macy's, Lord & Taylor, and others folded into the magazine); and "Photography in Fashion/Fashion in Photography" (with portfolios and commentary by Penn and Avedon—the work of both these photo-deities appears so often throughout the pages of these publications, they seem wired into the very DNA of magazine photography). Of Brodovitch, *Portfolio*'s creator, Truman Capote once wrote: "What Dom Pérignon is to champagne, Mendel to genetics, so this over-keyed and quietly chaotic but always kindly-mannered Russian-born American has been to the art of photographic design and editorial layout, a profession to which he brings boldness bordering on revolution. . . ."

The *look* of a magazine—the design, the layout, the contextualizing of subject matter in visual terms—is the singular responsibility of the art director, whose seminal role is often invisible to the lay public. Art directors from Brodovitch and Alexander Liberman to Marvin Israel, Henry Wolf, Bea Feitler, Tibor Kalman, and Janet Froelich have continuously reinvented the landscape of the printed page. The explosion in graphic design may have resulted from the pervasiveness of television and film after World War II; the cinematic image demanded more active design solutions for the magazine page. Art directors blurred the line between word and image, utilizing type as shape, privileging white space as "negative space," and nurturing the talent of photographers to provide striking visual content around which the page could be designed. Their job has always been to harness, in purely graphic terms, the feel and attitude of the time, just slightly ahead of its moment.

This is the thrill of magazines for Vince: the surprise of seeing what is now a culturally definitive picture residing *in its time, in its place*; this is what makes his collection of magazines so important in terms of historic value and meaning.

Maybe all collections begin with stamps. That is how Vince first got started as a child, in Hollywood, Florida, sending away for them from advertisements in the backs of magazines. "It was," he says, "always about the picture on the stamp." Later, as a teenager, when he started collecting books, sending away for them from esoteric publishers such as Grove Press and Evergreen, it had to do with the way the books looked as much as what they exposed him to about the world.

Vince's father was an amateur photographer with his own stacks of *U.S. Cameras*, which Vince pored over when he was young. This was the beginning of his photographic education and his first introduction to the work of August Sander, Dorothea Lange, and many others. He was able to salvage thirty or so *U.S. Cameras* from his father's collection, from the 1930s to about 1960; these are among the magazines in Vince's apartment today.

A formative image for Vince, which he encountered at the age of twelve or so in one of those issues of *U.S. Camera*, was George Rodger's famous 1949 photograph of two Nuba wrestlers, one on the other's shoulder. "It imprinted something about exoticism and the male body that never went away. . . . The intimacy was really kind of shocking for me because of the super-masculinity of these naked men together like that."

Today the male body is a central theme in Vince's collections of images. Along with the ubiquitous male nudes and other portraits of men that stare out from the walls of his apartment, some of the more marginal publications in his archive fall into a genre of soft-core pornography from the 1940s through the early '60s referred to as "physique" magazines. More like pamphlets, these small-scale publications offered any number of pretexts for newsstand respectability in their time—bodybuilding, drawing instruction, dieting—but to a closeted homosexual readership in the pre-Stonewall era, they provided a kind of san-

ity along with their (fully intended) erotic thrill. These magazines stand on shelves along-side other muscle magazines of the 1940s and '50s, such as *Mr. America*, geared for the all-American boy and clearly anticipating the superhero phenomenon; a glance at them provides a range of insights into the way American masculinity was defined and shaped in the mid twentieth century.

It's worth noting the comparison between the stylized femininity represented in *Harper's Bazaar* or *Vogue* and the striving toward the Greek male ideal in magazines like *Fizeek*. Showing me several issues of this latter magazine, Vince observes that "the mannered lighting, the framing, and the composition are classical. The physique pictures have so much in common with fashion photography and Hollywood glamour." Vince maintains that part of his interest in these magazine collections is fundamentally about masculinity and femininity. He points to the stacks of fashion magazines, and then to the pictures of naked men all around us. "It's about how we look at ourselves, how we are portrayed over the years. The differences and the continuities between how we look today versus in the 1940s."

One of Vince's favorite magazine covers is a grid of images by Penn on *Vogue*, May 1946. Of this issue and its period, Vince says: "Right after the war, there was a sense of culture opening up, of celebration, some semblance of normality, a resurgence in advertising, maga-zines getting fatter." He draws a connection between this Penn cover and Charles Eames's very similar *House of Cards*, made a few years later. This is an example of the cultural cross-pollination, identifiable only in retrospect: the dots that connect one artist to another, the influences of the commercial world on art, and vice versa. The range of Vince's collection of magazines brings to light these crosscurrents of culture and history — the anatomy of the ever-shifting zeitgeist, most clearly observed with the distance of time.

Vince goes to Chelsea every Saturday afternoon, religiously, to look at art. He collects not only tangible, printed materials for his archive, but also, I believe, keeps a mental catalog of the ideas and images he comes across on these weekly expeditions. This, of course, is his professional responsibility for the *Village Voice*, but, more to the point, it comes from his profound personal fascination with work being produced today, in its time and place, now.

One Saturday afternoon, I accompanied Vince on his rounds and, after nine galleries, with flagging energy I begged off. But Vince was not finished for the day. He is dogged and apparently insatiable in his quest to know what's out there, to see what artists are doing. I have come to understand that his commitment to looking at art stems from the same impulse to collect: know thy culture, know thyself.

Originally published in *Aperture* magazine, Spring 2005.

For Photography, Extreme Home Makeover

When the J. Paul Getty Museum in Los Angeles decided to quadruple its exhibition space for photographs, the obvious goal was to trumpet the breadth of its holdings in the medium: some thirty-one thousand works acquired in a mere two decades.

Yet at a museum best known for Greek pots and Old Master paintings, the move was also a way of proclaiming the Getty's relevance to the here and now—and more broadly, affirming photography's global importance as an art form.

"Photography is our bridge to the modern world," said Michael Brand, the director of the museum, whose new Center for Photographs opens to the public on October 24. "It's our only link to the twentieth century."

Photography has become a churning art-world industry: more Chelsea galleries are devoted to photographs; the number of photography books published has dramatically increased; the value of photographs sold at auction annually has doubled since 2001; and even the average size of photographic prints has grown.

The Getty's photography collection, among the finest in the world, includes more than one hundred works each by William Henry Fox Talbot, Julia Margaret Cameron, Roger Fenton, Gustave Le Gray, Alfred Stieglitz, and Walker Evans. Some 150 living photographers are also now represented in the collection, and the Getty has embarked on a campaign to add three hundred more.

Weston Naef, the curator of photographs, encourages private collectors who plan to donate works to the museum to acquire individual photographers "in depth." The goal is to represent each living photographer with more than ten images, Mr. Naef said, because an artistic signature becomes apparent only when one can look at multiple images from the body of work.

The vast expansion of the gallery space—to seven thousand square feet from its original seventeen hundred—was precipitated by the Getty Villa's reopening in January. Moving the Greek, Roman, and Etruscan antiquities to their permanent home at the Villa opened up the lower galleries in the west pavilion at the Getty Center.

Over lunch in the Getty Center's airy dining room, Mr. Naef discussed the case he made to claim the space for photography.

"It has to do with the numbers," he said. "Month after month for ten years, our exhibitions have attracted forty to fifty percent" of the Getty Center's visitors.

"Of the 1.3 million visitors per year, seven hundred thousand come for photography shows," he added. "I have the highest audience share of any museum in the world."

While photographs constitute only one of six collections at the Getty—the other five are drawings, paintings, sculpture and decorative arts, manuscripts, and antiquities—the deci-

sion about who would be given the west pavilion galleries also turned on practical issues.

The drawings collection, for example, isn't large enough to require seven thousand square feet. More to the point, paintings, sculpture, and decorative arts all need to be shown in natural light, while photographs will fade if not shown under controlled lighting. The upper galleries all have skylights; the lower galleries, having no natural light, are ideal for exhibiting photographs.

The Getty has 58,000 square feet of exhibition space, and the number given over to photographs now exceeds that of many major museums. The Museum of Modern Art, for example, has 125,000 square feet of gallery space and devotes 5,700 to photographs. The International Center of Photography, with 6,800 square feet, has "the largest dedicated space to photography in New York City," said Willis E. Hartshorn, its director. "But that's because we're all photography all the time."

Mr. Naef said the museum began considering two years ago how to use the space. "By the fall of last year we had a good idea of how we wanted to configure the galleries," he said. "Michael Brand made this project a high priority, as one of the first important decisions, when he arrived in January. Construction work began double-time early this year."

The morning that the polished solid white-oak floors were unveiled, Mr. Naef took his first solitary walk through the photography galleries. "I squealed with delight," he said.

The exhibition space, while tailored to the needs of the photography department, is consistent with the plush look of all the museum's galleries. A spacious diagonal exhibition corridor spans the entire lower floor of the west pavilion, with five individual galleries set off on either side. The galleries can be segmented for separate small shows or opened to traffic flow throughout the floor.

Each gallery is approximately thirty by thirty feet, consistent with the geometry of Richard Meier's design for the entire Getty Center, based on thirty-inch grids. (Even the travertine marble bricks on the exterior facade are fifteen by thirty inches.)

Mr. Meier designed a new entrance for the west pavilion, adding an exterior canopy and a structure for exhibition banners that can be seen across the Getty Center's grand plaza. The exhibition design department at the museum designed the galleries; Houston Tyner is the architect of record. The cost for the new entrance and the reconfigured galleries was about $2.3 million.

The galleries will open with *Where We Live: Photographs of America from the Berman Collection*, an exhibition of 168 images by twenty-four contemporary photographers that have been given or lent to the Getty by Bruce and Nancy Berman. A survey of the American social landscape, it includes work by Robert Adams, William Christenberry, William Eggleston, Mitch Epstein, Joel Meyerowitz, Stephen Shore, and Joel Sternfeld, among other contemporary photographers. Since 1998 the Bermans have given 467 photographs to the Getty.

Mr. Naef plans to have photographs on public view at all times. "We have one of the great collections anywhere in the world and it's meritorious to show more of it," he said. Until now the photography galleries were dark for eight weeks a year during installations between shows. Because of the limited space, many works in the collection were never exhibited.

The new galleries will provide flexibility—not only in how many photographs can be hung but also in the size of the prints that can be shown.

Pearblossom Hwy, 1986, by David Hockney, for example, is a six-by-nine-foot image and the largest piece in the photography collection. It was last exhibited in 1998. In the second in a new series of exhibitions, *Photographs: Re-Imagining Art*, it will be the focus of a show that addresses the influence of Cubism on Mr. Hockney's work.

After lunch, walking through the climate-controlled storage area where photographs are kept, Mr. Naef pointed out the "earthquake mitigation" design of the three thousand shelves. The shelving units are connected directly to the superstructure of the building, and the shelves are angled to be lower in back, to prevent the boxes of photographs from sliding out if a tremor hits.

Now, finally, with its spacious new showcase, the Getty can bring more of those images out of storage. "Photography has become a full-blown artistic medium in its own right," Richard Armstrong, director of the Carnegie Museum of Art in Pittsburgh, said by phone about the Getty expansion. "So if you have a high-quality collection, why not just put it on view?"

Originally published in the *New York Times*, October 15, 2006.

The Marketplace

In 1981, *Moonrise, Hernandez, New Mexico*, by Ansel Adams, was sold to a private dealer for the highest price ever paid at the time for a photograph: $71,500. It sent shock waves through a still quaint and parochial photography world, and certainly caught the art world by surprise. For the true believers, though, who shared a kind of secret society solidarity in their awareness of photography as an art form, the deeper jolt was that money—and not scholarship—gave legitimacy to the medium.

Since then, the forces at work that determine the market value of any single photographic image are varied and complex, of course, and not completely mercantile. Delicate balances are struck—and struck down—in the ebb and flow of curatorial choice, critical judgment, connoisseurial taste, scholarly research, and dealer representation. Never mind the hand of fate dealt to the artists themselves with the passing of time.

Consider the Sotheby's spring 2008 auction: A print of Diane Arbus's *A Family on Their Lawn One Sunday in Westchester* (page 88), sold for $553,000. And, an Edward Weston nude set a record for the artist at $1,609,000. Of course these prices are nothing compared to Edward Steichen's platinum print, *The Pond–Moonlight*, which sold in 2006 for nearly $3 million, the current record price for any photograph. How did all of these small black-and-white pieces of paper get to be so expensive?

Here's one explanation: In the 1970s, there were only a handful of photography galleries in New York: Light, Witkin, and Daniel Wolf comprised the only real game in town. Today, the monthly gallery guide, *Photograph*, lists dozens of photography galleries in New York City, alone. Since photography is now firmly regarded as an equal among the arts, its history assumes greater weight in the marketplace. Diane Arbus, Edward Steichen, and Edward Weston are all dead and their deification in the history of the medium is secure. Additionally, in their lifetime, as there was no market for photography, they never thought to make prints of their work in editions. Rarity increases the value of any print, both within the artist's oeuvre and as an example of an outdated process. The condition of a print, too, is taken into account when assessing its value.

Technology is at play in demarcating periods in photography, and in recent years, digital technology has rendered light on film and darkroom printing archaic. The three prints referred to above were made with methods and materials virtually obsolescent today. The ubiquity of contemporary color work adds a layer of nostalgia to black-and-white pictures that reflect the look of a bygone era. No wonder, then, that the marketplace value of mid-century black-and-white photographs has increased because of the outmoded techniques used to create them. That Diane Arbus's work is considered among the best of that period

makes it almost understandable that her prints, in particular, have reached well into the six-figure zone.

Another measure of a print's value is its pedigree. Only three platinum prints of Steichen's *The Pond–Moonlight* exist, and two are in the collections of the Museum of Modern Art and the Metropolitan Museum of Art. The prints were made with gum bichromate, to which Steichen added a patina of color and left a bit of brushwork. As one of the best examples of Pictorialism, its importance in the history of photography further increases its value. Still, does all of that add up to a record price of nearly $3 million? You decide.

Of course, the value of contemporary photography has skyrocketed, too. Due to the wonders of digital technology, photographic prints are now measured in feet instead of inches. Photographs can hold a wall in the same way paintings do. The growing size of the photographic print has changed the formal properties of the medium, but the scale of the photographic print also responds directly to market forces.

The social currency of collecting art has brought one record price after another at auction. In the scheme of things, the value of photography is dwarfed by the astronomical figures commanded by painting. Nevertheless, while the photography curator may ordain the work of a photographer, it is the private collector who can afford to buy it. As museums necessarily rely on patronage to mount exhibitions and to expand their collections, the private collector assumes a greater role. How much the marketplace influences not only curatorial decision-making, but art-making itself, at this point in time, and vice versa, is a question best posed, perhaps, to Faust.

The Theater of the Street, the Subject of the Photograph

On Philip-Lorca diCorcia

In 1999 Philip-Lorca diCorcia set up his camera on a tripod in Times Square, attached strobe lights to scaffolding across the street and, in the time-honored tradition of street photography, took a random series of pictures of strangers passing under his lights. The project continued for two years, culminating in an exhibition of photographs called *Heads* at Pace/MacGill Gallery in Chelsea. "Mr. diCorcia's pictures remind us, among other things, that we are each our own little universe of secrets, and vulnerable," Michael Kimmelman wrote, reviewing the show in the *New York Times*. "Good art makes you see the world differently, at least for a while, and after seeing Mr. diCorcia's new *Heads*, for the next few hours you won't pass another person on the street in the same absent way." But not everyone was impressed.

When Erno Nussenzweig, an Orthodox Jew and retired diamond merchant from Union City, New Jersey, saw his picture last year in the exhibition catalog (page 110), he called his lawyer. And then he sued Mr. diCorcia and Pace for exhibiting and publishing the portrait without permission and profiting from it financially. The suit sought an injunction to halt sales and publication of the photograph, as well as $500,000 in compensatory damages and $1.5 million in punitive damages.

The suit was dismissed last month by a New York State Supreme Court judge who said that the photographer's right to artistic expression trumped the subject's privacy rights. But to many artists, the fact that the case went so far is significant.

The practice of street photography has a long tradition in the United States, with documentary and artistic strains, in big cities and small towns. Photographers usually must obtain permission to photograph on private property—including restaurants and hotel lobbies—but the freedom to photograph in public has long been taken for granted. And it has had a profound impact on the history of the medium. Without it, Lee Friedlander would not have roamed the streets of New York photographing strangers, and Walker Evans would never have produced his series of subway portraits in the 1940s.

Remarkably, this was the first case to directly challenge that right. Had it succeeded, Evans's *Subway Passenger, New York City*, 1941, along with a vast number of other famous images taken on the sly, might no longer be able to be published or sold.

In his lawsuit, Mr. Nussenzweig argued that use of the photograph interfered with his constitutional right to practice his religion, which prohibits the use of graven images.

New York State right-to-privacy laws prohibit the unauthorized use of a person's likeness for commercial purposes, that is, for advertising or purposes of trade. But they do not apply if the likeness is considered art. So Mr. diCorcia's lawyer, Lawrence Barth, of

Munger, Tolles & Olson in Los Angeles, focused on the context in which the photograph appeared. "What was at issue in this case was a type of use that hadn't been tested against First Amendment principles before—exhibition in a gallery; sale of limited-edition prints; and publication in an artist's monograph," he said in an email message. "We tried to sensitize the court to the broad sweep of important and now famous expression that would be chilled over the past century under the rule urged by Nussenzweig." Among others, he mentioned Alfred Eisenstaedt's famous image of a sailor kissing a nurse in Times Square on V-J Day in 1945, when Allied forces announced the surrender of Japan.

Several previous cases were also cited in Mr. diCorcia's defense. In *Hoepker v. Kruger* (2002), a woman who had been photographed by Thomas Hoepker, a German photographer, sued Barbara Kruger for using the picture in a piece called *It's a Small World Unless You Have to Clean It*. A New York federal court judge ruled in Ms. Kruger's favor, holding that, under state law and the First Amendment, the woman's image was not used for purposes of trade, but rather in a work of art.

Also cited was a 1982 ruling in which the New York Court of Appeals sided with the *New York Times* in a suit brought by Clarence Arrington, whose photograph, taken without his knowledge while he was walking in the Wall Street area, appeared on the cover of the *New York Times Magazine* in 1978 to illustrate an article titled "The Black Middle Class: Making It." Mr. Arrington said the picture was published without his consent to represent a story he didn't agree with. The New York Court of Appeals held that the *Times*'s First Amendment rights trumped Mr. Arrington's privacy rights.

In an affidavit submitted to the court on Mr. diCorcia's behalf, Peter Galassi, chief curator of photography at the Museum of Modern Art, said Mr. diCorcia's *Heads* fit into a tradition of street photography well defined by artists ranging from Alfred Stieglitz and Henri Cartier-Bresson to Robert Frank and Garry Winogrand. "If the law were to forbid artists to exhibit and sell photographs made in public places without the consent of all who might appear in those photographs," Mr. Galassi wrote, "then artistic expression in the field of photography would suffer drastically. If such a ban were projected retroactively, it would rob the public of one of the most valuable traditions of our cultural inheritance."

Neale M. Albert, of Paul, Weiss, Rifkind, Wharton & Garrison, who represented Pace/MacGill, said the case surprised him: "I have always believed that the so-called street photographers do not need releases for art purposes. In over thirty years of representing photographers, this is the first time a person has raised a complaint against one of my clients by reason of such a photograph."

State Supreme Court Justice Judith J. Gische rejected Mr. Nussenzweig's claim that his privacy had been violated, ruling on First Amendment grounds that the possibility of such a photograph is simply the price every person must be prepared to pay for a society in which information and opinion freely flow. And she wrote in her decision that the photo-

graph was indeed a work of art. "Defendant diCorcia has demonstrated his general reputation as a photographic artist in the international artistic community," she wrote.

But she indirectly suggested that other cases might be more challenging. "Even while recognizing art as exempted from the reach of New York's privacy laws, the problem of sorting out what may or may not legally be art remains a difficult one," she wrote. As for the religious claims, she said: "Clearly, plaintiff finds the use of the photograph bearing his likeness deeply and spiritually offensive. While sensitive to plaintiff's distress, it is not redressable in the courts of civil law."

Mr. diCorcia, whose book of photographs *A Storybook Life* (Twin Palms) as published in 2004, said that in setting up his camera in Times Square in 1999: "I never really questioned the legality of what I was doing. I had been told by numerous editors I had worked for that it was legal. There is no way the images could have been made with the knowledge and cooperation of the subjects. The mutual exclusivity, that conflict or tension, is part of what gives the work whatever quality it has."

Mr. Nussenzweig is appealing. Last month his lawyer Jay Goldberg told the *New York Law Journal* that his client "has lost control over his own image."

"It's a terrible invasion to me," Mr. Goldberg said. "The last thing a person has is his own dignity."

Photography professionals are watching—and claiming equally high moral stakes. Should the case proceed, said Howard Greenberg, of Howard Greenberg Gallery in New York, "it would be a terrible thing, a travesty to those of us who have been educated and illuminated by great street photography of the past and, hopefully, the future, too."

Originally published in the *New York Times*, March 19, 2006.

Why Photography Has Supersized Itself

There was a time when most photographic prints were small enough to hold in the palm of your hand. If you had visited Alfred Stieglitz's 291 gallery in 1920, for example, you might have been handed one of his pictures of Georgia O'Keeffe. It would have been an intimate experience.

Fast-forward to the era of the big picture. In early 1981, an atypically large print of Ansel Adams's *Moonrise, Hernandez, New Mexico*—39 by 55 inches—was sold by G. Ray Hawkins Gallery in Los Angeles for $71,500, at the time the highest price ever paid for a photograph. Since then, the size of photographs has been steadily expanding, along with their importance in the eyes of critics and their value in the marketplace.

Proof of this evolution is on display in photography shows throughout Chelsea, as well as at the recent Armory show and the current Whitney Biennial, where photographs can be measured in feet rather than inches. The current prominence of prints of such a scale has come to affect not only how pictures look, but how we look at pictures.

In 1983, the Museum of Modern Art mounted an exhibition titled *Big Pictures by Contemporary Photographers*. In the wall text, John Pultz, the cocurator, pointed to the "recent trend in photography to treat size and physical presence as consciously considered formal elements."

He went on to describe the technical limitations of large-scale photographs: "The print loses much of its descriptive quality and falls back on the tones and grain of paper and film." A quaint observation by today's standards, now that technology has made it possible for photographers to enlarge their prints without compromising the quality of the image.

Joel Sternfeld first exhibited his series American Prospects at the Daniel Wolf Gallery in New York in 1980. The prints were 16 by 20 inches and 20 by 24 inches. This same body of work was shown last fall at the Luhring Augustine Gallery in prints that were 45 by 52 inches. Several years ago, Mr. Sternfeld had the original 8-by-10 negatives electronically scanned as a way to preserve them; the process also enabled him to make the larger prints on finer paper with better control over tone, sharpness, and clarity. "We're at a tipping point," he said recently. "The digital print is becoming the look of our time, and it makes the C-print start to look like a tintype."

Now, with movie-size video monitors in public, large-scale television screens at home and multimedia billboard advertising, commercial imagery has gotten not only bigger, but clearer than life and increasingly cinematic. Perhaps as a result, still images are reflecting the world back to us in a way that is ever more experiential.

A photograph by Thomas Struth taken inside the Louvre—6 by 7 feet—places the viewer directly in front of Géricault's *Raft of the Medusa*. The scale elicits a sensation that

you are among the people in the museum looking at the painting. At any point, you expect one of them to turn and walk out of the frame. This is the effect of many of Mr. Struth's photographs, which, because of their grand scale, seem to place the viewer inside the picture field.

In a new body of work (seen at PaceWildenstein in New York and the Fraenkel Gallery in San Francisco), Richard Misrach set out to explore what he calls the "heroic scale" of the landscape in relationship to the human figure. The sheer magnitude of his prints—in some cases as big as a picture window—engulfs the viewer. It's rare for a photograph to elicit a physical sensation, but looking at his aerial picture of a lone sunbather on an empty field of sand nearly brings on vertigo.

"When I started working with Richard Misrach in 1977," recalls Jeffrey Fraenkel of the Fraenkel Gallery, "his images measured 15 inches square. Now they measure 58 by 120 inches, and a crane is required to hoist them four floors up into the gallery."

Mr. Fraenkel attributes the growth in the size of photographs to, among other things, "a long-standing feeling in the art world that photography was, perhaps, a second-class citizen."

"Once it became possible to make authoritative large-scale prints, photographers could challenge the other arts, especially painting, on a level playing field," he says.

Jeff Wall, whose work is currently on view at the Marian Goodman Gallery, was among the earliest photographers to make images aimed at the scale of grand painting. *The Destroyed Room*, 1978, measured 5 by 8 feet and referred directly to *The Death of Sardanapalus*, 1827, by Delacroix.

The comparison of large-scale photography to painting may be artificial, but it is also inevitable. Andreas Gursky, around whom the discussion of size in photography always rotates, makes photographs so large and so optically precise that, as with mural-size paintings—Veronese's *Marriage at Cana*, for example—you marvel at the godliness of craft alone.

"The size of a Gursky print is consonant with the scale of the subject," says Susan Kismaric, curator of photography at the Museum of Modern Art, referring to images as large as 80 by 124 inches. "His picture of a soccer field is meant to accommodate the spectacle of the sports event. His photograph of ship containers and new cars in Salerno reflects the globalization of trade."

Even photojournalists have started to flex this visual muscle. In *War in Iraq: The Coordinates of Conflict, Photographs by VII*, a show at the International Center of Photography, images taken with journalistic intentions are exhibited in prints measuring both 30 by 40 inches and 40 by 60 inches. It's curious that these pictures, taken for editorial purposes, are parading on the gallery wall as art objects. Their size confers an authority that the pictures themselves may or may not possess.

Not too long ago, when photography was still a chemical process based on light and film, the anatomy of a picture was evident on the negative or the contact sheet. Since the size of a photograph can end up being no more than a formal conceit, it's worth considering how well a picture works small to determine how well it will hold up large.

Today, any photograph can be made huge. But not every photograph should be. Vince Aletti, writing about the big-picture phenomenon in the *Village Voice* in 2001, observed that: "When virtually everyone is striving for new levels of drop-dead monumentality, size loses its power to wow and becomes almost beside the point. . . . For too many photographers, however, bigger is not better; a weak image doesn't suddenly look important when it's blown up to the size of a store window."

In the end, size might be driven by the marketplace. While it makes sense that photographers are seduced by the mythic potential of "grand photography," it's worth pointing out that, in 1993, a Stieglitz print, *Georgia O'Keeffe: A Portrait, Hands With Thimble*, 1920, sold at Christie's for $398,500. It was 9 by 7 inches. Maybe the value of a photograph is not measured in size at all, but time.

Originally published in the *New York Times*, April 18, 2004.

A Thousand Words? How About $450,000?

Is the price of a photograph the measure of its value? Hold that thought while you consider these record-setting figures: last April, a signed Diane Arbus print of *Identical Twins, Roselle, New Jersey,* sold at auction at Sotheby's for $478,400. During the fall auctions at Christie's, *Memphis,* ca. 1970, by William Eggleston (page 83), sold for $253,900, and *Calla Lily,* 1986, by Robert Mapplethorpe, for $242,700. For "brand name" photographers of later-twentieth-century vintage, six-figure prices have ceased to be exceptional.

The art world, layered with prestige, the weight of history, serious scholarship, and not a little pretense, has finally embraced photography, but the verdict is still out about the medium's position as an arriviste. Serious collectors of art are now seriously collecting photographs, but so are people with cash on their hands who view photography as just another status collectible. That status depends in part on the belief that these fantastic prices reflect some inherent worth, not just canny marketing. Do they?

In setting these prices, some basic rules are clear. The value of photographs by Diane Arbus, for example, is based on her stature and influence on the medium, the high regard of curators and historians, and the collections in which her work resides. In the last year, it has been buoyed by a retrospective that originated at the San Francisco Museum of Modern Art and is now at the Metropolitan Museum of Art.

Yet the prices of Arbus prints vary. Dealers and astute collectors will focus on the significance of the image in context of her oeuvre; the vintage, whether it was printed by her or not; the print's provenance and its rarity, that is, how many were made from the negative and whether Arbus signed them. Even the pedigree of the dealer selling it can be a consideration.

Then there is the condition of the print. "Minor dings, creases, scratches, etc., can make a difference of tens of thousands of dollars," Jeffrey Fraenkel, who represents Arbus at the Fraenkel Gallery in San Francisco, said in a recent email message. Even the paper the image is printed on. "One might be able to study side by side two pristine prints by Edward Weston of *Pepper No. 30,* for example, yet one may have a glow, a warmth, subtle distinctions in the shadow areas, or other factors that can make a big difference in the value of a print," he said. Connoisseur-speak on one level; the stuff of art historical scholarship on the other.

The dealer Peter MacGill describes his criteria for assigning prices to photographs concisely: "Is it the best print? Is it the best presentation? Is it a transformative work of art?"

In 1999, his gallery, Pace/MacGill, sold Man Ray's *Glass Tears,* 1930–33, for $1.3 million, at that point the highest price ever paid for a photograph. "It was a vintage print, one of only four printed from the negative," he said. "It was an impeccable print, breathtak-

ing." As for the provenance, he had acquired the print from someone who had received it directly from Man Ray.

Mr. MacGill had engaged three outside experts to assess the authenticity of the print. In one test, it was held up to a black light to see whether it fluoresced, proof of the presence of optic brighteners, which were not used in print papers before the 1950s. It did not fluoresce. And, of course, he added: "Man Ray is always sought after. He is a major Surrealist artist, so the scope of his work goes beyond photography."

Photographs have gained serious credibility not least because of the blurred distinction between artists who use photographs and photographers who are artists, from the Man Rays of old to Cindy Sherman, whose conceptual work makes it hard to assign her to one discipline.

Among the seventy galleries represented at the annual armory show of the Art Dealers Association of America in New York last month, only half a dozen were devoted strictly to photography. Other galleries exhibited photographs among works of art in other mediums. Yet while some photographs held their own among the Gustav Klimts, Andy Warhols, and Gerhard Richters, the scale and prices of the paintings made it clear that they still lead the art-market conversation. But the same rules apply to both mediums. If an image has been exhibited in a groundbreaking or historic show, like the 1913 Armory Show for painting or the 1929 *Film und Foto* show for photography, its value increases.

Deborah Bell, a private photography dealer, recently sold five vintage August Sander portraits. All were in perfect condition and all came directly from the Sander family. Their prices ranged from $8,000 to $22,000, and size accounted for some of that difference: the smaller pieces sold for less than the bigger ones. The other factor was their importance in his body of work: two that were far earlier than the portraits in Sander's famous series, People of the Twentieth Century, sold for less than a later piece that was one of the best examples of his work.

All in all, a bargain compared with his portrait *The Bricklayer*, which sold in London in 1999 for $450,000, and *Anton Raderscheidt*, 1927, which sold at Sotheby's in New York in 2001 for $85,000.

According to Ms. Bell, those prices could have occurred only at auction, not at a private dealer. She believes that auction prices are serendipitous; some people pay top dollar at auctions because, she said, they "are reassured by the belief that the work has been authenticated to the nth degree by the auction house. That venue gives the illusion of greater authenticity."

Yet from auctions to galleries to art fairs, the photography market can be as speculative as any investment arena, and even the most confident projection of a photograph's worth can be misleading. Last month, at the annual fair of the Association of International Photography Art Dealers in New York, an image by Walker Evans, *The Breakfast Room*, 1935,

measuring roughly 6½ by 8½ inches, sold at the Laurence Miller Gallery booth on the first night for $195,000.

Asked how he arrived at that price, Mr. Miller cited the importance of the image in the body of Evans's work, including a comment from a well-placed curator attesting to its significance; the print's rarity because of an unusual cropping; its pristine condition and its provenance—as a gift from Evans to Calvert Coggeshall, a painter, from whose estate Mr. Miller had obtained it. He outlined all those strengths in a letter to collectors before the show.

But "the picture sold too fast," he said. "It must have been priced too low." He is philosophical, nonetheless: "Every picture has three prices—yesterday's, today's, and tomorrow's. If it has yesterday's price, it's a bargain; today's is fairly priced, and tomorrow's, you have to wait a while before it achieves its value."

When it comes to contemporary photography, obviously, prices cannot yet be assigned on the basis of the photographer's place in history. So what is the science—or the alchemy—that determines market value? As the size of photographs has grown, for example, the calculus for pricing them has changed. And as Susan Kismaric, curator of photography at the Museum of Modern Art, wryly observed, "Large color photographs decorate; small black-and-white photographs don't decorate."

The artist Andreas Gursky certainly wins in the sweepstakes of size. In his first show at the Matthew Marks gallery in 1997, his 6-by-8-foot images sold for $20,000; in his second show at the gallery, in 1999, the images were slightly bigger, reaching 10 feet long, and sold for $60,000 to $75,000. By then, "Gursky was entering the best collections," Mr. Marks, the gallery owner, said. Last year, Mr. Gursky's new works, some more than 10 feet long, were priced at $200,000.

"Gursky is dealing with issues of painting, the way an abstract painter deals with color and space and form," Mr. Marks explained. "You begin to price them as paintings as they begin to look like paintings." But it can take a while for collectors to catch on. Recounting Gursky's first show in his gallery, Mr. Marks described himself trying unsuccessfully to sell *Prada II*, 1997 (page 116), to distinguished collectors for $20,000. "Now it's one of the top images in his body of work, by all accounts," he said. In 2000, it sold at Christie's for $270,000.

But as the prices for high-end photography change so does the clientele. "As I get older," the dealer Janet Borden said, "collectors get younger." She currently prices Tina Barney's 40-by-60-inch color prints at $15,000, up from about $1,000 twenty years ago. One reason Ms. Barney can command the upper figure, according to Ms. Borden, is that she was a pioneer in the genre of narrative photography. Another is that she doesn't produce that many images in a year, Ms. Borden explained—six to ten pieces. "At $12,000, they were selling too fast," she said. "If they're all sold out too quickly, then they are undervalued."

Other hidden components of pricing include the high production costs of big photographs, as well as the gallery's role in policing the legacy of the artist's work, developing a following for the artist through museum contacts, and cultivating collectors. In other words, overhead.

So, has photography come of age, or is it simply that the prices for painting and installation work have reached such stratospheric heights that photography can also now reach for the moon?

To reach the current Arbus exhibition at the Met, you have to pass through the European paintings galleries. The scale of the canvases dwarfs Arbus's small gray pieces of paper, raising yet again the question of how photography will ultimately fare in the majestic field of art history.

Still, photography is a modern medium. It continues to evolve with new technologies, reflecting something vital about our contemporary experience. And at these prices, money talks. It's just not always clear what it's saying.

Rick Wester, director of photography worldwide for Phillips, de Pury & Company, observed ruefully: "You can buy the best Robert Frank you can find for half of what you can expect to pay for an Andreas Gursky at auction. Frank is among the most important artists of the twentieth century. Anyone looking for the logic to that will end up mumbling to himself over a bottle of scotch for years to come."

Originally published in the *New York Times*, March 13, 2005.

From a Studio in Arkansas, a Portrait of America *On Mike Disfarmer*

Dead for half a century, Mike Disfarmer, the eccentric portrait photographer from Heber Springs, Arkansas, has drawn modest yet respectful attention in recent decades. From the 1920s to the '50s, he photographed a steady stream of townspeople in his Main Street studio in an American Gothic style of portraiture that was singularly his own.

Now, a trove of recently discovered vintage prints is generating renewed interest in his work. In a hush-hush entrepreneurial race to the finish, two photography collectors from New York have separately bought up about thirty-four hundred vintage prints stashed away in the attics and basements of relatives of Disfarmer's subjects.

The only prints of his work previously known to exist were made posthumously from about three thousand glass negatives found in his studio when he died in 1959.

The New York collectors, Steven Kasher and Michael Mattis, began acquiring the vintage prints last year after a young couple from Heber Springs who had relocated to Chicago offered Mr. Mattis fifty family pictures taken by Disfarmer. Word of the sale traveled back to Heber Springs, where residents realized that their family pictures might also be of value. Several people tracked Mr. Mattis down to offer their pictures for sale. That's when he saw gold — well, silver (as in silver prints) in them there hills.

Around the same time, other Heber Springs residents began contacting Mr. Kasher, a dealer who once worked for Howard Greenberg Gallery, which sells prints from Disfarmer's glass negatives. That piqued Mr. Kasher's interest in buying up as many vintage prints as he could find.

What makes these postcard-size prints of unknown people so valuable is their authenticity. A vintage print, one made by a photographer around the time the picture was taken, will be closer to the way the photographer wanted it to look. Because the photographic paper dates from when the picture was taken, the print is a genuine artifact of its era. Disfarmer's clients often ordered several copies of their pictures, so Mr. Mattis and Mr. Kasher realized that a single image might be in the possession of more than one friend or relative.

Now, fresh from the foothills of the Ozarks, several hundred of these newly discovered portraits are the subject of simultaneous exhibitions in Manhattan, at the Edwynn Houk Gallery on the Upper East Side and at the new Steven Kasher Gallery in Chelsea. Two books are being published in conjunction with the shows.

"It's always a good way to make a big statement, and it's definitely a marketing strategy," Mr. Kasher said of the exhibitions and books.

Mr. Houk is less enthusiastic about the simultaneous timing of the shows.

"It's not particularly a good thing," he said. "In fact, it would be better to do it sequentially." But Mr. Kasher had decided to time his Disfarmer show with the opening of his new

gallery in Chelsea, so the two dealers agreed to work together.

Mr. Kasher is pricing his Disfarmer prints from $10,000 to $30,000. Mr. Houk's will range from $7,500 to $24,000.

Mr. Kasher said he had bought four hundred prints overall, and Mr. Mattis said he had acquired three thousand, selling about one thousand of those to Mr. Houk.

Mr. Kasher would not say what he had paid overall for his photographs. Mr. Mattis would only say that he had invested a seven-figure sum in the process of acquiring his vintage prints.

"Michael and I were both doing the same thing at the same time," Mr. Kasher said. "Sometimes we were competing. Sometimes we were cooperating more, just like any two collectors who were interested in the same subject." He added that they even traded prints.

In his quest for the vintage work, Mr. Mattis mounted a show of Disfarmer prints from the glass negatives at the Cleburne County Historical Society in Heber Springs and put advertisements in the local paper seeking vintage Disfarmer prints.

Mr. Mattis hired half a dozen residents to go door to door, because he said he thought they would be more likely than New Yorkers to gain people's trust when asking about their family photos. He found some scouts by searching for the Heber Springs ZIP codes on eBay, others by word of mouth.

He trained his scouts to identify good prints from bad. "There is image quality and there is print quality," he explained, saying he preferred subjects wearing overalls instead of suits, and with serious expressions rather than smiles. If the print was yellow, creased, flushed out in the highlights, or had a flat tonal range, he wasn't interested. Eventually, he said, his representatives in Heber Springs were giving him "the same kind of condition report you'd get from Sotheby's or Christie's."

Representatives scanned the Disfarmer prints they gathered from residents, and emailed them as digital images to Mr. Mattis.

Mike Disfarmer, formerly Mike Meyer, was viewed as a maverick. To drive home his individuality, he adopted a contrarian surname. (In German "Meier" means dairy farmer.) Farmland surrounds Heber Springs and farmers make up the majority of the local population.

As a bachelor, loner, atheist, and the only person in town to practice studio photography, Disfarmer was in fact very different from most people there. Notice of his name change appeared in the local paper under a headline, "Truth Is Stranger than Fiction," which included Disfarmer's account of his origins—something about being delivered on his parents' doorstep by the winds of a tornado.

According to an essay by the writer Richard B. Woodward in *Disfarmer: The Vintage Prints* (powerHouse Books), published for the show at Edwynn Houk, the photographer

"paid far more attention to people as artistic problems to solve, sometimes taking as long as an hour to make a portrait, than as individuals with lives outside the studio."

Mr. Woodward cites one subject, Charlotte Lacey, photographed by Disfarmer in her school band uniform during the early 1940s. Disfarmer wasn't friendly or talkative, she recalled. The studio, she said, was "this big empty room" with "damp walls," and he was "very spooky and scary" when he vanished under the camera cloth for minutes at a time.

"There wasn't much of a greeting when you walked in, I'll tell you that," another subject, Tom Olstead, is quoted as saying. "Instead of telling you to smile, he just took the picture. No cheese or anything."

The race to scavenge for Disfarmer prints says a lot about the photography market today. Both Mr. Kasher and Mr. Mattis astutely recognized an investment opportunity and strategically set out to amass respective bodies of Disfarmer's notable, if under-the-radar, American vernacular portraits. Packaged in simultaneous gallery exhibitions and separate books, they are bringing these portraits to the public's attention, which is a worthy venture. At the same time, they are creating a market event that ratchets up the price of the work—perhaps beyond its value.

In a telephone interview last week, Sandra S. Phillips, curator of photography at the San Francisco Museum of Modern Art, said of Disfarmer's images: "He's not an expansive voice, but he's carved out a very small field for himself, which is studio portrait photography of ordinary people. He's great at what he does when he does it well."

His images, with their stripped-down, no-nonsense quality, focus directly on the individual as specimen. In that era, of course, self-consciousness was less about how to play to the camera than about the shyness of posing in front of it. With his outsider's eye, Disfarmer captured that awkwardness, and provided a record of people from a particular time and place in America.

Originally published in the *New York Times*, August 22, 2005.

What's New in Photography: Anything but Photos

In New York City, a vast number of commercial galleries show photographs. Many of them represent photography exclusively; some show photo-based art that incorporates other mediums; others are galleries that represent painters and sculptors primarily but also include a handful of photographers. But in the last few years, some of the most famous and long-standing photography galleries have begun mixing nonphotographic work in with their primary offerings.

It may not be a revolution, but it is a significant change in the gallery landscape. These are the places that helped to establish photography's viability as an art form as well as to create a business model. Having proven their point, they are now at liberty to experiment.

There is an unofficial hierarchy among photography galleries, and the oldest tend to be at the top of the heap. Many of those have featured photographers who over the years have earned a place in the medium's canon—sometimes because of their dealers' efforts.

Peter MacGill, who opened the Pace/MacGill Gallery on East 57th Street in 1983, said he has always tried to show work that advances photography as a whole. "The work must closely interface with the history of art and advance it along with the other mediums," he explained. "I believe there is one history." His artists could constitute a foundation course in photography since the 1950s: Robert Frank, Harry Callahan, Duane Michals, Irving Penn, Philip-Lorca diCorcia, among others.

But his last show didn't contribute to that history at all. It was a collection of drawings and sculpture by David Byrne. While Mr. MacGill has shared exhibits of work in other mediums with PaceWildenstein, his partner gallery, at Pace/MacGill he has mounted only three in the last twenty years. "Until recently, everyone seemed to think of photography as an entity separate from the rest of the art world," Mr. McGill said. "Currently there is more freedom to show other works of art on paper along with photographs to what is now a very receptive audience."

Janet Borden, Inc. opened in SoHo in 1988, and among the photographers she has represented are famous names like Lee Friedlander, Jan Groover, Tina Barney, Larry Sultan, and Martin Parr. When Lee Friedlander came to Ms. Borden, he had already won the approval of the Museum of Modern Art, but many of her other artists owe at least some of their prominence to her imprimatur.

Asked if her gallery has an aesthetic mission, Ms. Borden waved the question away. "That's a little too religious for me," she said. "We try to identify the best artists working in photography and work with them to promote and sell their photographs. I tend to be more interested in artists' ideas, so that their work is consistently interesting over the years."

What about showing work that is not photographic? "We never call ourselves a photog-

raphy gallery, in case we want to show something else," she said. "When one of the artists whom we represent is making other art, that's what we show. Robert Cummings is a good example. He often works in intricate cut-paper silhouettes as well as drawings. We think his vision is totally photographic, so we're thrilled to show whatever he makes."

One of the most prominent dealers, Jeffrey Fraenkel, plays a central role in the photography world even though his gallery isn't in New York. He opened in San Francisco in 1979 and over the years has assembled a stable that approximates the modernist canon: Robert Adams, Diane Arbus, Richard Avedon, Lee Friedlander (shared with Janet Borden in New York), and Richard Misrach (with Pace/MacGill), among others.

Mr. Fraenkel neatly defines his gallery's aesthetic profile: "Modern art, specializing in photographs. A place where one can depend on seeing serious photographs regularly considered in relation to other arts."

His current show, *Nothing and Everything*, includes drawing, painting, photography, and sculpture, in work not only by his gallery photographers but also by Carl Andre, Jean Dubuffet, Donald Judd, Ellsworth Kelly, Robert Rauschenberg, and Robert Ryman.

Explaining why he is showing work in other mediums, Mr. Fraenkel said that when he first opened his gallery people consistently asked him if photography was art. "That battle has been won, and photography is no longer an island," he said. "Now it's more fruitful to investigate the areas where photography intersects the other arts."

Photography does so to a greater and greater degree, in part because of galleries like Marian Goodman on West 57th Street, a top contemporary art gallery with a branch in Paris. Among Ms. Goodman's stars are Rineke Dijkstra, Thomas Struth, and Jeff Wall. In Chelsea, Matthew Marks represents Nan Goldin and Andreas Gursky. Sonnabend Gallery has Hiroshi Sugimoto; Cheim & Read shows William Eggleston; 303 Gallery shows Stephen Shore; and Luhring Augustine represents Gregory Crewdson and Joel Sternfeld.

All of these artists use photographic equipment, but like the pioneering work of Cindy Sherman, some of their work crosses genres, styles, and mediums to become a conceptual form all its own. Their association with high-profile galleries that show a variety of mediums has afforded them international visibility, record sales, and a certain cachet.

Laurence Miller Gallery, which opened in 1984, has given many international photographers their first solo shows, including Daido Moriyama, Toshio Shibata, and Erwin Olaf. Mr. Miller considers his West 57th Street gallery a place to educate his audience about "the qualities and possibilities that are unique to photography." But, he added, "what constitutes 'photographic' keeps changing. The history of photography is one big technological evolution. New technologies keep challenging us, and I'm excited about the future."

When Julie Saul opened her gallery in the 1980s, she and her contemporaries took a considerable professional risk by committing themselves to photography. But today she speaks of "works on paper" more broadly, so as to include drawings by Maira Kalman and

Roz Chast. In the same West 22nd Street building, Yancey Richardson also shows a wide range of photographic imagery, from Julius Shulman's straightforward documentation of mid-century modernist architecture to Mitch Epstein's large-format color photographs of the contemporary social landscape. She also shows films and videos, as well as site-specific installations, a show of original artist books by Ed Ruscha, and two shows of drawings and works on paper by emerging artists.

Bonni Benrubi, who opened her 57th Street gallery in 1986, is one dealer who is holding firm to her photographic roots. "The aesthetic core of our gallery has to do with what the camera can make," she said. "Abelardo Morell's camera obscura pictures, Matthew Pillsbury's time-lapsed pictures, Simon Norfolk's political views, Massimo Vitali's beach scenes. All of them use the camera and do not manipulate. They show the magic of what the lens can do and show a view that we do not see or notice with our normal eyes."

A number of younger photography galleries have commanded a new kind of respect — built not on longevity but on sale prices. Yossi Milo opened a small Chelsea gallery in a second-floor walkup in 2000. Three years later his show of eerie portraits of children by the German photographer Loretta Lux put him on the map. He set prices no one had seen before for a new gallery, offering images under fifteen inches square by an unknown artist. And the show sold out, causing a sensation.

Mr. Milo next showed work by another unknown photographer, Alec Soth. Mr. Soth had studied with a preeminent photographer, Joel Sternfeld, which helped assure a collective nod of approval from the old-guard photography community. That show also did extremely well, and Mr. Soth has since been swooped up by the much more famous dealer Larry Gagosian. Mr. Milo, meanwhile, has moved his gallery to a sleeker storefront space.

"The characteristics that our artists share are psychological intensity, technical innovation, imagery that does more than record reality — pushing the boundaries of the medium of photography," Mr. Milo wrote in an email message.

But even he isn't ruling out some variety. "With the opening of our North Gallery at 531 West 25th Street this month, we may expand our program to include nonphotographic work."

Some of the newest galleries came on the scene so recently that the old divisions between photography and other art forms don't seem relevant to them at all. They may have forged their identity through the sale of photographic work, but they do not see themselves as particularly beholden to that medium or to any other. ClampArt, on West 25th Street, has featured a great deal of photography since opening in 2003. But Brian Clamp, the gallery's owner, said, "With the notion of medium specificity having less and less relevance, we will begin mounting occasional solo exhibitions by artists producing nonphotographically related paintings and works on paper."

And Daniel Cooney Fine Art, also on West 25th Street, which opened in 2004, represents eleven photographers, one artist who makes sculpture and drawings, and others who

use video in their work. "I am looking to increase the number of nonphoto people that I represent," Mr. Cooney said.

With the variety of photographic work being made and the increased cross-pollination of mediums, specifying a photography gallery from an art gallery may soon seem like a retrograde distinction. Asked how she maintains her gallery's identity within the shifting landscape, Ms. Borden offered a blithe observation about art-making in general: "Of course, you know the adage, if you can't make it good, make it big. If you can't make it big, make it red. So we do like big red photographs."

Originally published in the *New York Times*, December 3, 2006.

Acknowledgments

So many people have contributed to the realization of this book, not only in terms of my thinking about photography, in particular, but also as a result of their encouragement, either personally or professionally, and I would like to offer my appreciation:

First among them are my two great friends: Susan Kismaric, for her clarity and the many invaluable insights over the years; and Larry Sultan, for his imagination—always an inspiration to me. Others who form a community of photography world coconspirators in my mind, who have given me a lot to think about, and to whom I am grateful for their friendship, our conversations, and their accomplishments: Vince Aletti, Elisabeth Biondi, Stephen Frailey, Marvin Heiferman, Bill Jacobson, Sandra S. Phillips, and Carol Squiers.

Among my colleagues at the *New York Times*, I am grateful to Ariel Kaminer, who so often said yes to my story ideas and no, thankfully, to my favorites turns of phrase; Margaret O'Connor for her friendship, wisdom, and pitch-perfect eye; Michele McNally for her steady guidance; Jodi Kantor for her initial leap of faith; Annette Grant for her visual sensitivity; and Scott Veale, for his continuing support.

At Aperture, I would like to thank Juan García de Oteyza for supporting this project; Melissa Harris and Lesley Martin, respectively, for engaging my ideas—as well as a world of ideas; Susan Ciccotti, for the pleasure of her editorial hand and good judgment; Diana Stoll, for her painless but incisive editing skills; Francesca Richer, who designed a book I am happy to look at; Matthew Pimm, for his exacting production standards; and Alex Freedman and Emeline Loric, for their vigilance.

To Véronique Vienne, who thought to interview me a long time ago about the Page One process at the *New York Times*, for her delightful esprit.

I would like to acknowledge several photography dealers who I've known since they first started out—long before there was a marketplace for photographs—and with whom I have grown older, for the love of the medium that first compelled them, their sophisticated choices, and the knowledge they have always been generous in sharing: Janet Borden, Jeffrey Fraenkel, Peter MacGill, and Julie Saul.

My deep regard goes to all the photographers who have made bodies of work that add up to something worth looking at and contemplating, including my mother, Judith Gefter, who introduced me to photography to begin with and encouraged me to open my eyes wide and to trust what I see.

Finally, to Richard Press, who, everyday, makes what I know and think and feel and see worthwhile.

Index

Page references in *italics* refer to illustrations.

Y

Reproduction Credits

Front Cover
Courtesy of Team Gallery

Page 7
Copyright © Frank Paulin, Courtesy of Silverstein Photography

Plates
Page 73: Copyright © The Estate of John Szarkowski, Courtesy of The Estate of John Szarkowski and Pace/MacGill Gallery, New York; Pages 74–75 (images): Copyright © Robert Frank, from *The Americans*; Page 76: Copyright © Cornell Capa/ Magnum Photos; Page 77: Copyright © Bruce Davidson/Magnum Photos; Pages 78–79: Courtesy of the artist and Janet Borden, Inc.; Page 80: Copyright © The Estate of Garry Winogrand, Courtesy of Fraenkel Gallery, San Francisco; Page 81: Henry Wessel, *Santa Barbara, California*, 1977, Charles Cowles Gallery, New York; Henry Wessel, *Tucson, Arizona*, 1974, Gallery Thomas Zander, Köln, Germany; Page 82: Courtesy of 303 Gallery, New York; Page 83: Copyright © 2008 Eggleston Artistic Trust, Courtesy of Cheim & Read, New York; Page 84: Copyright © William Christenberry, Courtesy of Pace/MacGill Gallery, New York; Page 85: Courtesy of Sonnabend Gallery; Page 86: Copyright © Robert Adams, Courtesy of Fraenkel Gallery, San Francisco, and Matthew Marks Gallery, New York; Page 87 (top): Copyright © Richard Misrach, Courtesy of Fraenkel Gallery, San Francisco; Marc Selwyn Fine Art, Los Angeles; and Pace/MacGill Gallery, New York; Page 87 (bottom): Courtesy of the artist and Luhring Augustine, New York; Pages 88–89: Copyright © The Estate of Diane Arbus; Pages 90–91: Copyright © Emmet and Edith Gowin, Courtesy of Pace/MacGill Gallery, New York; Page 92: Copyright © Nan Goldin; Page 93 (top): Copyright © Nan Goldin; Page 93 (bottom): Courtesy of the artist and Luhring Augustine, New York; Pages 94–97: Copyright © 2009 The Richard Avedon Foundation; Pages 98–99: The Peter Hujar Archive, L.L.C., Courtesy of Matthew Marks Gallery, New York; Pages 100–101: *Man in Polyester Suit*, 1980, Copyright © The Robert Mapplethorpe Foundation, Courtesy of Art + Commerce; *Untitled (Patti Smith)*, 1973/75, Copyright © The Robert Mapplethorpe Foundation, Courtesy of Art + Commerce; *Untitled (Sam Wagstaff)*, 1973/75, Copyright © The Robert Mapplethorpe Foundation, Courtesy of Art + Commerce; Pages 102–103: Courtesy of the artist and Metro Pictures; Pages 104–105: Courtesy of the artist and Janet Borden, Inc.; Page 106: Courtesy of the artist and Jack Shainman Gallery; Page 107 (top): Courtesy of the artist and Janet Borden, Inc.; Page 107 (bottom): Courtesy of the artist and Janet Borden, Inc.; Page 108: Copyright © JoAnn Verburg, Courtesy of Pace/MacGill Gallery; Page 109: Copyright © Jeff Wall; Page 110: Copyright © Philip-Lorca diCorcia, Courtesy of the artist and David Zwirner, New York; Page 111: Copyright © Gilles Peress/Magnum Photos; Page 112 (top): Tyler Hicks/*New York Times*/Redux Pic-

tures; Page 112 (middle): Copyright © James Hill; Page 112 (bottom): Edward Keating/*New York Times*/Redux Pictures; Page 113: Carrie Boretz; Page 114: Produzenzen Galerie Hamburg/B. Gross Galerie, Munich; Page 115: Photographs by Paul Shambroom, Courtesy of the artist; Pages 116–17: Copyright © 2008 Andreas Gursky/Artists Rights Society (ARS), New York/VG Bild-Kunst, Bonn; Page 118: Copyright © 2008 Thomas Struth; Page 119 (top left and right): Copyright © Katy Grannan, Courtesy of Fraenkel Gallery, San Francisco, and Greenberg Van Doren Gallery, New York; Page 119 (bottom): Courtesy of Cheim & Read, New York; Page 120: Courtesy of Team Gallery

Essays

Original publication information is listed at the end of each essay. Essays without a citation were written specifically for this volume.

Pages 14–39: Courtesy of the *New York Times*; Pages 40–44: Reprinted by permission of *Art + Auction* magazine; Pages 45–49: Courtesy of the *New York Times*; Pages 52–55: Courtesy of *Aperture* magazine; Pages 56–64: Courtesy of the *New York Times*; Pages 65–67: Reprinted by permission of *Art + Auction* magazine; Pages 68–71: Courtesy of the *New York Times*; Pages 124–31: Courtesy of *Aperture* magazine; Pages 132–38: Courtesy of the *New York Times*; Pages 139–43: Courtesy of *Aperture* magazine; Pages 144–46: Courtesy of the *New York Times*; Pages 150–56 Courtesy of *the New York Times*; Pages 157–59: Original title *Irving Penn: He Photographed the Most Important Artists of the Last Half-century—and in the Process*

Joined Their Ranks, Copyright © *New York Times*, reprinted by permission. Pages 160–62: Courtesy of *Dear Dave* magazine; Pages 163–65: Courtesy of the *New York Times*; Pages 168–80: Courtesy of the *New York Times*; Pages 181–86: Courtesy of *Aperture* magazine; Pages 187–89: Courtesy of the *New York Times*; Pages 192–208: Courtesy of the *New York Times*

Front cover: Ryan McGinley, *Dakota Hair*, 2004

Editor: Susan Ciccotti
Designer: Francesca Richer
Production: Matthew Pimm

The staff for this book at Aperture Foundation includes:
Juan García de Oteyza, *Executive Director*; Michael Culoso, *Director of Finance and Administration*; Lesley A. Martin, *Publisher, Books*; Joanna Lehan, *Associate Editor, Books*; Nima Etemadi, *Editorial Assistant*; Sarah Henry, *Production Manager*; Andrea Smith, *Director of Communications*; Kristian Orozco, *Director of Sales and Foreign Rights*; Diana Edkins, *Director of Exhibitions and Limited-Edition Photographs*; Alex Freedman, Emeline Loric, and Ben Reichenbach, *Work Scholars*

Photography After Frank was made possible, in part, with generous support from The Andrea Frank Foundation.

First edition
Printed in Hong Kong
10 9 8 7 6 5 4 3 2 1

Library of Congress Cataloging-in-Publication Data

Gefter, Philip.
 Photography after Frank / essays by Philip Gefter.
 p. cm.
 Includes index.
 ISBN 978-1-59711-095-2 (flexibind : alk. paper)
 1. Photography--History. 2. Photographic criticism. 3. Photographers--Biography. 4. Frank, Robert, 1924- I. Title.

TR185.G44 2009
770--dc22

 2008051216

Aperture Foundation books are available in North America through:
D.A.P./Distributed Art Publishers, 155 Sixth Avenue, 2nd Floor, New York, N.Y. 10013
Phone: (212) 627-1999, Fax: (212) 627-9484

Aperture Foundation books are distributed outside North America by:
Thames & Hudson , 181A High Holborn, London WC1V 7QX, United Kingdom
Phone: + 44 20 7845 5000, Fax: + 44 20 7845 5055, Email: sales@thameshudson.co.uk

aperturefoundation
547 West 27th Street
New York, N.Y. 10001
www.aperture.org

The purpose of Aperture Foundation, a non-profit organization, is to advance photography in all its forms and to foster the exchange of ideas among audiences worldwide.